Babungo

Jean-Paul Notué – Bianca Triaca

Babungo

Treasures of the Sculptor Kings in Cameroon
Babungo: Memory, Arts and Techniques

Catalogue of the Babungo Museum

CONTINENTS

Editing
Robert Smith

Graphic design and layout
Gaia Pasini
Giulia Tacchini

Photography
Mauro Magliani
with the collaboration of
Francesca Magliani
Marco Furio Magliani
Barbara Piovan
with the contribution of
Kodak Italia

Colour Separation
Eurofotolit

Printed in January 2006
by Bianca & Volta, Truccazzano (MI), Italy

Project "Training, Protection of Artistic and Cultural Heritage, Development in Cameroon"

Promoters
COE, Centro Orientamento Educativo, Barzio, Italy
IFA, Institute of Artistic Training, Mbalmayo, Cameroon

Co-Financers
MAE, Ministero degli Affari Esteri, Rome, Italy
CEI, Conferenza Episcopale Italiana, Rome, Italy
COE, Centro Orientamento Educativo, Barzio, Italy

Project and Coordination
Architect Bianca Triaca, COE Expert

Scientific Responsible
Jean-Paul Notué
Doctor of History and Art History (University of Paris I), Professor of Art History and Museology, Head of the Plastic Arts and Art History, Section of the University of Yaounde I, Associate Senior Researcher at IRD (formerly ORSTOM)

Contributions
Jean-Paul Notué
Bianca Triaca
Emmanuel Nchio Minkee
Protus Bofua
Lawrence Mbowoh
Cyvil Nangwa Nsanyui
Julius Ndifor

Preface

It is so much easier to believe than to think. The expressed opinion of one person can only give rise to conviction in another if corroborated by the same or a similar experience of the latter. In other words, a people can only truly believe what they themselves know and they can only actually know what they themselves have experienced.

In my role as the traditional leader of the Babungo people, I have experienced a lot that could be of great help to the future generations. So many people and writers have misinterpreted the cultural values of our people. This book is intended to be a point of reference for any subsequent publications on the history, arts, memory and techniques of the Babungo people.

The numerous artistic works in this edition reflect the ideas that had occupied the minds of more than twenty-five fons (kings) during their lifetimes. The history and deeds of these people have to be preserved. After all, is it not true that humanity has outgrown the infancy of its present cycle? To do this, we were lucky to have the help of Non-Governmental Organizations like COE, the Italian Episcopal Conference, the Italian Ministry of Foreign Affairs and the United State Embassy in putting up the structure and the museum. COE, on its part, has not only completed the museum building, but has also taken upon itself the training of four young citizens of Babungo as museum curators at the IFA-Mbalmayo. Most importantly, the present book has been published on the initiative of the Italian non-governmental organization COE and the authors, Jean-Paul Notué and Bianca Triaca. To assist the palace in putting the historical materials together, the museum curators—Lawrence Mbowoh, Cyvil Nangwa, Julius Ndifor and Protus Bofua—have demonstrated what they learnt in the IFA-Mbalmayo during their training period. In effect, knowledge gives strength while doubt paralyses the will. Vision, hard work and creativity had been the motto of the Babungo kings, as he who desires unlimited knowledge must rise above limitations. May the contents of this book appear as a sun, shedding its light upon a better and happier generation. We are grateful to the COE in the persons of Bianca Triaca, coordinator and project supervisor, and Jean-Paul Notué scientific responsible of the project and commissioner of the permanent displays in the museum. As the Babungo adage says, 'Happiness measures no time and knows no danger'.

Fon Ndofoa Zofua III of Babungo

A cultural heritage preservation project for development in Cameroon: the four museums of Babungo, Baham, Bandjoun and Mankon

The preservation and upgrading of the cultural and artistic heritage of the countries in the South of the world are rarely to be found in projects of cooperation for development. And yet many of the works of art, often of great importance, which enrich Western museums and private collections come from this half of the world. Africa is a significant example. Masterpieces of African art in museums in Europe and the United States have been the basis of epoch-making events and exhibitions, sponsored by prestigious institutions, in the West. Of the many elements of discovery, reflection and comparison that emerge on these occasions, one is of particular importance, but usually little explored: what have the Africans left of their artistic heritage, which has been subjected to colonial looting, the destruction that has accompanied the wars in the various countries of the continent and a market that is practised at levels of robbery? In what condition is it? How can what remains be preserved? How can what remains be shown off to its best, become an element of development without extracting it from its cultural context which gives it meaning and the reason for its existence?

The project entitled "Training, protection of artistic and cultural heritage, development in Cameroon" came into being in the attempt to find answers to questions like these. It received space and attention from the Centro Orientamento Educativo, an NGO that is characterized by its support for culture and the arts of the countries where it implements initiatives for development. In Cameroon, the COE set up an Institute for Artistic Training in 1980, which continues to be the only school offering this type of syllabus in the country. Thanks to the illuminated courage and intellectual sensibility of Don Francesco Pedretti, founder and the very soul of COE, a project to upgrade and preserve the artistic heritage of Cameroon was born. The initiative started with the opening of the Institute to the field research by the students. The consequent and growing awareness of the wealth of the artistic and cultural heritage of the territory together with its value and fragility highlighted the urgency to preserve it. Don Francesco was nearing the end of his life when, in 1999, I began to lay the foundations for this project, discussing it with him, and measuring myself against his great courage and unbounded trust in the capacity of men to change the world with the force of the deepest values of their humanity. 'Think on a large scale' he would say to me, because his love for the cultures of the world was great and because in the objects that are materialized from them and make their contents visible he saw the greatness of the values of the community expressing them.

Today, in the west and north-west of Cameroon, the four museums resulting from the COE project are a reality. They preserve a part of the great heritage that is still widespread in that area, keeping it in the territory that generated it and where it continues to live as a strong element of cultural identity. The objects that make up the collections of each museum express a collective cultural heritage: the history, myths, legends, religiousness, social, political and cultural reality of the community to which they belong. They speak of migrations in search of better living conditions, the values of welcome and the costs, suffering and lacerations that accompany conflicts. They speak of the respect for nature and its cycles, of life, death, ancestors, justice, solidarity and courage. They hand down the collective memory and make it the basis of values on which to build the present and open up to the transformations that lead to the future.

The museum preserves these objects but does not imprison them or uproot them from the context in which they continue to live. Each time that tradition requires their presence on the ceremonial

or ritual occasions of the community, they leave the museum and perform their function of communication and transmission of cultural, religious, magical and political values necessary for the social cohesion of which they are the expression, and then return to the place assuring their preservation.

Curators trained by the project are responsible for them. Natives of the areas where the museums have been created, they have been helped by the fact of working, during the study and cataloguing of the collections, in the places where they were born and brought up. They were helped by their knowledge of the local language and an awareness of the reality linked to their individual and family experience. In line with the identity of the COE, the training of the curators represented a priority and qualifying objective, and figures from Cameroon culture, university lecturers and officials from the Ministry of Culture of the country took part. I owe very grateful and respectful thanks for the great commitment, in-depth knowledge and constant helpfulness of the scientific co-ordinator of the project, Doctor Jean-Paul Notué, who was a fundamental reference both during the theoretical phase of training and in the practical training in the field. A native of the Grassland, he unites with a rare knowledge of the artistic heritage of that territory his cultural belonging and a long and prestigious research experience which were precious to coordinate all the museological work.

The intervention of the museum designer was the only one for which we looked outside the country, where this professional figure was not present. We were lucky to be able to have the collaboration of architect Antonio Piva, who lectures in museography at the Faculty of Architecture of the Milan Politecnico. Assigning the display of these collections, in the traditional context of the villages, to a foreign professional could have entailed problems that were not easy to solve. However, his contribution was of great value, highly appreciated and respected by the authorities and by the local communities, due to the wealth of museographic ideas and for the constant attention to displaying to their best the local materials, techniques and traditional craft skills.

In the west of Cameroon, the region where the four museums have been created, there is a material, raffia, which grows plentifully in the natural environment and which is very widely used with ancient and refined techniques. Present from the market stalls to the walls of the most sacred and important traditional building of the royal residence, the 'grande case', raffia is a constant reference to the culture and artistic and traditional craft skills of the local communities. In the museographic design, the supports for the display of the objects were made from canes of raffia tied together by lianas, exactly like the stalls in every market in this area. Only the horizontal surface is made from wood: padouk, an essence of a beautiful bright red, which strongly sets off the wood and clay of which most of the objects on display are made of. The walls of two of the museums have been covered with panels made from canes of raffia tied together by elegantly woven creepers. The lamp-holders running along the whole length of the exhibition rooms are also made from canes of raffia. In the museum situated in the area of production of ndop fabric, traditionally used as a precious backdrop to the most important events in the social life of the local community, a whole wall has been covered with these long hand-made pieces of cotton, dyed indigo blue except for the white outlines of rich symbols translated into refined geometric designs.

These interventions made a great contribution to shortening the distance between the museum and the communities, which appropriated them working on the construction of the spaces outlined by

the museographic project, giving them form with their materials and technology. The royal brides sewed ancient notables' costumes, consumed by time and wear, which were then put on wooden mannequins sculpted by local artists. Traditional objects and techniques entered the museum with important functions, the village approached a completely new intervention which took on, as it became tangible, familiar and recognizable features. The thanks to Professor Antonio Piva and to the architect Michele Piva, who followed the execution of the project, summarizes the admiration and gratitude of the COE and the villagers, for the quality of the work and for the central focus given to the participation of the local communities in creating the exhibition area.

Each museum has and expresses its own identity, and in each one an attempt has been made to document the personalities of great artists, such as the masters of the beaded thrones and the *batcham* masks of Bandjoun, the creators of the large cowrie-covered statues in Mankon and the bas-reliefs that ornate ancient door panels in Baham and the sculptor-kings of the dynasty of Babungo. The effort to succeed in attributing the works to their artists has been one of the commitments characterizing this project. The results can be found in the detailed study on the artists in the catalogues of the four museums. A great deal of work has also been devoted to dating the objects, which is not easy in view of the almost total lack of archives and written documents. Although there are still some shortcomings in the results, the research activity linked to the cataloguing of the collection has certainly marked consistent progress in the documentation of the heritage of the courts where we operated.

The commitment to preserving the culture of this territory also goes beyond the exhibition areas: each museum offers an itinerary in the collective memory leading to the places of the legends, myths, history, religiousness and tradition of each community. Often characterized by the presence of water—a waterfall or a river—and trees, or marked by stones which can be recognized by the remains of sacrifices which are still celebrated there, these sites recall an episode, a legend, a character or are known for having some magical or therapeutic property. They are places of belonging and, at the same time, frontiers which are opened to extend the visitors' experience.

This project came into being to contribute to preserving the cultural heritage of Cameroon, to create new professions in this sector, to open up possibilities of employment for young people in Cameroon and to be a segment of the path of growth of the country. I would like to place it in the vision of development of Don Francesco: 'We feel that the language of art is a universal language that goes through people, uniting them beyond all diversity and beyond all frontiers. The promotion of self-development which goes no further than technical and commercial aspects is terribly mortifying and divides men into a competition for power. The promotion of art is exalting and unites men in the joy of new creations which communicate feelings of freedom and the infinite to all' (F. Pedretti, Artisti a Kinshasa, exhibition catalogue, Graphicoe, Milan 1991, p. 5). The four new museums of Babungo, Baham, Bandjoun and Mankon are dedicated to Don Francesco Pedretti, to his love for Cameroon, for the people, culture and art of this country. With the recognition and awareness that this has been a process of growth for all those who have worked on it, open to all those who wish to follow it.

Bianca Triaca
31 May 2005

Contents

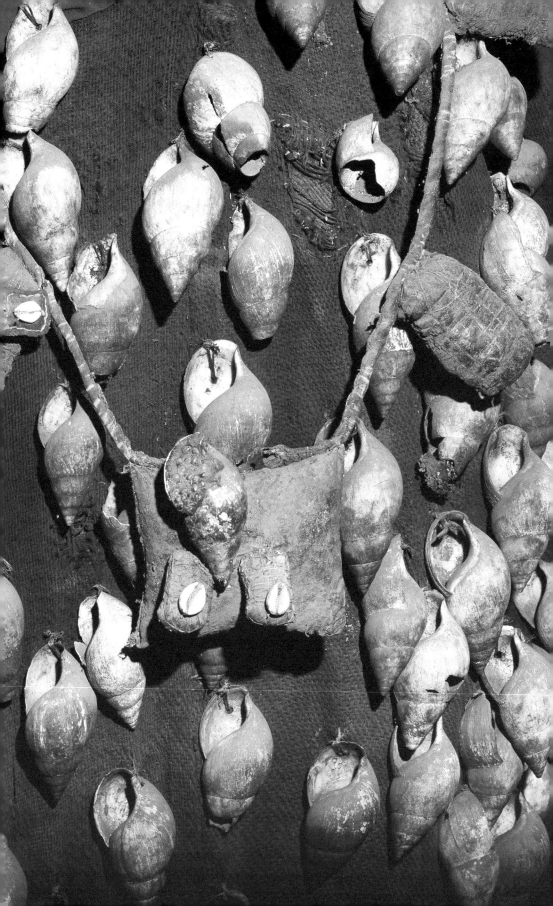

General Introduction

Jean-Paul Notué

Cameroon is a microcosm of African art. The western part of this country, a region of high plateaus called the Grasslands, is one of the main homes of artistic creation and African culture. It is divided into a few hundred small kingdoms or *chefferies* that are important artistic centres, one of the oldest and most remarkable of which is Babungo. The Babungo language is related to that of the kingdoms of Kom and Nso, all belonging to the *ring,* a sub-group of bantu languages. Eugen Zintgraff—who, in 1889, was the first European to visit Babungo—reported that it was the prettiest part of the Grasslands. According to certain art critics, the aesthetics of the art of Cameroon is for Africa what German Expressionism was for Europe. The plastic arts, the expression of a society in a given context, try to represent and immortalize what people see, know, think, imagine and believe. The art objects and all material culture are genuine evidence of the values, religion, world view and civilization of those who created them. We can understand why the promotion, protection and valorization of the artistic and cultural heritage are major concerns of various countries in the world, including Cameroon. Knowledge of the arts of this country with their different approaches and in all their variety is also important and necessary insofar as art objects are cultural evidence, sources of both inspiration for artists and cultural transmission. Aesthetics and modern art in the West have been transformed and positively enriched by contacts with other artistic traditions, in particular African and Cameroonian.[1]

Just like Babungo, Cameroon is known for the remarkable wealth of its artistic heritage, including authentic masterpieces of African art. But many of the objects dispersed in the territory of the country, owned by groups that only display them on exceptional occasions, are often kept precariously through lack of appropriate assistance. The places where they are kept do not always offer guarantees in terms of security and conservation. Now, the artistic and cultural heritage represents an essential element of identity for several countries in the world. Its protection and valorization are therefore a moral obligation and a political responsibility. Unfortunately, there are insufficient works of synthesis, monographs or surveys, so that complete and accurate information on the artistic and cultural heritage of Cameroon is lacking. Besides, the paucity of documentation on local cultural and artistic assets impedes important cultural actions in Cameroon, such as school and arts faculty courses; various projects by the Ministries of Culture and Tourism; publishing; the promotion and protection of Cameroon architecture and art; and the art market. All these reasons and the problems mentioned above argue for the renewed launch of field and documentary research with the publication of results, the creation of museums and the implementation of multiple valorization projects concerning the heritage of this country.

Thus, the achievement of the project entitled 'Formation, protection of the artistic and cultural heritage and development in Cameroon', organized by the Centro Orientamento Educativo (COE)[2] and sup-

Costume of the *felingwi* dance (*mba kang vessi*), detail (cat. 27)

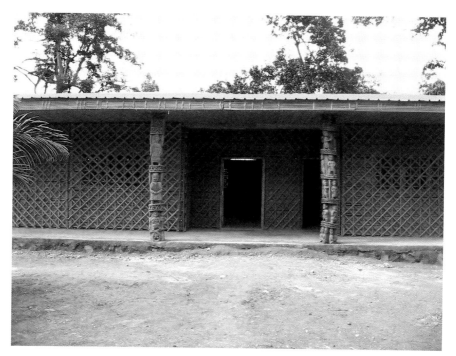

fig. 1. An external view of the Babungo Museum

ported by the Institut de Formation Artistique (IFA)[3] of Mbalmayo, is of great interest. The project was conceived and coordinated by the architect Bianca Triaca. The present writer was the scientific responsible for the training of the museum curators, the fieldwork and the publication of the results. In addition to COE, the other organisations promoting the project are: CEI (Conferenza Episcopale Italiana); MAE (Italian Ministero degli Affari Esteri); the community of each "chefferie" or kingdom (where the museum was created), represented by its king.

The objectives (now reached) were:
– to project and enhance the value of the cultural and artistic heritage where in "lives" through the creation of four museums (with the publication of catalogues four the collections) in for different places from one initial area, the Cameroon Grassland which is the western part of the country where the artistic heritage is the richest and where the danger of disappearance and loss of artistic objects is the greatest;

– to train young people (4 in each place) in museum management and in the protection and conservation of cultural objects;
– to encourage the dynamics of cultural and economic development in the circles concerned by the project and more generally in the country;
– to open new possibilities for employment and work for the young people of Cameroon

Four kingdoms or chieftaincies/chiefdoms (Bandjoun, Mankon, Babungo, Baham) were chose from 200 others after their awareness-raising according to the following criteria: the presence of a significant artistic heritage; the willingness of the traditional authorities to allow the study and cultural and social enjoyment of the objects of their community's heritage; the extent of the place's wishes to have a modern museum in parallel with the commitment of putting at the disposal of the project a suitable building. The museographic project was assigned to the architect Antonio Piva, a lecturer in architecture and design at

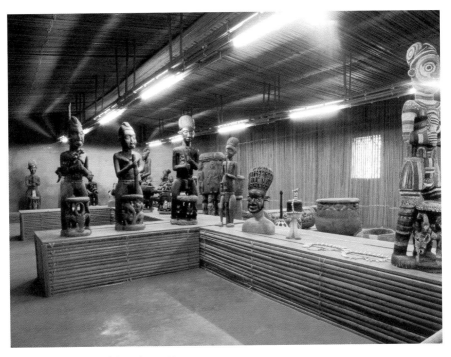

fig. 2. An internal view of the Babungo Museum

the Faculty of Architecture / Politecnico of Milano, an expert of UNESCO and well known for having designed important museums in Europe and in Latin America.

As the result of an examination, 20 young people were selected. The fact that the majority had at least the diploma of the second year at university enabled raising the level of the training. The activities of the training of the future museum curators included two phases: a theoretical one (first year) at the Institut de Formation Artistique de Mbalmayo) and a practical one in the field (second year), concerned with the inventorying and documentation of the collections, catalogues and the establishment of the museum.

The opening of the museums of Babungo, Mankon, Bandjoun and Baham, collecting essential and well-documented pieces in each locality and the catalogues published for this purpose, represent one of the elements of concrete solutions to the different problems mentioned above (figs 1, 2).

This work presents a range of significant objects of the rich cultural and artistic heritage of Babungo, in the past the most important iron-working centre in Cameroon. It is an invitation to visit the kingdom of Babungo and its artistic and cultural wealth, without forgetting its places of memory. In addition to the works, illustrated with photographs, it provides primary sources of information, inspiration and knowledge of this outstanding Cameroonian heritage. It has the merit of making an original contribution to the reconstruction of the artistic and cultural heritage of Cameroon and the Grasslands through this study of their cultural and artistic assets.

Babungo (20,000 to 30,000 inhabitants) is one of the few hundred small kingdoms or *chefferies* that have been gradually formed in the Grasslands over at least six centuries. Situated in the Ngo-Ketunjia division, it stretches across the high plain of Ndop, dominated by peaks reaching an altitude of three thousand metres. The emergence and evolu-

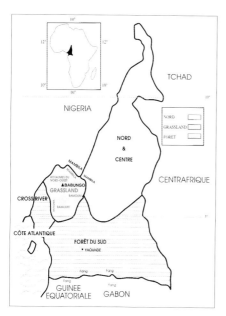

map 1. Babungo in Cameroon and in Africa/the major artistic regions of Cameroon (see Notué Jean-Paul and Triaca Bianca, *The Treasure of of the Mankon Kingdom; Cultural Objects of the Royal Palace*, Les Cahiers de L'IFA, Mbalmayo et Milan, COE/IFA, 2000, p. 24)

map 2: Babungo in the region of Bamenda / The road infrastructures in the Grassland (see Perrois Louis and Notué Jean-Paul, *Rois et sculpteurs de l'Ouest-Cameroun. La panthère et la mygale*, Paris, Karthala, Paris and ORSTOM, Paris, 1997, p.129)

tion of the kingdom are shown by recorded historical events, archaeological information and, above all, oral tradition. According to the generally accepted version (see the essay by Emmanuel Nchio Minke), a group of migrants, the Vengo (literally 'of the same family'), originally from 'Ndobo' or the 'Tikar' land, settled in the plain of Ndop to found the kingdom of Bavengo, Bamungu or Babungo before the fourteenth century, forming alliances with the pre-established populations, including blacksmiths who had mastered remarkable technologies for iron-making dating back more than twenty centuries. Twenty-five kings have ascended to the throne of Babungo since Saingi I, the first sovereign up to the present reigning fon (chief, king), Ndofoa Zofua III (Zofoa III). The history of the kingdom since its origins until the end of the nineteenth century was marked by the frequent displacements of the royal residence, the expansion of the territory and increase in population, wars against neighbouring kingdoms or invaders, the dawn of the royal civilization and the development of a remarkable court art under the impetus of powerful kings, some of whom were sculptors (for instance, Nyichikau, Nyifuan and Saingi II). Various accounts, including the reports left by the first European visitors from 1889 onwards, testify to the stunning setting in which people lived in Babungo in the nineteenth century and lay emphasis on the splendour of royal art, the quality of the metallurgy and their artistic creations.

In Babungo, the social, political and religious life is nourished by representations of various kinds, including those linked to royalty and the customary societies necessary for the exercise of power, so that certain objects are mediators of the power of the fon and the notables. The division into a hierarchy of titles and the structure divided into quarters, customary societies and lineages act as a framework for social and political organization. Masks, statues, costumes, adornments, musi-

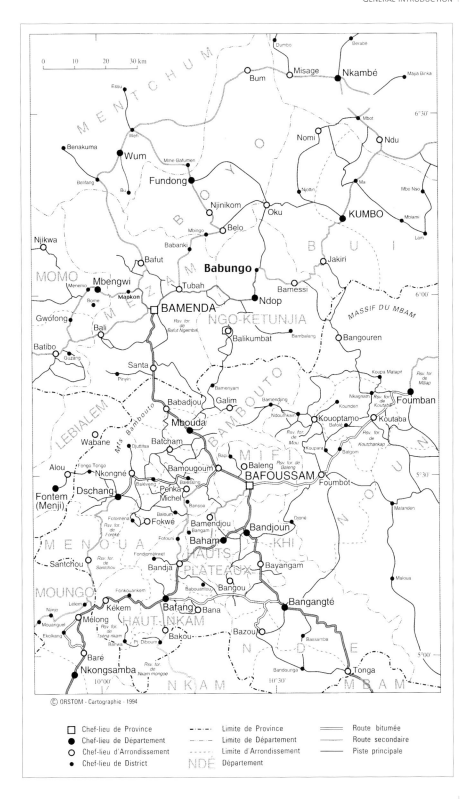

cal instruments and constructions—in a word, various elements of material culture— are used as symbols indicating the social rank of each individual, legitimizing the power and authority of the king, the notables, the customary societies and the different social categories.

The sources of the study are essentially the computerized records of the inventory of the Babungo Museum. Almost all the objects described here, which form part of the museum's permanent displays, had a function in the kingdom. In view of the living character of the institution, certain pieces are allowed to leave the museum from time to time to be used in ritual ceremonies.

This book comprises a series of six essays followed by the catalogue of the cultural objects. The essay by Emmanuel Nchio Minkee deals with the origin of the kingdom and the royal dynasty, providing general information on the socio-political structures, the traditional religion and iron working. However, there is still some uncertainty regarding the genesis of Babungo and the royal dynasty, the order of succession to the throne, the length of the reigns, the exact number of kings and numerous political and cultural details. Oral traditions, as they have been collected, are often too stereotyped to be able to reflect real events: above all, they seem to express the contractual relationship between the fon and the notables. We can understand why the emergence and evolution of Babungo are explained in the essay—and quite rightly so—by history, legend and myths. The present writer makes a study of the history, the conditions of artistic creation (materials, techniques and sculptor kings) and the forms, functions and meanings of the cultural objects of the palace of Babungo. Protus Bofua and Julius Ndifor deal with the artists (mainly sculptors) and blacksmiths from information collected in the field. Lawrence Mbowoh offers a more detailed approach to the traditional religion of the

kingdom, while Cyvil Nangwa analyses in depth its social and political life and organization.

It should be noted that, throughout the Grasslands, art is closely linked with the setting, knowledge of which is necessary to understand artistic creation and to be aware of everything that may have contributed to the birth of such forms. Moreover, it has been shown that the context plays a decisive role in the conception of works of art and the ways they may be interpreted. Thus, it is also essential to analyse the elements of the context associated with these forms. The catalogue presents a sample of eighty objects from the permanent collection,[4] such as thrones, seats, sculpted beds, architectural elements, statues, masks, objects of prestige, insignia of power, pottery and accessories from traditional events and worship. The art objects of Babungo certainly express all the aspects of social life and the artistic heritage includes works belonging to different collections spread across the kingdom, although close to three-quarters of the important pieces were kept in the royal residence. Throughout history, the objects and noble materials were strictly controlled by the king, while it was the royal workshops that produced the finest pieces. Moreover, the art of Babungo is doubly royal: on the one hand, it is made to reinforce the prestige of the fon, royalty and the kingdom; on the other, it is royal like everything that is made or emerges from the very strength of the fon, even by delegation, and this is particularly so for the major works. The objects in the catalogue are grouped together in eight themes organized in relation to museological, aesthetic, artistic, historic and sociological considerations, seen in relation to the local situation.

The work as a whole underlines the importance of the notions of 'iron working', 'context', 'sculptor king', 'forms' and 'plastic quality' as well as those of 'royal treasure', 'techniques' and 'memory'. Everything belongs

to the very old cultural and technological tradition of the Grasslands, which has remained alive and dynamic, evolving in the course of time. Indeed, since the fourteenth century, the civilization of the hunter kings (at the same time smiths and sculptors in certain places such as Babungo) and founders of the Grasslands kingdoms has only been the extension of the cultural tradition of the proto-Bantu, dating back a few millennia. The traditional production of iron has been dated to before the Christian era and was continuous up to the twentieth century in the Ndop region around Babungo. It is in this area that one of the most important traditional iron industries known to date in the whole of the African continent existed. In the Grasslands the reigning dynasties of certain kingdoms and *chefferies*—such as Babungo, Kom and Lebang (Bangwa)—included sovereigns who were talented sculptors. The works made by the sculptor kings of Babungo occupy most of the catalogue, but even when the monarchs did not sculpt themselves, they sometimes claimed the paternity of the works of power, as any creation in Babungo could only come from the fon in person. This art of Babungo is conceptual, symbolic, expressionist and decorative: the sculptor kings used methods of expression from total simplification to the most faithful realism. They used a plastic language that was carefully codified in a multitude of typical motifs, allowing them to express ideas, religious subjects, mythical scenes and historical tales. Such a language at the level of principles, its conception, its technique and its application extends beyond the scope of Babungo, to embrace the whole of the vast region of the Grasslands, with nuances in space and in time. Beyond the beauty of the forms, we find, in the majority of these plastic productions, all the essential concerns of humanity: the fascination and fear of death, the need for power, the aspiration for happiness and love, and the struggle for survival.

Despite Western influences and the introduction of Christianity to Babungo in the early twentieth century, the art of this area still remains attached to its ancestral traditions although it is confronted with modernity. Certain forms are still alive and have been adapted to the reality of modern life, whilst others have disappeared (or are disappearing). The implementation of the project has allowed objects of value—as well as information obtained thanks to systematic field studies and bibliographical research—to be preserved in the museum, thus providing tourists, artists, researchers, students and connoisseurs of African art and culture with sources of information and inspiration regarding the cultural heritage of Cameroon.

Notes

[1] For example, the German sculptors and painters of the avant-garde—in particular, the Expressionists—including Karl Schmidt–Rottluff, Emil Nolde and Ernst Ludwig Kirchner highly appreciated the art of the Grasslands and its influence clearly appears in some of their works.
[2] Created in 1959 with its head office in Barzio, COE is an Italian NGO recognized as competent for cooperation with developing countries by decrees of the Italian Foreign Ministry (1978 and 1988). This organization received authorization for legal existence in Cameroon as a foreign association by a ministerial decree of January 1995 and in 1999 signed a cooperation agreement with the government of the Republic of Cameroon (source: *Rapport d'activités 2000–2001*, COE, Mbalmayo).
[3] The IFA is not only a place for training, but also a centre for research, promotion and conservation of the artistic heritage and for the stimulation of creativity.
[4] As space in the museum is limited, only eighty objects selected from a few thousand have been put on display to the public until the building is extended. More than a thousand pieces are in the museum storerooms.

Books and documents quoted: see the bibliography of Jean-Paul Notué's essay 'History, Forms, Functions and Meanings of the Cultural and Artistic Objects of the Royal Palace of Babungo'.

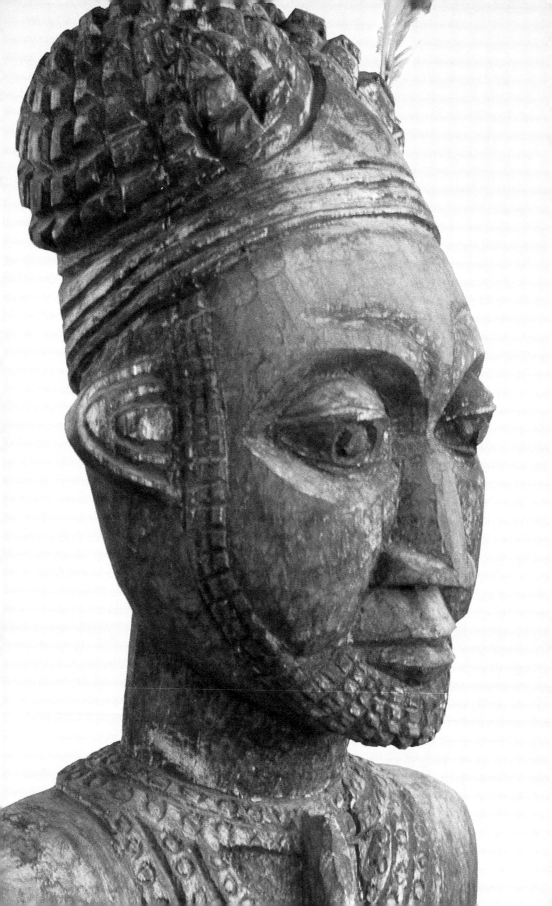

Babungo in History and Legend: the Historical, Social and Cultural Framework of the Kingdom

Emmanuel Nchio Minkee

The origin of the kingdom of Babungo

Babungo is one of the kingdoms (or *chefferies*, depending on the author) called *tikar* of the North-Western Province of Cameroon. It is situated on the Bamenda Ring Road, about ten kilometres from Bamunka, on the high plain of Ndop, which is fertile and rich in water, intensely cultivated and surrounded by a ring of hills covered with meadows, making it ideal grazing land.

The original name of its people was Vengo, which means 'of the same family'. They were called *Bavengo* (*ba*: people; *vengo*: of the same family). The Germans transformed this name into Babungo. The story of the origin of the *chefferies* of the Grasslands is generally based on oral traditions and has different versions that are often uncertain and even contradictory, involving history, legend and myth. According to one of these traditions, it was because of wars that the Babungo left their home territory—Ndobo in the Tikar country in the Mbam valley—to settle in the present location. The group of emigrants included Tifuan, considered to be the chief, Nswi, Teh Ndiwah, Songho and a mother, Mange, with her children Fuanje, Bah, Saingi and Nfanyi. Their names have been remembered and they are still used today in the hierarchic organization of the authorities in the kingdom.

In a first stage of their migration, the Vengo occupied a calm and shady region called Forghai, downstream from a waterfall where Ngesekwa, a peace-loving god lived. After some time had passed they decided to migrate from Forghai. The god gave them a black sheep as a guide and instructed the Vengo to halt where the sheep topped to rest and, where the animal died, they were to bury it and settle there. The group set off on the day of the week called *mbaa*, guided by the sheep. They were some way from Forghai, on a plain, when the eldest of the group, Fuanje—who was tired and unable to continue the journey—decided to settle there and called this place Mbenje. In order not to leave the elderly man without shelter, the rest of the group stopped and built him a house. The Vengo then realized that they had forgotten to bring fire with them and they sent Songho to the god of Forghai to ask him for it. Ngesekwa gave Songho fire and told him that they had also forgotten to take with them the bag containing the *muunkwan* (a thick rope on which the skulls of humans and certain animals, such as the chimpanzee or lion, were hung), still the most powerful protection for the kingdom. Songho accepted this as well and brought it back with the fire. Since then, his name has been the title of the notable who keeps the bag containing the *muunkwan* in his home. This bag is brought out only on the death of a prince, a princess and members of the *muunkwan* secret society, to which it belongs. Songho, the fon or any other member of the *muunkwan* society, cannot touch this object until he has fathered a son and a daughter.

Fuanje, Mange's eldest son, thus stayed in Mbenje. Today, the title of *fuanje* denotes the head of the counsel of seven, the executive body of the government of the kingdom. Fuanje is also the spokesman of the *ngumba*, the most powerful customary society in Babungo.

Commemorative statue of King Seevezui, detail (cat. 10)

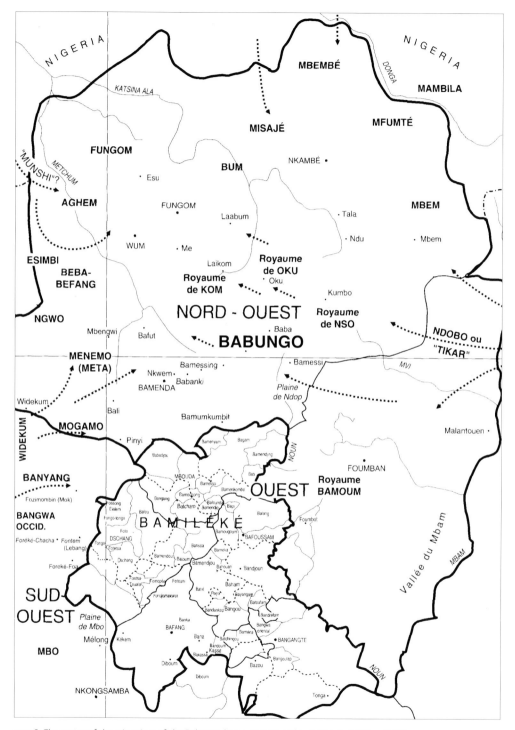

map 3. The routes of the migrations of the Babungo (see L. Perrois and J.-P. Notué, 1993, p. 215)

fig. 3. Ngineh, the first palace of the babungo people

The group then continued its journey, still guided by the sheep. They arrived at a place called Ngineh where the tired sheep rested. There, on the day called *mbaa*, the animal died and, two days later, it was buried. This was the day of the week called *nkunse*, which became the traditional day of rest and is still respected today by the Babungo people. As the god of Forghai had ordered them, the Vengo settled in Ngineh, where the sheep had been buried, and built their first palace, the Ntoh-Ngineh. The sheep that the god had given them and that had led them to the place of their settlement was venerated as the guide of the people and the 'first chief' of the Vengo.

Tifuan was then considered their king; he was his mother's only child. Mange's children thought that there were more of them and they could not accept that an only child could be their fon. They went to Tifuan to send him away from home telling him that he had been called by Bah, the eldest of the brothers who had got as far as Ntoh-Ngineh. When Tifuan left, they sent one of their brothers to his home to get the leopard skin—the symbol of the fon's power—that was on his bed, only to find it had been stolen and replaced by a goatskin. Realizing what had happened in his absence, Tifuan ran to the children of Mange, where he saw Saingi sitting on the leopard skin surrounded by his brothers who were venerating him as the chief. After these events, Tifuan decided to leave this place and Saingi became the first fon of the people who had migrated from Ndobo to Ntoh-Ngineh passing through Forghai. Tifuan was called *chinje*, which means dreamer, by Mange's sons, because he continued to think of himself as the chief although he had been deposed. The title of *tifuan* is used today for the doyen of the most important customary society in Babungo, the *ngumba*.

After the *Vengo* had finally settled, Bah decided to separate from the group and establish himself elsewhere. He built his house and, as he was the eldest of Mange's children

who had got that far, he brought his now eld-
erly mother to be with him. Songho, Nswi
and Teh Ndiwah stayed with the fon, becom-
ing his retainers. Today, the title of *bah*
denotes the first assistant of the fon, *fuanje*
indicates the assistant of the *bah*, whilst
songho and *nswi* are the titles of two neigh-
bourhood chiefs. When all the members of
the group were established, they decided to
devote themselves to hunting and farming.
On their first hunting expedition, they went
east of the present site, far into the forest,
and discovered houses next to a river, where
a chief called Nchiafe lived with his two wives
and four children, a boy and three girls.
Nchiafe had called his neighbourhood
Chikaw, which means 'to live in love', and
Dong the river, where a god lived. The Vengo
stated who they were; Nchiafe was very kind
and gave them a warm welcome. They asked
him for one of his daughters as a bride for
their fon. Nchiafe accepted and gave them
his daughter, whom they took to the palace
of Ngineh. Her name was Magho and she
became the first wife of Fon Saingi.

Some time after, the members of group
went out hunting again, this time to the west
of the kingdom. After having travelled for quite
some time, they discovered an original inhab-
itant of the place whose name was Biniteh: he
had a wife and two children, a son and a daugh-
ter. The first time they saw Biniteh, he was
bathing in the river, sitting where there were
some flat rocks, so they nicknamed him Fuan-
Kangoh, chief of the flat rocks. After he had
washed, Biniteh asked if they would go with
him to where he lived. They accepted and they
explained who they were and where they came
from. When Nswi saw Biniteh's daughter, he
asked for her hand in marriage. Biniteh
accepted and so Nswi married his daughter.
During another hunting expedition, they met
Biwojia, who had a wife and a daughter; Songho
married the girl. Thus the bonds between the
natives and the new group became stronger and
stronger and the population grew rapidly.

The Dynasty of the Fon of Babungo

According to tradition, the first fon, Saingi
I, is believed to have reigned for about 115
years and his successor Sake I, for ninety
years. The introduction of iron working to
Babungo is attributed to the latter. At this
time, the Vengo made their clothes from tree
bark and animal hides.

Voekoefuan is then believed to have
ascended to the throne, reigning, according
to tradition, for sixty years. On his death, the
new fon, Fuanforyung, is thought to have
stayed in power for forty-five years. The fol-
lowing fon was Seevesui; legend attributes a
reign of 105 years to him. He transferred the
royal residence of Ntoh-Ngineh to a new site
called Ntoh-Yindoh where another palace was
built. He was succeeded by Lafuan I: under
his reign, which is believed to have lasted
eighty years, the Bamunka emigrated from
the Bamoum area to settle in a part of the
Babungo territory. In the same period, from
the Bamoum land where they lived, the Kom
people left for Babessi, stopping in Babungo
for some time before reaching their present
location.

Nchiafuan, the successor of Lafuan, is
said have been fon for about ninety years.
Under his reign, the *ngumba*, the most impor-
tant secret society of Babunga, was estab-
lished. There was a small lake in the area of
the Ntoh-Yindoh palace, where the retainers
and the wives of the fon would go to get
water. According to legend, one day, whilst
they were on their way there, they heard gen-
tle music coming from the lake and when
they got to its shore, to their great surprise,
they saw a duck dancing on the water. As
soon as they returned to the palace, they told
the fon what they had seen and heard.
Nchiafuan, in order to get an idea of exactly
what was happening, went to the lake shore,
where he also saw the duck dancing and
heard the music. He sent someone to fetch
his harp (*ndoente*), on which he repeated the
melody. One of the daughters of the fon, who

fig. 4. Ntoh Yindoh, the second palace of the babungo people

was dancing as she listened to the music her father was playing, died immediately. The chief's retainers, who were doing the same thing, did not die. From that moment the *ngumba* secret society was established and the music of the lake became that of the *ngumba*. It was taboo for the wives, daughters and sons of the fon to listen and to dance to it. The mystery and the magic of *ngumba* and all its secrets were to be kept by the chief and his closest servant.

After the death of Nchiafuan, he was succeeded by Zofoa I: he encouraged iron working and legend has it that he reigned for 102 years. After him, Fon Nyichikau, known as a practitioner of traditional medicine and sculptor, is said to have reigned for sixty years. One day he was hunting in the Chikaw neighbourhood, when he decided to rest under a large tree: on returning to the palace, he told his retainers that when he died he was to be buried under that tree. His wishes were not respected, however, and he was buried else-

where. A boa constrictor then came out of his tomb, went to the place the king had chosen for his burial ground and, when it arrived under the tree, disappeared into the ground. From that moment onwards, the spot was considered sacred and the tree of Chikaw became a warning to respect the wishes of the fon.

Nyichikau's son, Lafuan II, apparently reigned for a brief period of only five years. After his death, Ndofuan I is believed to have stayed on the throne for fifty years, while his successor, Kweh-Njoh, a great hunter, is reputed to have governed for a hundred years. The next fon, Yaveswah, known as a *bon viveur*, is alleged to have reigned for seventy-five years and, after him, Feetilui is said to have been on the throne for ninety years. He was followed by Nguifuan who ruled for seven years and Lavensui for thirty years. The latter was known as a very evil chief, whose body was covered in wounds; each time his servants washed him, he forced them to drink the bathwater. Abandoned by all, he

25

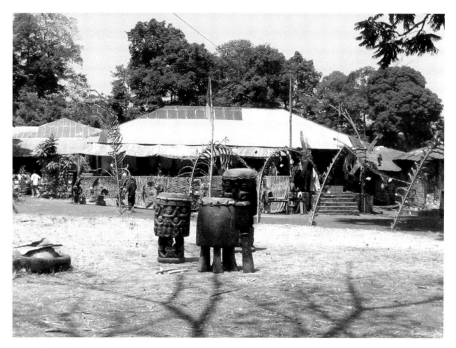

fig. 5. The present babungo royal palace in occasion of the annual celebrations, 2003

fig. 6. King Saingi II; fig. 7. King Sake II; fig. 8. King Zofoa II, fig. 9. King Ndofua Zofoa III

died in solitude. Again according to legend, he was followed by: Lofuan I, who reigned for sixty-five years; Fuan Forting, who drowned in the river, was on the throne for eleven years; Lofuan II, who was sovereign for eighty-five years; and Nkafuan, who held power for sixty years. The last-mentioned fon tried unsuccessfully to transfer the Ntoh-Yindo palace to the Ibia neighbourhood, the present-day site. This enterprise was successful for his successor, Fon Nyifuan. The reasons for the move were linked with the wars between Balikumbat and Babungo, on the one hand, and between Kom and Babungo on the other.

After he had settled on the present site, Nyifuan decided to build another palace in Shaale, where he housed his mother, Nah Wendimuwa. But the inhabitants of Balikumbat arrived there and carried off the fon and his mother as prisoners to their village. The queen mother died on the way and

her body was abandoned in the bush, while Nyifuan was imprisoned for three months. Legend has it that a magic dog, sent by the Babungo, arrived on the spot whilst the guards were asleep and took him home. The Babungo people celebrated his return and he is believed to have reigned for eighty years.

After him, Saingi II became fon. He rebuilt the palace and established good relations with the neighbouring villages. The kingdom of Kom was an exception: on several occasions they attacked the Babungo and each time the assailants were driven back. Saingi II reigned until 1927. His successor was Sake II, who introduced the crops of coffee and mangoes into Babungo territory; he governed for twenty-eight years. He was succeeded by Zofoa II, who reigned for forty-four years until 25 April 1999. He was very well known as a sculptor and he rebuilt the palace. His son, Ndofoa Zofua III, is the current fon of Babungo.

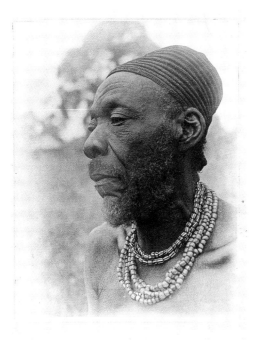

Häuptling von Babungo.

6

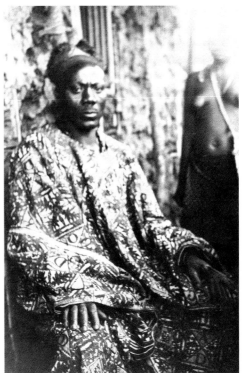

7

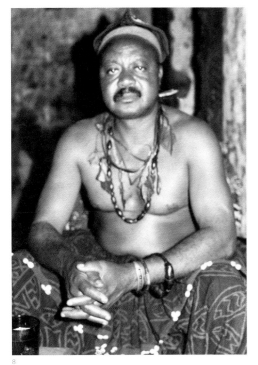

8

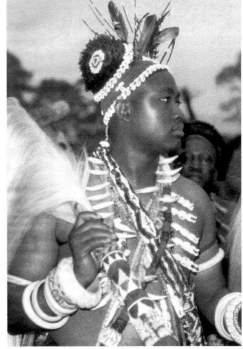

9

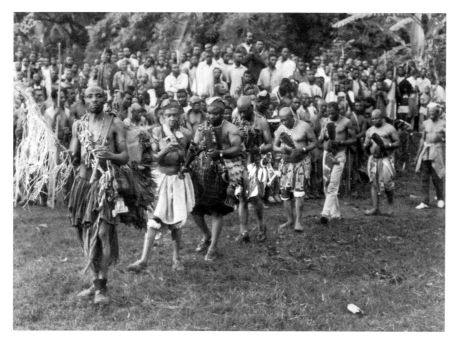

fig. 10. The *tifuan* society, *guu* in action

*Some Aspects of the Traditional Social
and Political Structure of Babungo*

The political and social system of the
Babungo is based on a patrilineal organiza-
tion and on the division of the territory into
quarters. The kingdom of Babungo is divided
into quarters, some of which are further
divided into two or more sub-quarters.
Amongst the oldest quarters, such as
Mbuakang or Mbenjeng, there are some that
are mainly formed of a single lineage, whilst
the population in other quarters is made up
of members of different lineages. The most
densely populated quarters have more than
about eighty compounds, whilst others have
thirty or less. Each compound is represented
by a head, called *tiifu*, who exercises his
authority over his brothers and children, in
other words, his lineage.

Above the compound head, the major-
ity of the administrative questions are
referred to the chief of the quarter (*tii ntih*),
who is assisted by advisors (*vetii ngii njong*).

The *tii ntih* has the right and responsibility
to attribute land and solve problems con-
cerning this aspect of social life. The *tii ntih*
chooses his successor during his lifetime, but
he only reveals the name to the doyen of the
ngumba regulatory society, the *tifuan*. The lat-
ter makes the name public only after the
funeral of the quarter head. The successor
is then installed by the highest-ranking
members of the *ngumba*, the most important
political institution in Babungo.

The quarter heads chosen by the fon
form the council of five, the governing body
of the *ngumba*, which assists the fon in gov-
erning the kingdom. The council of five has
the legislative power in the kingdom. Other
tii ntih make up the council of seven, which
represents the executive body of the king-
dom's government.

The third group of the members of the
ngumba is the *veshih*, which is made up of
retainers selected by the fon. They all hold
meetings with the king in the large *ngumba*

house. Each member has his own seat linked to his rank. The fon occupies the first seat, followed by the *bah* and the rest of the members. Today the high-level ranks are also spoken for by members of the modern elite, who have often left the *chefferie* and live in the city, or by the large plantation owners, or even by businessmen who have accumulated a great deal of money and who can thus buy important titles in the kingdom.

The *ngumba* is the strongest political institution in Babungo. It represents the executive power of the traditional government, which limits the power of the fon. The elder members of the *ngumba* also have an important role in the burial of the fon and in the enthronement of his successor. Thus the Babungo say that the *ngumba* is a kingmaker, and that it is the father of kings.

Other customary societies with an important role in Babungo include:
the *samba*, organized at the level of the quarter, helps the *tii ntih* to regulate the life of the community;
the *shav*, the members of which comprise the fon's wives and daughters;
the *nintai*, which includes the fon's male children, represents the king at the front during war and closes the funerals of the royal family;
the *fembwei*, which is made up of all the women in the kingdom ;
the mfwei, which deals with the blessing of the population.
[For more details, see the essay by Cyvil Nangwa]

General Information on the Religion
At the centre of the traditional religion (see the essay by Lawrence Mbowoh), there is *Moh-Mbi* or *Nwi*, the supreme being, the creator of the world. Other divinities are the intermediaries between the supreme God and men; they live in the natural environment at the foot of a tree or in a waterfall, a river or a stone. People worship them with sacrifices

fig. 11. The *bah,* the king's first assistant

at their dwelling places. Each chief of a compound, quarter or village also has his god who protects the community. The first and most important of the gods is Ngesekwa, the god of Forghai, the waterfall where the migrants from Tikar country stopped. The god of Mbelung also lives in a waterfall; people pray to him to give strength to the new chief. At the beginning of the seasons, the Babungo pray to the god of Lai, who lives in a lake, to bless the village. The Boe Waterfall, Lake Dong and the small Fechah River are also home to gods.

For the Babungo, death is not considered as the end of everything, but rather a new and very important dimension of life. They believe that the deceased have gone to another world to which they have been summoned by the superior being. When a person dies, the appropriate funeral rites are performed, symbolizing the ideas and customs of the people. The body is washed with water contained in a calabash which is then broken; the eldest of the family puts camwood powder over the deceased's body; adults who have not had children are buried with a pebble in their hands. The fon and the notables are buried in a house (*ifung*) inside their compound; they are laid in the ground in a sitting position, holding their goblet or pipe. The others are buried besides their dwelling. Although half the population of Babungo follow the native religion, those who have embraced imported religions still adhere to their ancestral beliefs.

The Traditional Technology of Iron Working in Babungo

In the last two centuries Babungo was one of the most important centres for the production of iron in North-Western Cameroon thanks to the iron ore of this region, which was mined to extract the mineral. More than ten metres tall, the piles of slag, abandoned after the extraction of iron, bear witness to this activity, which was practised until resources were exhausted in 1920. In the next thirty years, the smiths extracted the iron that remained from the slag; then the mineral was imported from Europe, which became the source of supply of this raw material from 1950.

Traditionally iron working and the production of coal (although in limited quantities) were the specialities of Babungo. The blacksmiths' quarter is called Finkwi: the largest of the quarters, it has kept many traditional homes made from raffia with thatched roofs. Today there are about fifty-eight compounds in Finkwi with a forge. Each smith is specialized in the production of an object: knives, machetes, daggers, arrowheads, hoes, ceremonial staffs and ritual musical instruments such as gongs. A team of craftsmen is made up of an elderly master smith, chief of the compound, and a certain number of his adult sons. Helpers work the bellows and women bring food to the forge during the very intense working day. The members of the lineage of a smith who do not work with him often send their children to help him.

The smiths are said to guard their ancient customs more jealously than the other inhabitants. Their social position in Babungo is very important. According to oral tradition, they were the first inhabitants of the region: the first two smiths are believed to have fallen from the heavens to the earth, one carrying a sledgehammer in his hands and the other a pair of bellows. They are considered to be a group apart with a social position that is distinct from all the other inhabitants of Babungo. Although they are regarded with great reverence and respect, at times they are even ignored. They are frequently considered to be different from the population of farmers. However, everybody needs them: farmers, hunters and warriors depend on the tools that only blacksmiths can produce.

In the Babungo language, there are two words to refer to the smith: *wuu-ndaa*, which

means someone who has the gift of iron working; *iyeh*, which means the man whose symbol is a man with a sledgehammer of supernatural origin. *Iyeh* is also the name of a group of nine smiths who ritually represent all the others. It is thus the title of all the smiths, who cannot have any other title in the government of the kingdom. The special status of the smiths exempts them from having to go to the inner parts of the palace and prevents them from being involved in the politics of Babungo.

Dynastic List

In order to give, where possible, a chronological context to the cultural objects of the palace of Babungo, it may be useful to reconstruct the dynasty of the Fon of Babungo according to, firstly, oral tradition and then history: it seems to go back very far in time.

1. Saingi I
2. Sake I
3. Voekoefuan
4. Fuanforyung
5. Seevesui
6. Lafuan I
7. Nchiafuan
8. Zofoa I
9. Nyichikau
10. Lafuan II
11. Ndofuan I
12. Kweh-Njoh
13. Yaveswah
14. Feetilui
15. Nguifuan
16. Lavensui
17. Lofuan I
18. Fuan Forting
19. Lofuan II
20. Nkafuan
21. Nyifuan
22. Saingi II (on the throne in 1889, when Dr Zintgraff arrived)
23. Sake II (enthroned in 1927)
24. Zofoa II (enthroned in 1955)
25. Ndofoa Zofua III (enthroned in 1999)

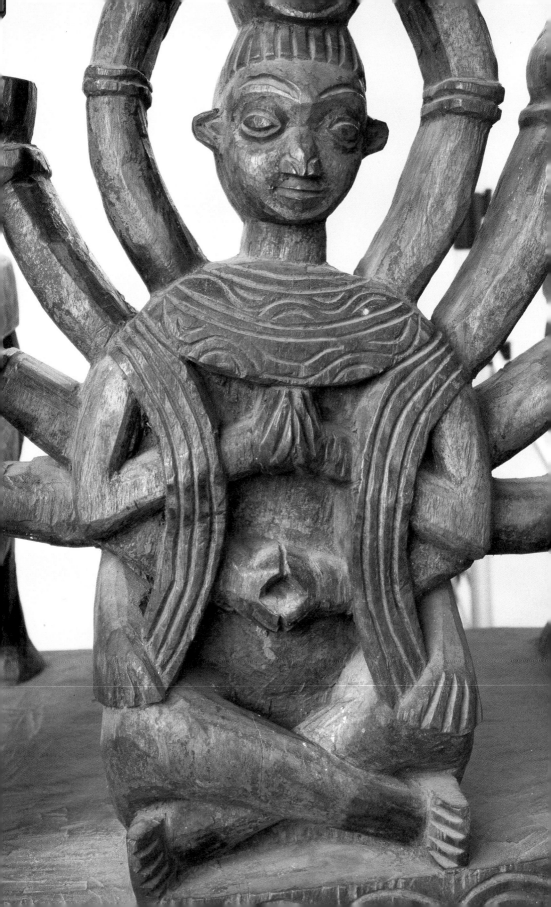

History, Forms, Functions and Meanings of the Cultural and Artistic Objects of the Royal Palace of Babungo

Jean-Paul Notué

Introduction

In 1889, Saingi II, the twenty-second king of Babungo, received the German explorer Dr Eugen Zintgraff at his court with great pomp and ceremony. Deeply impressed by the sovereign, his kingdom and his wealth, the German, in his accounts, underlined the prosperity and the quality of the iron working of Babungo, the cleanliness and beauty of the royal capital, the splendour of the local architecture and the opulence of the monarch who gave hospitality and food to the sixty members of his retinue without any problems. Amongst the royal gifts Zintgraff received, there was a magnificent locally-made sword which, he thought, recalled the finest arms of ancient Rome in its workmanship.

In the nineteenth century, Babungo (maps 1, 2 and 3), the main centre of traditional iron metallurgy in the region and in Cameroon, had at least sixty furnaces producing a hundred tons of pure iron each year, which was exported to various areas.[1] The Bamoum kingdom, the most powerful and important in the Grasslands at that time, imported eight tons of this production each year. It was with the aim of reducing this dependence that King Njoya unsuccessfully attempted to obtain from Saingi II the secret of the technology of Babungo iron production in exchange for a large reward, according to Anna Rein-Wurhmann, a German schoolteacher who lived with the Bamoum in the early twentieth century.[2]

Comprising a few thousand pieces of a great stylistic variety, the collection of the sculptor kings of Babungo is the most impor-tant royal treasure of the North-Western Grasslands in terms of quantity. Many objects of what is a real museum of traditions are considered to be elements of the Cameroon national heritage, as I was told by the provincial representative for information and culture of the North-West in 1984, when I visited that region. All the art forms (plastic arts, dance, music, rites with a dramatic character, etc.) are intimately linked and well represented in Babungo. But sculpture, particularly using wood, occupies a predominant place here amongst the different plastic arts. In addition, it is very frequently integrated into architecture (for example, door frames and sculpted pillars); this has not always been very frequent in Black Africa. The presence of smiths producing iron, craftsmen capable of making efficient tools, many patrons of the arts and talented artists amongst the sculptor kings, the abundance of high-quality wood and its excellent geographical position at the confluence of centuries-old trade routes all help to explain why the kingdom of Babungo has been—and still is—one of the main centres for traditional arts and crafts in the Grasslands.

In addition, for art to be able to develop and creativity to express itself at its best, there has to be a demand—that is, a clientele—which is often wrongly under-estimated. Thus, the artists of Babungo did not work solely for 'the love of art'. They had to—and today still have to—meet orders and satisfy the demand of a market that is local, regional and even touristic. It is, in particular, the need for exchange and competition that has acted as a stimulus to the artistic genius of Babungo. It

Royal throne (*keneh*), detail (cat. 38)

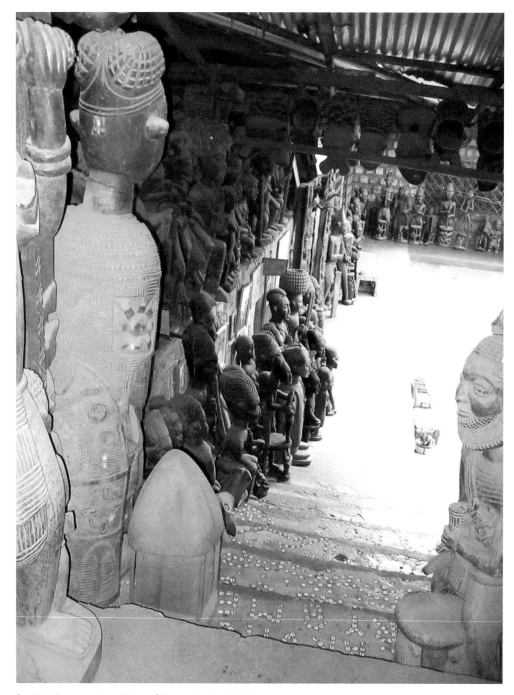

fig. 12. Babungo, an internal view of the royal palace, 2003

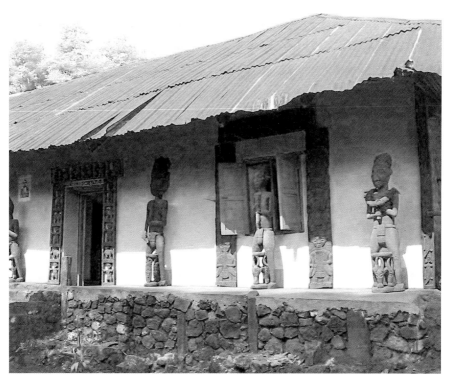

fig. 13. Babungo, a wing of the royal palace, 2003

is thus the demand by local and regional elites that allowed the extraordinary development of the quality and great artistic productivity of Babungo and its neighbours (Kom, Oku, Babanki and Bamessing, in particular). The production, conservation and marketing of the works of art of value were concentrated in the palace royal, the dwelling of the sculptor kings and patrons of the arts. Royal art flourished, with a search for excellence under the impetus of those monarchs, the most important of whom were Nyifuan (nineteenth century), Saingi II (nineteenth and twentieth centuries), Sake II and Zofoa II (twentieth century), supported by skilled artists and assistants. (See essay by Protus Bofua and Julius Ndifor).

When we observe, on the one hand, the diversity of the objects of Babungo (eighty significant pieces are included in the catalogue), the majority of which are conserved and used as sources of history and expression of the authority of kings, notables and customary societies, and on the other hand, the combination of multiple motifs, such as the changing craftsmanship of forms revealing complex aesthetics, symbolism and spirituality, various questions come spontaneously to mind. Who are the sculptor kings and the artists who produced the works that we admire? What is the history of all these objects? What materials and techniques are used and what are their origins? What are the functions of these objects and the meaning of all these representations? How does this art relate to that of the Grasslands and Africa as a whole? How can this production contribute to the rise of contemporary creativity? What is the reason for this religious or superstitious attachment to certain objects, sculpted or otherwise, which at first sight may seem obsolete?

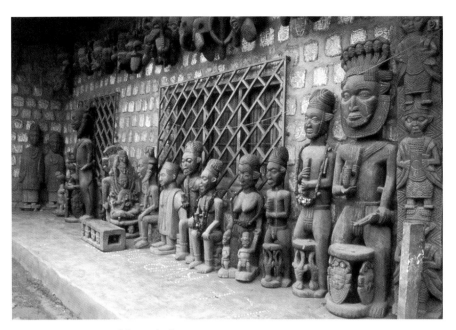

fig. 14. Babungo, a court of the royal palace

Presentation of the Objects of the Royal Treasure (cat. 1–79)[3]

The treasure of the talented sculptor kings of Babungo comprises thousands of pieces (apart from a few hundred strictly commercial pieces, which have been set aside) kept in the museum on one hand (eighty in the permanent displays and almost a thousand in the storerooms)[4] and, on the other hand, in the king's private apartments (including secret rooms and others accessible to the public). While certain objects are only replicas (for example, copies of objects in styles of other African regions or even Asia)—encouraged since the German colonial period by Western travellers and collectors—scores of others are authentic masterpieces of African art. Certain ritual and power objects kept by notables and customary societies in secret houses, sheltered from indiscreet eyes, could not be photographed or selected. Significant examples of the arts and techniques of Babungo appearing in the catalogue

are: creations, often showing great value in their production, of unquestionable authenticity; cultural evidence of great aesthetic, historic and socio-cultural value; concrete evidence of the past and of the present; messages from the men of the past and of today.

Statues (cat. 8–10, 15, 17, 20, 24–26, 29–33, 74, 77, 79)

The statues in the round, about forty of which are included in the catalogue, are generally anthropomorphic, while some are life-size. On the whole, they are realistic, dynamic, vigorous and expressive, and they may be sheathed in beads and cowrie shells. They represent people seated or standing, their legs bent to varying degrees, wearing the adornments and insignia relating to their powers. Their faces and eyes may, for example, express serenity, majesty, vivacity, threats or mystery. The motifs that decorate the surfaces of the works (sometimes polished) are simplified and geometric (cat. 10, 17, 18, 31); they may also be figurative. The sculptures are of extremely varied

as far as their styles, forms and ritual functions in the community are concerned: these may include, for instance, the cult of royal ancestors, divination, healing, justice, the cult of twins, war ceremonies, agricultural and fertility rites. They are not all on display to the public and those that are associated with an occult power are often kept away from indiscreet eyes. We can note that several other figures are not functional or do not have any religious function. The works described in this catalogue comprise:

statues commemorating kings who are seated or standing wearing royal insignia (bonnets, pipes, adornments, cups). (cat. 8, 9, 10, 30, 31, 32, 74);

commemorative statues of queens accompanying the sovereigns (cat. 19, 20, 28, 77, 79);

figures of guardians and retainers—the composition of these works and the morphological features recall the royal statues in the form of thrones of Kom known as *afwa-a- Kom* or 'things from Kom' (cat. 11, 18, 29, 33);

figures of warriors and notables (cat. 17, 24, 25).

The majority of the statues in the catalogue were produced a long time after the reign of the kings and queens represented. In addition, the information on the ages, reigns or producers of some objects must be treated with caution. Several pieces attributed to the sculptor king Nyifuan do not look old. The morphological and stylistic features (emphasis on nails, legs unusually crossed, etc.), the type of shoes and clothes worn, the composition of the works, certain coverings and the varieties of such decorative items as beads and cowrie shells induce us to think that these are mainly examples of perhaps more recent production. It is probable that the majority of the royal statues were made by the sculptor king Zofoa II (or even some by his father, Sake II), in the opinion of Tamara Northern, who made several field studies in Babungo.[5] This author doubts that the present plastic tradition of representation of royal ancestors in the Grasslands is ancient and continuous in Babungo, and it could even have been introduced by King Zofoa II.[6] This is why additional research is necessary for greater enlightenment, all the more so as some relatively recent works have been made to replace older pieces that have disappeared.

Masks (cat. 3, 16, 26, 65–73, 76)
The masks show great diversity, both in morphological terms and as far as their political, social, religious, therapeutic, ritual and judicial functions are concerned. Hundreds of them are to be found in the royal palace of Babungo and in the treasures of the notables and secret societies. The examples reproduced in the catalogue are anthropomorphic, zoomorphic, anthropozoomorphic, and even hybrid. On the whole they are richly decorated and expressionist in style. Some are covered with cowrie shells and multicoloured beads. Each mask belongs here to a specific society that uses it during processions, dances or ceremonies. It has to suggest and prove the presence of the supernatural—and sometimes even entertain. In addition to the wooden head or fabric covering the face, it also includes the costumes and accessories forming part of it. One of the most remarkable symbolic expressions of the art of Babungo, the zoomorphic masks are in order of decreasing frequency: bovids, elephants, birds, monkeys, and more rarely leopards and crocodiles. The anthropomorphic masks can be divided into several sub-groups: facial masks worn against the face (rarer); mask-helmets (very common) without eyeholes; crest-masks showing a human head or ending in a cervical cylinder (less frequent); multiple-sided masks; giant masks of the helmet type.

Furniture (cat. 2, 7, 11, 13, 18, 20, 21, 28, 29, 33–38)
This comprises portable ceremonial stools (sometimes covered with beads and cowrie shells), with a back that can often reach impressive dimensions, beds and tables, all

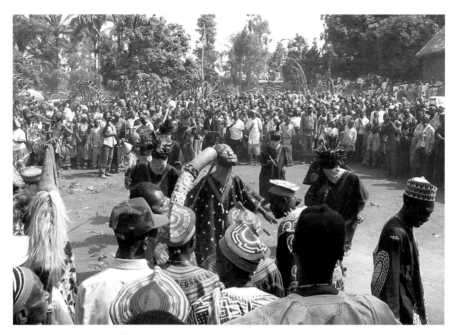

fig. 15. Babungo, annual celebrations, 2003

of which are very well sculpted. The main pieces are decorated with geometrical shapes, animals crafted with harmony and rhythm in a rich and complex composition. The form, size and decoration of the seat depend on the position of the individual or collective owner in the Babungo community. From his accession, the heir (fon or notable) who succeeds his father has a seat made that has a commemorative value after his death. The fon's stools and thrones appear in different royal ceremonies and cults and are amongst the most impressive of the symbols of royalty in Babungo and the whole of the Grasslands. Statue-thrones representing kings, queens and retainers are also of particular importance.

The royal bed often has two vertical sides decorated with geometric motifs, anthropomorphic and zoomorphic figures. According to the fon Ndofoa Zofua III, at the beginning of his reign, each king of Babungo must personally sculpt a bed with a commemorative character. He proudly showed us the bed that he had made and then the beds made by his predecessors: Zofoa II, his father; Sake II, his grandfather; and Saigi II, his great-grandfather. Details on how far back this tradition dates are lacking.

Insignia of power, adornments and costumes (*cat. 4, 12, 14, 15, 26, 75, 78*)
The sculpted staffs are often supports for varied motifs (men, animals, geometric patterns); in addition there are costumes, ceremonial spears, dance whips, panther skins, headdresses, necklaces, bracelets and other adornments are used in the daily and/or cultural life of the court, sometimes as emblems of the authority of the king, notables and secret societies. Certain objects have been meticulously decorated: they generally play important ritual and ceremonial functions in Babungo, apart from some contemporary pieces used simply for prestige.

Musical instruments (cat. 39–47)
In Babungo, different wooden, metal or ivory

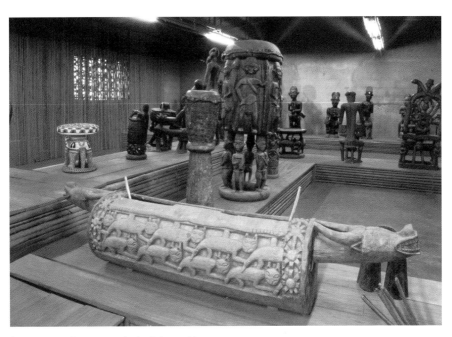

fig. 16. Musical instruments in the Babungo Museum

musical instruments are used in leisure time or in various activities of the social life at court. A good number of them belonging to the fon, while the notables and secret societies have an important role in liturgy, accompanying or providing the rhythms for songs, dances and processions. Some iron instruments are believed to have been used at the time in the foundation of the kingdom. Here, some of the objects (drums, harps, flutes, gongs) with a sacred character have been sanctified by sacrifices and magical practices. In this case, it is forbidden—and even dangerous—to look at them, especially when they emit sounds. For example, the servants and one of the daughters of the seventh king, Nchiafuan, were struck by lightning and died after having danced whilst listening to sacred music played on the royal harp (*ndoente*). The most important of these numerous musical instruments in the social and religious life of Babungo are gongs (single or double), flutes, drums and harps, sometimes richly decorated. These objects,

used as symbolic motifs, decorate works of art (cat. 5, 6, 31, 40). The *kwifo*, consisting of two tall wrought iron gongs, joined by a metal handle, which is often reinforced and embellished with ties, is the most sacred instrument in the Grasslands. It is associated with the *ngumba* or *tifuan*. Each kingdom has a set of between five and seven, in different sizes; the rhythm they emit either announces the group or itself becomes a sort of language. The horns, simple or sculpted in ivory, belong personally to the fon and may only be played when a serious danger threatens Babungo. The smaller and richly decorated ivory horns are used by the heads of the warrior societies. The cylindrical bamboo flute, which can be decorated with beads, is a sacred instrument and can also be played with gongs. The slit or membrane drums are remarkable for their size, which can at times be impressive, and the extraordinary wealth of their decoration with anthropomorphic, zoomorphic and geometrical motifs (cat. 41 and 43).

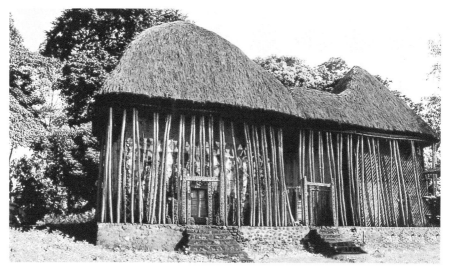

fig. 17. The house of the Bah, the king assistant

Containers (cat. 1, 22, 23, 48–64)

In Babungo, the main materials used to make containers are baked and unbaked clay, wood and other materials of plant origin (such as fibres), metal and ivory, giving artists an ample opportunity to diversify their production. Many of the techniques that prospered in the past, such as pottery, have almost disappeared. There are a great variety of containers (pots, jars, cups, pitchers, bowls, bags, calabashes, pipes, etc.) each used for cooking or other purposes (ritual or ceremonial objects, for example). The receptacles, belonging to the fon and notables, in which products for cults or prestige are kept or prepared, are carefully made and richly decorated with geometric patterns or symbolic figurative motifs that, at times, are exuberant. Pipes and terracotta and wooden receptacles are the most characteristic containers of the royal treasure of Babungo. Horns, pipes, calabashes and bags, functioning as supports for varied motifs (men, animals, geometric patterns)—and sometimes made from valuable materials—are used in the daily and/or cultural life of the court and may serve as emblems of the royal authority and unity of the country.

Architectural elements

The Babungo have ingeniously built many buildings with their shapes varying according to their purpose, the social rank of the individual or collective owner and the nature of the decoration. Indigenous decoration has evolved under Western influence since the mid-twentieth century, when traditional houses gradually gave way to modern houses (sometimes built of concrete) or constructions combining modern and traditional elements. We should remember that sculpture is very closely linked with indigenous architecture—for example, the pillars (or posts) of sculpted wood and worked door frames (or panels) decorating the houses of the fon, the customary societies and dignitaries of the kingdom. Panels and posts are often engraved or sculpted in low relief, high relief or even in the round, sometimes with carving that comprises openwork to a greater or lesser extent. They are used as a support for a variety of motifs, including men, animals and geometric patterns. The principle of the decoration of the post is the same as that of the door frame, but the figures are sometimes more elongated.

Ivory

In Babungo (as throughout the Grasslands) the elephant's tusks were the monopoly of the king and were part of the insignia of his rank. The sovereign would sit on a sculpted throne, his feet resting on one or two tusks, the throne itself being placed on a panther skin; his retainers stood playing horns (sometimes made of ivory) to signal his presence or assemble the population. The monarch also wears adornments (bracelets, necklaces, etc.), made of ivory during the major ceremonies. The practice of sculpting ivory dates back to ancient times in Africa, as may be seen in certain works in Egypt that are more than six thousand years old. The ivory works which remain nowadays (cat. 5 and 6) are also very old, but their chronology is uncertain. Here, the sculpted ivory, liturgical objects and objects of prestige were the exclusive attributes of kings and the most important notables. The royal treasure contains cups, horns, small horns, dozens of bracelets and necklaces, statuettes and daggers, all made from ivory. A number of these objects are richly and skilfully decorated with geometrical, anthropomorphic and zoomorphic motifs.

The History of the Art of Babungo

In order to have an in-depth knowledge of the arts in Babungo it is important to take a historical approach. The objects are evidence of the past: the result of traditions the origins of which have been lost in time, they may be seen as messages from the men of the past. Many archaeological finds and information from other sources suggest that the arts of the Grasslands, including Babungo, have a long history, extending from prehistoric times to the present. Thus, before the fourteenth century, the Vengo—who are believed to have come from Ndobo (valley of the Mbam)—settled in an area that was already occupied, setting up the kingdom of Babungo (or Bavengo) in an alliance with the indigenous people who had mastered the technology of iron more than twenty centuries earlier. Iron was used as a material to make art objects (musical instruments and cult objects in particular) and tools used by artists. Archaeological excavations have revealed ancient pottery from Babungo in association with iron-working activities; the decorative pottery of the region of Bamenda, in fact, dates back over three thousand years. The emergence of the royal dynasty and the old customary societies was accompanied by the production of cult objects that were carefully conserved and used in ritual ceremonies. This is the case of musical instruments and the bag containing the *muunkwan*, a thick rope on which human skulls and various animal skulls were hung, the most powerful protection in the kingdom (see the essay by Emmanuel Nchio Minkee).

Unfortunately, however, there is a dearth of hard evidence and accurate information regarding the artistic production during the long occupation of the Babungo territory prior to the eighteenth century. Besides, the study of African arts, including those of the Grasslands, from a historical perspective developed very slowly until recently. Despite some progress, many problems have been raised, in particular that of the chronology relating to the objects, without forgetting that concerning contemporary and associated events. In the specific case of Babungo, we do not have sufficient objects dated with accuracy to identify and historically reconstruct styles. The abundance of the works from the past two centuries contrasts with their rarity before the nineteenth century. Due to the lack of a systematic classification of all the objects of Babungo (within the kingdom and outside), the pieces presented in the catalogue are, in fact, limited to the fon's collection and mainly consist of twentieth century works. Even in this case, certain ritual objects, kept in secret rooms, have not been

displayed. In addition, the collections of notables and certain secret societies, of great historical interest, are totally absent as they have not been documented.

The objects of the royal treasure may be classified according to the different reigns, thus allowing us to establish a relative chronology concerning this heritage. But this collection is incomplete, as not all the reigns are represented. In actual fact, there are not as many groups of objects as the number of fons who have governed Babungo. The list of kings in chronological order should also be checked, especially because the lengths of the reigns are often somewhat imaginary. Lastly, the informers had difficulty in linking works to a specific period in time or event, or attributing them to a precise sculptor king or reign. This is why a finer ethnomorphological analysis of the pieces, the cross-checking (with a systematic study) of all the available information and the use of scientific dating methods (carbon-14, thermoluminescence, etc.) could improve our knowledge of the history of the art of Babungo, which, for the time being, is in an embryonic state, but is, nevertheless, not to be overlooked if we bear in mind the difficulties, mentioned above, of establishing the history of African arts. Thus the information given here is provisional: in addition, it is mainly associated with pieces from the royal collections of the nineteenth and twentieth centuries under the reigns of the fons Nyifuan, Saingi II, Sake II and Zofoa II.

Art of the Early Reigns
(until the Seventeenth Century)
There are some rare pieces believed to date back to the emergence of the dynasty and the period of the early kings up to the seventeenth century. The tenth fon, Nyichikau, is alleged to have been a skilful sculptor himself. Oral tradition also gives some information on the objects associated with the royal power and religion (this is the case of the

rope, *muunkwan*). But, as I have already mentioned, we do not have a sufficient number of series of pieces or enough detailed information to study the style of this period with any accuracy. We can, therefore, only get an approximate idea of artistic creation in Babungo before the seventeenth century because of the limited number of artefacts at our disposal.

Double gongs and spears were made in Babungo in this period; European travellers in the fifteenth century found spears on the coast of Cameroon from the interior of the country and certainly from the Grasslands (and perhaps even from Babungo). In fact, according to Jean-Pierre Warnier, there can be no doubt that, before the fifteenth century, the iron of the Grasslands was exchanged for the salt of Rio Del Rey, perhaps in the estuary of the Wouri.[7] Elaborate bracelets, decorated with chameleons recalling the patterns of ancient pipes, are thought to have existed in Babungo for more than fifteen generations. A copper bracelet that has belonged to more than fifteen consecutive fons is mentioned by Tamara Northern.[8] The older bracelets are heavier and more solid than the lighter specimens that appeared in the nineteenth century.

Like iron metallurgy, sculpture in wood dates back many centuries and there are pieces belonging to the first kings. In the Babungo Palace there is a sculpted bed and ritual pot with a panther.

The two objects are alleged to have belonged to the first fon, Saingi I. Even if the age of these works is uncertain, their style and the techniques of their production date back to the eighteenth century at least. Several objects from the palace have been presented by informers as copies of original works produced before the eighteenth century, during the early reigns (cat. 4). This is the case of certain objects that are the copies of authentic pieces made under the sixth fon, Seevesui.

fig. 18. People going to the ceremony giving a double gong

The statue of this monarch is believed to have been made from the original one in clay, which was in a poor state (cat. 10).

The headdresses of the fon of Babungo were mainly made from raffia fibres dyed black, others from birds' feathers, or they were decorated with animal fur. Raffia fibres were also woven to produce bags, the fabrics being dyed ochre or black. The royal architectural style of this period is represented by a house with a square base and a conical or pyramidal roof; the elements were prefabricated on the ground before their assembly.

Art of the Eighteenth and Nineteenth Centuries (cat. 1, 3, 13, 16, 29, 30 and 41)
The accounts of certain elderly informers, the reports and objects collected by the first Germans (missionaries, explorers, soldiers, scientists, etc.) who visited Babungo and the Grasslands at the end of the nineteenth century or the beginning of the twentieth century have contributed to a better knowledge of the arts of Babungo in the eighteenth and nineteenth centuries. In the first accounts of the German colonial officers, we note that the highlands of the Grasslands, including

Babungo, comprise some of the richest and most significant areas of artistic production in western and central Africa. Moreover, in 1889 Zintgraff described the dazzlingly beautiful setting in which the people of Babungo lived.

The trade of the Grasslands, which for a long time was directed towards the northern regions (Bénoué, currently North Cameroon, and Adamaoua), opened up to the prospects offered by the trading posts of the Gulf of Guinea: Douala in the mid-seventeenth century and Calabar in the nineteenth century. As far as the Atlantic trade was concerned, the Grasslands kingdoms mainly sent ivory, slaves and animal skins to the coast; the imported products they received in exchange included salt, beads, rifles and gunpowder (especially in the nineteenth century) and fabrics. The trade was carried out by intermediaries between the different peoples or areas from the Grasslands (including Babungo) to the coast. In the eighteenth century the local currency in Babungo and the surrounding area consisted of small hoes made by the smiths, but, in the following century it faced the competition of cowries, beads and rods, which finally replaced it. The massive arrival of beads in Babungo stimulated the development of the technique of bead embroidery (especially in the nineteenth century). The fon and the notables who took an active part in the slave trade grew rich, accumulating goods and obtaining works of art, signs of prestige and symbols of their material success, from as early as the eighteenth century. The political centralization and the hierarchical organization of society, which are reflected in the artistic production of Babungo, were reinforced in the Grasslands from north to south from the seventeenth to the nineteenth centuries. A short period at the end of the eighteenth century and the beginning of the nineteenth century was marked by insecurity, which was accentuated by the raids of the Chamba invaders in Ndop and the surrounding areas. The tendency to express terror and the intense expression of feelings and ferocity seem to characterize certain works of this period. In the second half of the nineteenth century, economic prosperity, the intensity of trade, the greater circulation of merchandise, objects and materials between Babungo and other kingdoms in the region and the role of the sculptor kings and patrons of the arts such as Nyifuan and Saingi II all helped different art forms to emerge and flourish. It is in this context that the artistic activities—some aspects of which are presented here—developed.

It was from the eighteenth century (and probably before then) that Babungo—and probably Bamessing and Oku as well—made spears of justice decorated with barbs, spirals and jagged palms, recalling the French decorated ironwork of the seventeenth century. These objects symbolizing power were common in the various kingdoms of the Grasslands. The commonest dignitary's headdress, made in Babungo in the eighteenth century, appears in royal statues and ancient masks. It is a bilobate bonnet covered with knitted raffia fibres. To each lobe is affixed a sort of small tail from four to five centimetres in length, also plaited in raffia. The old model, difficult to find in the field nowadays, was replaced in the nineteenth century by another similar black and white, or red and white, bonnet made of cotton (local or imported). The anthropomorphic mask decorated with a lizard, called *munkuncho* (cat. 16), the camwood pot (cat. 1) and the sacred stool (cat. 13), used during the new fon's ceremony of enthronement, were probably made at the earliest in the nineteenth century. Although this is only hypothetical, the style of the *munkuncho* mask belongs to a plastic tradition of the enthronement masks called *Kasho*, which flourished in the Grasslands in the seventeenth and eighteenth centuries. The German ethnographer Bernard Ankermann left interesting notes on the architectural styles of the Grasslands (including Babungo) and the technique of the prefabrication of elements on the ground before their assembly; the structure

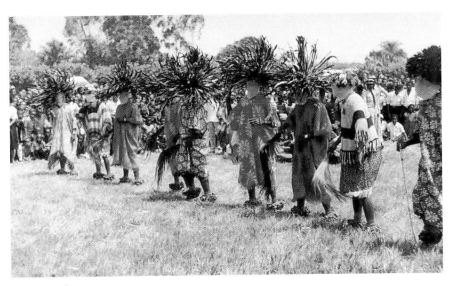

fig. 19. Masked dancers during a funerary ceremony

of the buildings and their decoration reflected the progressive improvement of a tradition dating back, he believed, several centuries.

In addition to the various objects presented in the catalogue, other pieces on display in Western museums express the skill, the remarkable talent and the aesthetic taste of Babungo artists (see the account by Zintgraff, who visited Babungo in 1889).[10] For example, mention may be made of the works collected in Babungo in 1908–11 (by Bernard Ankermann, Hans Glauning, Franz Thorbecke, for instance), which are presumed to have been made in the nineteenth century. Some of these are now in the Ethnologisches Museum in Berlin: two clay masks (such specimens are rare in the Grasslands) brought back by Thorbecke; a superb female statue; and a magnificent bronze pipe, remarkable for the richness of its composition and decoration. Artistic creation in the nineteenth century was characterized by the further development of the skills of the previous centuries, increased production and even greater specialization by the royal workshops. Innovations appeared in different art forms (architecture, weaving, sculpture) at a stylistic level, as well as at a thematic one.

Decorative arts developed rapidly, as is illustrated by bead embroidery and the decoration of fabrics and sculptures with an abundance of stylized, simplified or figurative motifs produced with rhythm. Some new plastic themes may be observed in the art of the second half of the nineteenth century, such as the horseman and his mount and the warrior holding his rifle. The horse's tail, as an object of prestige, replaced that of the buffalo: bearing a decorative motif, it became an important piece used in funeral rites. Buttons and nails of European origin were used, like beads, to cover objects. In the art of the nineteenth century, the richness, the variety of the iconography and the formal aspects were linked to an exploration of—or a continual search for—the possible variations on the different themes by the artists.

Art from the Twentieth Century to the Present (cat. 2, 5, 9, 10, 4, 11, 12, 14, 22, 23)

Although Cameroon was declared a German protectorate in 1884, much of the hinterland (including Babungo and the Grasslands kingdoms) continued to be ruled by the independent local chiefs. In 1901, the Germans

began to establish a military station in Bamenda as a base to conquer the whole of the region. Before being totally absorbed by the German colonial empire, Babungo (like Bali-Nyonga) was one of the allies of the Germans during the wars of 'pacification', or conquest, of the Grasslands. For example, Babungo actively took part in the conflict of 1906 in which the Germans and the Nso were opposed. As a reward, Babungo received from the Germans Nso royal wives captured during the attacks: consequently the kingdom of Nso broke off relations with Babungo, only resuming them forty years later, following bitter negotiations.

In the first half of the twentieth century, the German, then British, domination, the introduction of Christianity and Islam, and the massive import of goods of European origin—causing the failure of various local industries—completely upset many aspects of the social, economic and religious life of Babungo. As a result, the arts in their different forms (architecture, sculpture, pottery, basketry, etc.) underwent changes and transformations. The importance of the demand, the various possibilities of adaptation and the position in society are all factors that influenced their destinies. Generally speaking, the production of the plastic arts did not expand as it did in the nineteenth century, and this was especially true from the mid-twentieth century onwards, when many objects were taken to the West. Nonetheless, the art of Babungo did not lose all its vigour in the first half of the twentieth century: this is clearly demonstrated by the beautifully made works of art produced by the sculptor kings such as Saingi II, Sake II and the artists who helped them. The production of works of art as souvenirs started in Foumban and spread to various centres of the Grasslands, including Babungo, but with less verve. European and non-European collectors and travellers were satisfied with the production for this purpose, which included pipes, adornments, receptacles and sculptures more or less of Western inspiration representing soldiers, fig-

ures riding bicycles and scenes of daily life. Towards the 1940s, lay and religious craft schools were established in the Grasslands at Oku, Bali-Nyonga, Bamenda, Foumban, Dschang and Bafoussam. Models spread with varying degrees of modification to various centres, including Babungo. This led to the appearance of hybrid artistic forms that were sometimes of poor quality, mixing local and Western styles, without a cultural matrix, and accessible to any affluent villager. This is the case of certain works by the fon Zofoa.II and his assistants. Despite the assault by Christian missionaries, Muslim chiefs and the colonial system, the institutions of Babungo and the symbols associated with them have survived, justifying the continuity of some of the artistic productions. What strikes the observer in Babungo today is the vitality of the customs, even if we can see a real evolution, a certain humanization of the rites of passage for example and a shift in values. Titles associated with certain symbolic objects (seats, building, headdresses, adornments, pipes, fabrics, etc.), which enhance the social position of their owner, are still sought after. The continuity of the artistic activities thus helps to meet this demand; the present catalogue offers a sample of the pieces which are used today. In parallel, since the 1960s, talented artists, including the fon Zofoa II, have often produced excellently made works. The blacksmiths and wood sculptors are still active, whilst certain art forms (pottery, weaving, traditional architecture) have practically disappeared. The drop in demand, the lack of interest by young people in certain traditions, socio-cultural change and the rural exodus are the main causes for the decline in traditionally inspired artistic activities and the reduction in number of talented artists and workshops. We can also note that there are currently new forms of plastic expression which are the result of a masterly blend of Babungo- and Western-inspired themes, in an original synthesis.

The Conditions of Artistic Creation: Materials, Techniques and Sculptor Kings

Materials and Techniques

Artistic creation, heavily influenced by the age in which it takes place and closely linked to the socio-cultural context, is also conditioned by such factors as the materials, techniques and tools used, the training of the artists, the availability of patrons of the arts, the size of the market and the type of clientele (or other destination of the works). In addition to the materials of local origin, imported materials (scrap iron, beads, cowries, etc.) are used in the art of Babungo. Magic virtues and symbolic characters are attributed to certain materials and certain rites that are practiced, as we will see below. Obviously, wood is not treated in the same way as iron or stone: techniques that are proper to each material exist and it is necessary for artists to learn them during their training. Treatment of the materials varies according to such factors as the period, the type of human community involved and the tools used.[11] Sculpture, especially of wood, iron working and bead embroidery occupy a predominant place in the activity of Babungo nowadays.

Wood and Sculpting Techniques

Woodworking in general is an activity that requires real skills and an apprenticeship with an experienced specialist. The ability to choose the wood and carve and treat it—in a word, mastery of the material—can only be acquired gradually. Knowing which wood to use for each work is a fundamental part of the skill of the master sculptor. Several woods from various species of tree are used for artistic production in Babungo.

The raffia palm occupies a fundamental but completely separate place: it is used to produce works of art, food (palm juice or 'wine') and fibres from which ropes and fabrics are made.

Ibukwin (*Cordia platithyrsa*, family *Boraginaceae*) is considered the best wood for sculpture in the whole of the North-Western Grasslands. It is common in the region and its name varies according to the different languages or dialects, for instance *fangon* (Oku), *feshu* (Babanki), *far* (Bafut) and *fungom* in Kom. The fruit of the tree produces glue used to seal envelopes. This very good quality wood is used in Babungo to make royal beds, drums, stools, thrones and statues, in a word the important sculptures of the palace. The *ibukwin* tree is by right the exclusive property of the fon of Babungo.

The *dzuedzu* is also a species of quality, used in the production of masks, statues and stools.

The *yangma* (*Pachylobus edulis* or *Dacryodes edulis*) is called *kefée* in Oku, *dzom* in Bali-Nyonga, and *ekwebi* by the Moghamo. This wood—of a mediocre quality compared to *ibukwin*—is used to make talking drums and seats. The majority of the objects made in Babungo outside the royal palace were made with *yangma* or another inferior species such as *telem*.

As a rule, authorization by the fon is necessary to cut down rare or reserved trees, but today, certain important notables fraudulently evade this obligation. The sculpture of the cult objects for the fon and secret societies is accompanied by various rites. In particular, sculptors observe sexual continence during these operations and respect food taboos. The working of the material is sometimes reinforced by ritual gestures or singing; this is particularly true for certain sacred objects, which are also produced in secret.

Once it has been cut down, the tree is generally worked immediately: after it has been cut to the desired size, its bark is stripped off in the forest or in the fields and the final preparation is carried out in the palace workshop. The techniques of wood sculpture in Babungo are not fundamentally different from those of the other Grasslands

fig. 20. A craftsman producing
a raffia fabric

kingdoms. Limited by the shape of the wood, the artists tend to use the cylinder as the basic volume. They work by carving it directly—one fragment can modify the shape—while, as far as the statue in the round is concerned, they seek to maintain the proportions of the human body with its head, neck, bust or chest and limbs. They carve the eyes and ears—elements that may present some difficulties—and the surface of the object will be polished using abrasive sheets. The finishing technique may contribute to the identification of a sculptor or at least the workshop, in particular thanks to the direction and width of the adze cuts.

In general, the sculptures have several patinas: the first artificial one produced on cutting; the second one due to the effect of smoke (when the pieces are kept in dwelling-houses); the third one due to the handling of the works by users. However, certain ritual or ceremonial objects that are touched only occasionally keep their natural colour. Some newly-made pieces (thrones, stools, masks, statues and musical instruments), playing a specific cultic or symbolic role, undergo a sort of metamorphosis because of the complex rituals of consecration, which transform ordinary objects into works full of an extraordinary power.

In Babungo sculptors use simple tools including chisels of all sorts, machetes, scrapers, saws, hatchets, adzes and knives. These tools, in the past locally produced by smiths, are now gradually imported, although some undergo modification before use.

Iron and Iron-Working Techniques
The technique for producing iron objects has changed very little over the centuries. Since the mid-twentieth century, rather than being extracted from the local iron ore, the metal has been obtained from the scrap metal of various origins—for instance, old vehicles or various objects of Western origin. Alongside imported tools, the smiths use others, made

locally of stone (hammers, for example), which, despite their archaic appearance, are quite efficient and can be used for the bulk of the work. As soon as the iron starts to heat up, it is hammered on a stone anvil to obtain the desired shape.

The production of iron and the crafting of sacred objects are associated with religious practices and magic rites. When the forge is built, an animal (cockerel, sheep, ram or goat) is sacrificed and its blood sprinkled over the buildings to sanctify them. Medicine or substances offering protection, a sort of gris-gris (a charm, amulet or fetish), are buried under the furnace to guarantee the quality of the production and also for protection against those—people or spirits—entering the premises with evil intentions. These substances are made of plants and a specific type of earth and are used by the smith to fortify his heart, allowing him to plunge his hands into fire without getting burnt. This could be observed in the Bamoum and Bamileke territories and in different centres of the production of sacred iron objects in the Grasslands. Smiths and their helpers must abstain from sexual intercourse and respect certain food taboos during the production of objects used in worship. Work is sometimes done at night to avoid impure men or women coming unexpectedly into the forge, which would make the piece produced ineffective. Religious precautions are still observed today in the forges of Babungo, but less strictly and they no longer concern the production of simple articles for trade.

Beads, Bead and Cowrie Embroidery
In Babungo, beads and cowries are used not only for adornment and clothes but also in the plastic arts, sometimes with a religious purpose; in the past they were used as money and in divination. The ritual and religious functions concern certain categories of ancient beads, not the current examples found on the market, which are simply used for decoration. Beads

used in the art of Babungo were of several types as far as the shapes, colours, production techniques and origins were concerned. Before the appearance of European examples (from the seventeenth to the nineteenth centuries), there were other beads, probably coming from North Africa and the east coast of Africa before the fifteenth century. This is may be seen in relation to the intense trade, both direct and indirect (through intermediaries), between the different peoples who had settled in Africa since Neolithic times.

The bead artists have greatly contributed to giving certain works of the Grasslands their powerful expressionist appearance. A piece of fabric is fixed onto the surface of the sculpted object; on this, the embroidery artist fixes the cowries or beads, creating geometric figures with harmony and rhythm. In general, when the sculptor makes an object that is to act as a support for a covering with beads or cowries, the work is simplified, the face smoother and without details and the hands and feet may not be represented. Embroidery with beads is a very important element that influences the artist in the composition of volumes: embroiderers are delicate and skilful decorators using matching colours. They also divide the geometrical surfaces in an imaginative manner: beads of different origin may be combined to produce the decoration. The sculptures covered with beads include seats, statues, masks, wooden handles, dance whips, sceptres, ceremonial staffs and wooden human skulls (cat. 8, 9, 11, 12, 21, 48, 66, 67).

Artists, Sculptor Kings and Smiths
The objects of the palace of Babungo have been made with a keen aesthetic sense and a remarkable mastery of the materials—with a tendency to copy the works of the past, whilst adding innovations—by well-known artists, including sculptor kings, who are highly respected in this society. During a visit to Babungo in 1984, I made a list of about twenty talented sculptors

active at that time—including Fon Zofoa II, Ndifuangong, Ngong Siye, Nganwansui, Simbo Njinduh, Ndula Wangfung, Amadou Ngong and Kiefeh Wembai the great specialist in drums—and a large number of artists of the past (Fon Nyichikau, Fon Nyifuan, Fon Saingi II, Fon Sake II, Tisah, Nchia Kumeghe, Simbo Melang, Timbah, Tiwambi, etc.).[12]

Important members of society, guardians of customs and in the fore of innovation, Babungo sculptors have a mission to transmit from one generation to the next the artistic traditions of the community, to keep them alive and renew them from within, using, if necessary, other means of expression. They learnt their craft in the family compound or in the royal workshops where they received a long training; they also underwent initiation to make ritual cult objects. Their inspiration comes as much from their own imagination as from nature, society, history, religion and Babungo traditions. They must also adapt to the transformations of his environment and take into account the novelties that appear in the region. Their works reveal, at one and the same time, both their personal vision of life and the world and elements of Babungo culture. The inventive spirit of the artists clearly appears in their art. Artists are often versatile in Babungo, with many sculptors joining forces to create an artistic project.

Almost all the works illustrated in the catalogue are presumed to have been made by the sculptor kings (helped by talented assistants) or independent artists working in collaboration with the palace. In his youth, or as an adult, the sculptor king was a tireless worker; in time, he grew old and only made some pieces occasionally. But, generally speaking, he guided the apprentices at his palace, supervising their work, sharing his experience with them, as well as his knowledge and aesthetic sense. In Babungo, and generally in the Grasslands, when the king was not a sculptor himself, he often claimed the paternity of the works, as all creations in the kingdom could only come from the monarch in person. In addition, because of the prestige of sculpture in the Grasslands, certain sovereigns did not hesitate to usurp the authorship of particularly outstanding works that had, in fact, been made by artists under their protection. Sometimes this was done with the complicity of the latter, who thus found an opportunity to pay tribute to the *fon*, an act of prestige and a duty in the region. This is why, taking into account these facts, it is necessary to carry out further research in order to distinguish the works that the sculptor kings actually created from those they did not make themselves, but which are, nevertheless, attributed to them.[13]

The reigning dynasties of several kingdoms in the Grasslands (Kom, the two Babanki, Lebang-Fontem, Bali-Nyonga, Bakong near Bangangté, Bandokossang near Bafang, etc.), like Babungo, comprised several skilled sculptor kings. Of the Babungo kings, the most famous were Nyichikau (ninth fon), Nyifuan (twenty-first fon), Saingi II (twenty-second fon), Sake II (twenty-third fon), and Zofoa II (twenty-fourth fon). Information on their lives and works is still relatively incomplete at the present time; however, sometimes these monarchs were also smiths.[14]

Nyichikau, who probably reigned before the eighteenth century, is one of the oldest relatively well-known sculptor kings. He was a practitioner of traditional medicine and gifted with the exceptional magic power mentioned earlier. The fon Nyifuan was a great artist and patron of the arts, and, during his reign, the royal art of Babungo flourished. He is thought to have produced several objects kept in the royal palace (cat. 25), although what he actually made has yet to be identified and confirmed. Nyifuan was almost the contemporary of the remarkable sculptor king Yu of Kom (1865–1911). He was taken prisoner by the Bali for three months before being freed in about 1840. Did he learn the techniques from the Balikumbat, who came from the north and

who also lived with the Bamoum? His work was continued by his successor and nephew Saingi II,[15] his grandson Sake II and his great-grandson Zofoa II, who reigned from 1955 to 1999. Zofoa II was the most productive, inventive and best-known sculptor king of the dynasty. I personally saw him at work during my research in Babungo. In 1976, Tamara Northern filmed the monarch whilst he was carving a slit drum with, at his side one, of his helpers, the young servant Ndula Ndifango, who was learning the art of sculpture.[16] The sculptor Daniel Kanjo Musa, an intellectual originally from the region of Nso, who studied at the universities of London and Ifé, in Nigeria, benefited greatly from the artistic experience of Zofoa II. He has left some interesting, though fragmentary, information on the work of the sculptor king, who was a model example for him.[17] He visited the royal palace of Babungo, observed and studied the objects personally made by Zofoa II (stools, beds, drums, statues with and without beads, masks, etc.). The sovereign gave him a great deal of useful advice on the techniques of sculpture and the meanings of the symbolic motifs of Babungo.

Zofoa II introduced his children and his wives to the art of beads. He recruited apprentices and sculptors, and accommodated them in the palace. He was very curious about the artistic styles of other regions in the world and adapted them to his own creations. He was deeply anchored in the religion of his ancestors, whilst respecting the beliefs of the Muslims and Christians who lived in his kingdom. He was interested in all the different religions and attended their ceremonies.

The Forms, Functions and Meanings of the Artistic Representations:

Styles, Decorative Art and Artistic Expression
The Babungo sculptures have features that are similar to those of the Bamoum country and the kingdom of Kom—for example, on the masks, the eyes, ears and mouth are emphasized with the help of a pigment or kaolin. Moreover, the artistic styles of the Babungo, Oku, Kom, Babanki and Bamoum kingdoms are directly related. Although a careful examination of the art objects of the North-Western Grasslands highlights common forms that are easily recognized, stylistic differences in detail exist not only between the main centres, but also between the artists taken individually. Thus, each Babungo sculptor king had his own style of production: the sign of the cross often appears in the works by Sake II, who, before becoming an artist, was a catechist at the Basle Mission.

Whilst practising sculpting in the round or in high and low relief, the sculptor kings seem to have excelled, above all, in decorative sculpture. In fact, one of the dominant features of the art of Babungo is its highly decorative character, together with a tendency to favour intensity of expression. In addition, when we observe the sculptural output of the royal palace, we can see that, on the one hand, a current of simplification has developed that, at times, results in decorative forms having a geometric and abstract tendency, and, on the other, a more widespread tendency towards realism.

In their creations, the artists use a carefully codified language in a multitude of typical motifs in order to exploit their aesthetic, expressive and symbolic power. Thus the stylized toads become simple lozenges, while spiders are dots, circles and small cylinders. This trend towards reducing symbols to geometrical shapes sometimes involves the development of a sort of calligraphy that, in some cases, consists of ideograms transmitting knowledge. The sculptural art of Babungo is a sort of language in images, at times expressed in elements of 'strip cartoons' in relief, relating directly to the community that gave rise to it (see, for example, the decoration of architectural elements and of furniture). It shows the essence of royalty,

but also the hierarchy, social cohesion and social values of the community. The main aim of the art objects of the royal palace of Babungo is to display and demonstrate the power, prestige and grandeur of royalty, of the fon himself and the notables and customary societies.

Here, far more than in Mankon, the Babungo artists—whilst preferring the human figure in the various artistic representations and in ornamental art—also depict animals, plants, minerals, elements of the cosmos and, sometimes, man-made objects (pipes, gongs, etc.). The analysis of the artistic representations and of all the motifs having as supports the objects in the royal palace of Babungo would exceed the scope of this brief study. I will only refer to some cases of animal and human figures, without overlooking the motifs of cowries and the double gong observed on the pieces illustrated in the catalogue.

Animal Motifs

The fundamental importance given to the images of animal subjects, both in speculative thought and in practical applications, explains their persistent appearance in the art of Babungo. In addition, the forms and meanings of certain royal animals such as the elephant, the buffalo and the panther present points in common with those analysed with regard to the art of Mankon. Reference can thus be made to the descriptions made of the representation of these animals in the essay on Mankon.[18] I will only refer here to the case of the snake, the spider, the chameleon and the lizard, as typical examples, since there are too many animals represented in Babungo sculpture to discuss here.

In the early twentieth century, German authors such as Bernard Ankermann (1907–08) and Paul Germann (1910) referred to the stylization of the toad, the lizard, the snake, the spider and the chameleon in the art of the Grasslands. Subsequently, other works provided further information on this subject, even if the

case of the kingdom of Babungo has not yet been treated specifically. The figurative motifs of animals decorating various sculptures in Babungo had, first and foremost, a symbolic character. Pierre Harter, generalizing the phenomenon to the whole of the Grasslands, correctly showed that, although the geometrical symbolism of animals or objects had an esoteric or mythological value, their repeated representation gave them an increasingly simplified aspect, so they ended up by being merely decorative in character. The eye of a foreigner cannot find the original model, whilst an initiated Babungo (or, to a certain extent, an inhabitant of the rest of the Grasslands) recognizes it straight away. However, the motifs of animals sometimes attain such a degree of abstraction that it is difficult to distinguish them outside the context of the ritual objects they decorate.

The Snake (cat. 31, 38, 39, 41, 43)

In the Grasslands, the snake is amongst the animal species that have appeared most frequently in artistic representations associated with royalty and the notables. In Babungo, the representation of the reptile goes from zoological forms to a stylization tending towards abstraction. The motif of the snake appears both in its simple form and with a double head. Doubling a feature is a characteristic element of the arts of the Grasslands, where the figures of animals with at least two heads (snake, panther, elephant, buffalo, etc.) are widespread. The snake is also represented by a spiral, a circle and sometimes by a succession of chevrons or by a continuous meander, known as the 'hen's intestine', which, in general, has now become a simple decorative element. The reptile, the toad and the spider, in particular, often form a decorative design that has become abstract in many sculptures and other works of art.

The snake appears in different forms in the decoration of masks, statues, pipes and other receptacles, beaded objects, fabrics,

architectural elements, pieces of furniture, headdresses and so on. Apart from the two-headed snake, it is difficult to determine the kind of snake represented because of the degree of stylization of the animal. In fact, it is only with reference to the use of the object that the type of reptile represented may, in some cases, be distinguished.

The snake is the symbolic animal *par excellence*. Everything about it is extraordinary: it sloughs off its skin every year, seeming to be reborn, which gives it a character of immortality; it hypnotizes its prey, killing it with its poison, if it does not crush its victim to death. It is a universal ambivalent symbol (because it is both good and evil at one and the same time). In Babungo, the snake is linked with numerous cultural institutions and is present in several activities associated with social life. Here, and in various other lands, the snake has a place of prime importance in religious symbolism, but for reasons that are not necessarily the same everywhere. In Babungo there are countless myths, beliefs and tales involving the snake. According to a local tradition,[19] the ninth fon, Nyichikau, was buried in a place which was not the one he had chosen for his tomb. It was then that a boa constrictor emerged from this grave to move energetically move towards the real burial place previously designated, after which it disappeared. In Babungo and in various kingdoms of the Grasslands, the snake is considered to be ancestral spirit. The sudden or periodic appearance of a mythical snake in certain sacred places of the kingdom is reported by several witnesses. In addition, the relationship between the fon and the snake (one of the main symbols of royalty) is important in the Grasslands. In representations of the snake in Babungo the snake is linked to the concepts of twins, royal strength and the protective force of life; in addition it is the symbol of procreation and fertility and the guardian of places and treasures. Lastly, the motifs of snakes that decorate the objects displayed during funeral ceremonies are associated with death, but also evoke the spirit of a rebirth or resurrection in a new form of life, it is hoped will be better.

The Spider (cat. 2, 5, 6, 22, 31, 39, 40, 51, 53, 56, 57, 59, 60)

In the art of Babungo, the spider motifs, generally symbolic in character and with different meanings, decorate headdresses, masks, architectural elements, statues, pipes, pieces of furniture, musical instruments, vases and other containers. The representations of the arachnid range from realistic or naturalistic forms to stylized and even abstract ones. Several types of different motifs representing the spider can thus be distinguished, corresponding to different degrees of simplification of the animal in art. In general, two types of spiders are represented:

the house spider, which lives in dwellings where it weaves its web to catch insects;

the earth spider or trap-door spider (*ngaa, ngom, ngam'* or *ngamsî*) is a nocturnal animal that digs a hole in the earth to make its home; it recalls the tarantula, the usual name for the large spider, *Lycosa tarantula*, found in southern Italy.

Thus, the motif of the house spider will tend to be without a head, sometimes represented schematically with a round abdomen and six or eight legs. It may appear in a circle symbolizing birth, life, death and rebirth. The trap-door spider will often be shown in a realistic form, with its head in relief. Sometimes the abdomen is elongated and protuberant with two holes at the ends, and there are eight legs. This type of motif appears, above all, in the decoration of certain royal objects and the stools belonging to the notables and the soothsayers using the trap-door spiders. In practice it is difficult to distinguish between the two varieties of spider if it is without a specific context or by observing only the formal elements. A stylized or realistic motif may represent the trap-door spider as well as the house spider, depending on the object that is the support

for the motif and the context of its use. Thus, the stool of a notable who is the head of a clan is decorated with motifs of spiders in a circle, symbolizing peace and tranquillity for the whole of the clan. This is a house spider and like it, the clan chief weaves his 'webs'—here networks of relations and actions—to destroy those who disturb his family, so that peace will reign amongst his people.

In Babungo and throughout the Grasslands, the spider is the symbol of wisdom, foresight, clairvoyance and intelligence. The trap-door spider is used in divining: in fact, it is believed it can predict the future and 'speak'. With the trap-door spider, the seer has an occult power: he has four 'eyes' to see in the invisible world, allowing him to interpret the messages of the spider and translate its 'words'. It is because the trap-door spider lives under the ground, the dwelling place of the ancestors, that it is attributed with supernatural powers: it is the mediator between the living and the dead and it transmits the messages of the dead to us. It knows the secrets of life and death and it is also depicted in this way on several cultic or ceremonial objects that require its important qualities. In Babungo only the fon, the *bah*—the second figure of the kingdom and head of the *ngumba* society— and the queen mother have the privilege of using the symbol of the spider to decorate the vase of prestige and architectural elements.

The Lizard and the Chameleon
(cat. 1, 5, 6, 12, 16, 22, 25, 36, 50, 51)
The motifs of the lizard and the chameleon decorate various art objects, with the lizard being more frequent. The chameleon is recognized by its larger triangular head, globular eyes and curly tail, while the lizard is represented with a long tail, sometimes with scales in chevrons or diamond-shaped on a body like a crocodile's—but more often than not it is hard to distinguish between these two animals. The chameleon is the symbol of death and danger:

it is the messenger of death in the Grasslands. On the other hand, the lizard is the symbol of life and is respected and honoured for this reason. There are several types of lizard in Babungo beliefs: some can drive away sorcerers or even bring rain and rainbows; others are associated with twins and royal cults.

Human Figures
In Babungo, as in Mankon and throughout the Grasslands, man is at one and the same time the creator of art objects and the most important subject of artistic production. The human figure is represented in the art of Babungo both in the round and in relief in its dual male and female forms and in their multiple functions. The human subject can be either an independent figure—that is, a statue—or a decorative element that is part of a composition, a frieze or scene decorating various objects, and describing events of a religious, symbolic, political, philosophical, mythical or social nature. The most frequent representations are those of a generic man (or woman), the king, the queen, a warrior, a retainer, a protective guardian and a human head.

Representations of the Fon (cat. 8, 9, 10, 26, 30, 31, 32, 35, 74)
Artistic productions represent the stratification and hierarchy of Babungo society with, at its head, the fon, a sacred figure who has important powers and multiple functions in the life of the community. As in the case of the art of Mankon—and more generally in the arts of the Grasslands—the representation of the fon and the glorification of this exceptional being of a divine nature is the essential theme of the art of Babungo. This is intensified by the fact that the king is often himself a sculptor. The artist expresses the multifarious social, religious, political and economic functions of the fon with formal signs. The most important examples of objects representing the fon are the royal commemorative statues. Usually show-

ing a couple—the fon, his mother or one of his wives—they are treated with the same respect as the royal figures they represent. An effigy is often made immediately on the enthronement of the fon—elsewhere, as in Bamessi, it may be made on the death of the fon—and it is accompanied by the statue of a queen. This custom is extremely valuable in helping to date the objects or styles. But today, in the kingdoms of the Grasslands where this custom is practised, the collections of royal statues are incomplete because the introduction of this tradition is more recent or has died out or, as in the case of Babungo, contain replacements following destruction or looting. I mentioned above the problem of the age and of this tradition in Babungo; it should be added that its sacred and religious character also seems weakened in Babungo, whilst it is thought to have been very strong in the neighbouring kingdom of Bamessi. Thus four funeral ceremonies are organized on the death of the fon of Bamessi. The first one is called *Kemafeh*: on this occasion, the statue of the deceased fon is kept religiously in the secret place of the palace called the *ndze-yio vierghe*. This statue represents the deceased fon during royal cults; this type of object is not shown to outsiders.

The examples of this royal art included in this catalogue illustrate its splendour. The royal statues, often monumental and sometimes sheathed in beads and cowries, represent a sort of memorial, the ritual role and importance of which vary from one area to another. Regarded as receptacles of the spirits of the ancestors shown during sacrifices and, above all, symbols of the power and history of the royal dynasty, these objects are intended to be displayed during royal funerals and cults. Usually the sovereigns are standing (or seated) and hold the royal attributes in their hand. In fact, these statues represent remarkable sculptural themes common in the art of the Grasslands.

Representations of Queens (cat. 19, 20, 41, 77, 79)
In Babungo—as I have already stated with regard to Mankon—the role of the woman, who symbolizes fertility (mother and child) and love (a man's companion) and who appears as an expression of beauty, is very important in artistic production. The queen, as the wife or mother of the fon, is by far the most important and common artistic subject. She appears on various supports and, above all, in statues, standing, seated, holding symbolic objects, or a child, and in various positions. The statue of the queen is decorated with many ornaments and has the same function as the statue representing the king it is associated with.

Figures of Retainers and Protective Guardians (cat. 11, 17, 18, 23, 29, 33)
The anthropomorphic sculptures, sometimes ritual and generally made of wood, may be decorated with symbolic motifs and colours. Representing the ancestors and the servants of the fon, they may be simple portraits commemorating the fon's collaborators or have specific functions. But when they have a ritual character (which is not obvious for the majority of the examples included in the catalogue), their essential role is the protection of Babungo as a whole and its sacred or special places, huts, treasures and inhabitants against all the evil forces. They are of varying sizes and some examples are covered with beads and cowries.

In Babungo (and generally in the whole of the Grasslands) when the artist's work has been completed, the statue, the mask, the musical instrument or whatever is given to an 'expert'—who may even be the artist himself—endowed with an occult power, to be transformed into an object of power by rites of consecration. The sculpture has become capable of capturing the forces of nature. It has a dynamic force and a certain cosmic energy thanks to a medicine with occult pow-

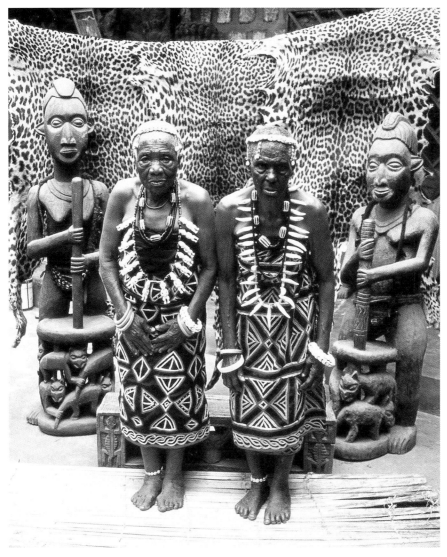

fig. 21. *Nah* Younwi (on the left) and *nah* Fuzo (on the right), wives of the king Saingi II, 2001

ers placed in a cavity: the object is then anointed with magic oil, with the addition of certain materials playing a magic role. This is followed by rituals, prayers and sacrifices that are made before it is used for the first time. The consecrated examples present in Babungo are often endowed with occult and supernatural powers giving them a magic and protective function. It is even believed that the examples with magic powers become dan-gerous and can inflict a slow or brutal death on the curious who approach them. This is why they are generally hidden away and are not made to be displayed. In every kingdom of the Grasslands there are always sculptures (or objects) guarding the royal residence, or protecting the kingdom, that are kept safe from prying eyes. Great care is taken over the preservation of these pieces, which explains why very old examples are still extant.

Representations of Warriors and Themes of War (cat. 24, 25, 41)

The theme of the warrior is very common in the sculptural arts of the Grasslands. The fon himself is often represented as a victorious fighter, sometimes holding the head of a conquered enemy. Whether he is a king, servant, notable or the protective guardian of a place, the warrior appears on countless supports in the form of a figure holding, for example, a weapon or a trophy head. Often particular emphasis is given to his threatening expression and his war colours, while, in more recent works, he may be portrayed wearing a uniform. In the past, the statues of warriors played a fundamental role in the wars between the kingdoms. The Babungo used these objects—for example, the *gwi-yighau* sculpture—to fight against their enemies (cat. 25). In the kingdom of Bafandji, the fearsome *djibimunang* statuette is a sort of god of war that was placed at the head of the troops during a battle. In the region of Nkambé and, in particular, in the kingdom of Binka, a guardian statue called *ngwè* (recalling the *gwi-yighau* statue of Babungo) is found inside a house of the *mpfu* warrior society. The figure is often elongated and red in colour, with a threatening expression: it has supernatural powers and is a real god of war and vengeance.

In the Grasslands, great importance was given to supernatural forces in all the different aspects of the war. This is still true nowadays in football matches and various social activities throughout Cameroon, admittedly in a different context. No fight was begun if the soothsayers and magicians had not been consulted and if sacrifices had not been offered to the gods. Spies were sent into the enemy country and magic substances were buried at strategic points to weaken the opponent, while weapons were consecrated with protective potions. In his accounts, Zintgraff described in detail the various aspects of the war magic practised by his allies (Bali-Nyonga in particular) during the conflict he fought with them against Mankon and Bafut in 1891. In Babungo, each quarter has its own club (or lodge) of war called the *mosangu*. The leader called *ta-mosangu* (father of the *mosangu*) is appointed by the fon, the supreme military chief of all these associations. In the past, they were involved with not only military activities but also royal hunting, and they carried out work with a community interest, such as building bridges and houses.

The Functions, Forms and Meanings of Other Motifs: the Shell and the Double Gong Shells (cat. 7, 12, 18, 19, 24, 27, 29, 33, 40, 65, 79)

Of the natural objects of animal origin found in Babungo sculptures, cowries are the most frequently used. Moreover, this shell has occupied an important place in the art of the Grasslands—and more generally in African art—as an added material for several centuries. Shells were used in the Grasslands to make necklaces even before 3000 BC, according to finds in archaeological excavations. At the time of the first dynasties in Egypt, cowries were the symbol of life, together with the open eye, and both were used in art. In the prehistoric cultures of the Middle East, as in Jericho (7000–6500 BC) cowries, often replacing the eyes in human skulls, appear to have played a role in ancestor worship. Some objects of the Grasslands dating back to the seventeenth or eighteenth centuries have either real cowries or representations of these. In the art of Babungo, the cowries that were used as money in the past are decorative objects, but are often associated with such cults and rituals as divination, fertility cults, the cult of twins, the cult of ancestors and medicine. A wide variety of the works of art are decorated with cowries (fabrics, masks, statues, thrones, calabashes, ceremonial staffs, etc.) To cover the objects, the cowries, after their convex side has been ground, are placed in parallel lines, end to end, on the support fabric, so that the two lips of the flat side are visible, then they are fixed with a knot by each of their corners. The

cowries may also be sewn end to end, forming the crowns that the queens wear.

The Double Gong (Kwifo) *(cat. 5, 6, 31, 40)* The double gongs have a great ritual, political or symbolic value, as mentioned above. These objects were made for the first time on the west coast of Africa, between the Ivory Coast (perhaps their place of origin) and Benin. They then spread to other regions of Africa, with adaptations and local productions, well before the fifteenth century. In Africa these objects have several shapes, although the place of origin of the first models is hypothetical. In Babungo, double gongs have become symbolic motifs that are often reproduced in relief on such objects as seats, masks, doorframes, drums and royal beds. Very stylized double gongs also decorate fabrics (for instance, the *ndop* fabric) and raffia bags. Several examples are illustrated in the catalogue.

Conclusion

The importance of the art objects of Babungo derives as much from the emotion that contemplating them may arouse in each of us as from the function that they have—or used to have—in their original setting as socio-cultural indicators and witnesses of other values. Here the functional and economic concern at the base of artistic creation is merged with the aesthetic intention. This study has not only approached the royal art of Babungo in its material and aesthetic reality, but has also provided extensive information on the history, conditions of artistic creation, forms, functions and meanings of the works.

Talented sculptor kings such as Nyichikau, Saingi II, Sake II and Zofoa II and their assistants (see the essays by Protus Bofua and Julius Ndifor) produced admirable objects which include all-time masterpieces of African art. They used means of expression ranging from total sobriety of the object to the most faithful realism to give power to the work. Beyond the beauty of the forms, in the major-

ity of the objects produced in Babungo now in the local museum, we find the fundamental concerns of man: respect for life, the need for power, the fascination and fear of death, the aspiration to happiness and love, a concern for the future and the struggle for survival.

Notes
[1] J.-P. Warnier, 1985, p. 13.
[2] C. Geary, 1984, p. 85.
[3] In this essay, the objects are classified and presented according to criteria relative to their forms and functions, whereas in the catalogue of cultural objects they are divided according to the theme and sub-themes of the museum's permanent displays
[4] At present, due to the limited area available in the museum, only eighty significant and representative objects—the photographs of which appear in the catalogue—are included in the museum's permanent displays. About a thousand other partially documented pieces are kept in the museum store-rooms.
[5] T. Northern, 1984, p. 35.
[6] Ibid.
[7] J.-P. Warnier, 1985, p. 151.
[8] T. Northern, 1984, p. 15.
[9] J.-P. Notué, 2000, p. 224.
[10] E.M. Chilver, 1966.
[11] J.-P. Notué, 1988, p. 201.
[12] See the essay by P. Bofua and J. Ndifor.
[13] This allowed the curators of the museum of Babungo to find the real makers of certain works that were wrongly attributed to the sculptor kings (see catalogue of cultural objects and the essay by P. Bofua and J. Ndifor).
[14] See the essay by E. Nchio Minkee.
[15] Nyifuan was sterile. On his death, it was Saingi II, the son of Yamagho, one of the monarch's two sisters, who became king in Babungo.
[16] T. Northern, 1984, p. 60.
[17] M. Kanjo, 1996.
[18] J. P. Notué, 2000b.
[19] See the essay by E. Nchio Minkee.

Bibliography
The essay was written following field studies. However, additional information was obtained from the publications listed below.
Chilver, Elizabeth Millicent, *Zintgraff's Explorations in Bamenda: Adamawa and Benue Lands, 1889–1892*, Ministry of Primary Education and Social Welfare and West Cameroon Antiquities Commission, Buéa, 1966.
Chilver, Elizabeth Millicent and Phyllis M.

Kaberry, *Traditional Bamenda. The Pre-colonial History and Ethnography of the Bamenda Grassfields*, Ministry of Primary Education and Social Welfare and West Cameroon Antiquities Commission, Buéa, 1968.

Fowler, Ian, 'Babungo: A Study of Iron Production, Trade and Power in a Nineteenth Century Ndop Plain Chiefdom (Cameroon)', PhD diss., University of London, 1990.

Geary, Christraud, *Les choses du Palais: Catalogue du Musée du Palais Bamoum à Foumban (Cameroun)*, Studien zur Kulturkunde 60, Franz Steiner Verlag, Wiesbaden, 1984. Eng. edition: Christraud Geary: *Things of the Palace: A Catalogue of the Bamum Palace Museum in Foumban (Cameroon)*, Studien zur Kulturkunde 60, Franz Steiner Verlag, Wiesbaden, 1983.

Gebauer, Paul, *Arts of Cameroon*, Portland Art Museum, Portland, 1979.

Germann, Paul, 'Das plastisch-figurliche Kunstgewerbe im Grasland von Kamerun', in *Jahrbuch des stadlischen Museums für Völkerkunde zu Leipzig*, no. 4, 1910, pp. 1–35.

Harter, Pierre, *Arts anciens du Cameroun*, Arts d'Afrique noire, Arnouville, 1986.

Kanjo, Musa Daniel, *Nso Traditional Sculpture (An Interpretation of Motif)*, Musa Heritage Gallery, Kumbo, 1986.

Knöpfli, Hans, *Sculpture and Symbolism, Crafts and Technologies: Some Traditional Craftsmen of the Western Grasslands of Cameroun; Part 2: (Wood carvers and Blacksmiths)*, Presbook, Limbe, Cameroon, 1998.

Nkwi, Paul and Jean-Pierre Warnier, *Elements for History of Western Grassfields*, University of Yaoundé, Yaoundé, 1982.

Northern, Tamara, *The Art of Cameroon*, Smithsonian Institution Traveling Exhibition Service, Washington, DC, 1984.

Notué, Jean-Paul, *Prospections relatives aux trésors des chefferies de l'Ouest et du Nord-Ouest du Cameroun; rapport scientifique de mission de recherche dans le Nord-Ouest du Cameroun*, MESIRES and ORSTOM, Yaoundé, 1984.

Notué, Jean-Paul, 'La Symbolique des arts bamiléké (Ouest-Cameroun); approche historique et anthropologique', doctorate diss., Université de Paris I, 4 vols., 1988.

Notué Jean-Paul, *Chronologie et histoire de l'art du Grassland; approche méthodologique*, MESIRES, ISH and ORSTOM, Yaoundé, 1991.

Notué, Jean-Paul, *Batcham. Sculptures du Cameroun*, Musée de Marseille and Réunion des Musées Nationaux, Marseilles, 1993.

Notué, Jean-Paul, 'Contenants du Grassland', in Christiane Falgayrettes-Leveau (ed.), *Réceptacles*, Éditions Dapper, Paris, 1997, pp. 141–85.

Notué, Jean-Paul, 'Arts du Grassland', in Christiane Falgayrettes-Leveau (ed.), *Arts d'Afrique*, Musée Dapper and Éditions Gallimard, Paris, 2000, pp. 208–31.

Notué, Jean-Paul, 'Forms, Functions and Meanings of the Cultural Objects from the Royal Palace of Mankon', in Jean-Paul Notué and Bianca Triaca, *The Treasure of the Mankon Kingdom. Cultural Objects of the Royal Palace*, Les Cahiers de l'IFA, COE/IFA, Mbalmayo and Milan, 2000 (with the support of the European Commission), pp. 42–80.

Notué, Jean-Paul, 'Initiation à la culture artistique générale et connaissance des arts et cultures du Cameroun et du Grasslands', training course for curators of the museums and artistic and cultural heritage, COE and IFA, Mbalmayo, 2001, unpublished.

Notué, Jean-Paul, 'Parures de tête du Grasslands', in Christiane Falgayrettes-Leveau and Iris Hahner (eds.), *Parures de tête*, Éditions Dapper, Paris, 2003, pp. 263–98.

Notué, Jean-Paul and Triaca Bianca, *The Treasure of the Mankon Kingdom. Cultural Objects of the Royal Palace*, Les Cahiers de l'IFA, COE/IFA, Mbalmayo and Milan, 2000 (with the support of the European Commission).

Perrois, Louis and Jean-Paul Notué, 'Arts et cultures du Grasslands camerounais', in Louis Perrois (ed.), *Legs Pierre Harter, les rois sculpteurs, art et pouvoir dans le Grasslands camerounais*, Éditions Musee National des Arts d'Afrique et de Oceanie and Réunion des Musées Nationaux, Paris, 1993, pp. 31–91.

Perrois, Louis and Jean-Paul Notué, *Rois et sculpteurs de l'Ouest-Cameroun. La panthère et la mygale*, Karthala, Paris, and ORSTOM, Paris, 1997.

Rowlands, Michael, 'Notes on the Material Symbolism of Grassfields Palaces' in *Paideuma 31*, Wiesbaden, Franz Steiner Verlag, 1985, pp. 203–15.

Warnier, Jean-Pierre, *Échanges, développement et hiérarchies dans le Bamenda pré-colonial*, Franz Steiner Verlag, Wiesbaden and Stuttgart, 1985.

Zintgraff, Eugen, *Nord-Kamerun*, Verlag von Gebrüder Paetel, Berlin, 1895.

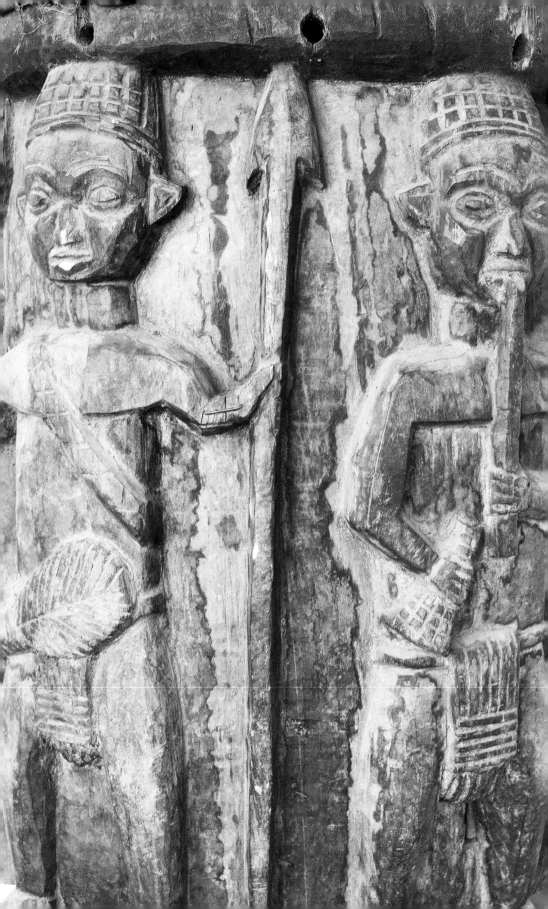

Artists in Babungo

Protus Bofua and Julius Ndifor, curators of Babungo Museum

Introduction

Owing to the great interest shown by many of our visitors, as well as by scholars, in the artists of Babungo, we have decided to finally put something in writing which we hope will help to answer at least some of the many questions asked. Here, we have tried to write about the artists in Babungo in general before dividing them into the two categories of former and present-day artists. Mention is made of the lifestyle of some of the artists and how they learnt their trade and specializations. In this essay we have also tried, as far as possible, to separate the artists into sculptors and smiths. Almost two-thirds of the information obtained in the field regards present-day artists and one-third deceased ones. The present-day Babungo artists who excel in woodwork or carving include Simbo Njinuh, Ndifua Ngow, Amadou Ngow, Songwe Emmanuel and Tah Wembai, to name just a few. Their work differs from that of the carvers of the past like Saingi II, Nyifuan, Sake II, Nchia Kumeghee, Simbo Melang and King Zofoa II in terms of style, aesthetics, motifs and materials used. Traditionally, although not consistently, artistic creation is linked to the historical and socio-cultural context and is influenced by a number of other elements, such as artists, patronage, the techniques and tools used, the clientele and the market. The techniques vary according to the periods; wood sculpture occupies a position of prime importance in the plastic arts in Babungo. Informants believe that artistic creation was handed down from their ancestors and that artists were inspired by the objects they

saw, which dated from some centuries back, although today we only have copies of them. Most frequently, traditional Babungo art is hereditary, with the younger generations inheriting the art from their forefathers and relatives. There are now fewer artists in Babungo than there were in the past because young people are no longer interested in creative work because they believe it does not allow them to earn money quickly. It should be noted that, at first, artists produced objects mainly for the love of art: certain items, such as ritual paraphernalia and ceremonial objects, were made on commission and were not publicly bartered or sold, but today everything has a purely economic function. Babungo artists also excel in iron smelting and blacksmithing from which they produce highly valued objects: primarily they are the custodians of tradition. Finkwi, Finteng, Ibia and Mbungwi are important areas as regards blacksmithing and sculpturing. According to informants, the royal family was gifted in iron smelting. During the nineteenth century, when blacksmithing was at its height, the smiths obtained the iron they needed for the production of valuable cultural objects (gongs, spears and knives) from the royal family members who had created more smelting workshops by this time, the most important being that of the palace. The smiths are those who have the greatest control over the *ngumba* of the palace. Considered to be its 'fathers', the smiths produce most of the objects used by the *ngumba* society. It is they who announce the celebration of the deaths of princes and princesses before any further action is undertaken.

Drum (*nkia yisan*), detail (cat. 39)

fig. 22. Forge at Finkwi

Apprenticeship

Most Babungo artists have trained younger artists who are either their own children or those of their relatives. In order to allow the sculptures to survive, it was necessary to attempt to avoid the use of poor-quality wood by the artists. To this end, a parallel study of contemporary artists was undertaken that indicated the evolution of new techniques to allow new sources of wood, iron and textiles to be used. The artist's workshop was a simple shelter constructed from two rectangular bamboo frames supported on a base of wooden stumps and thatched with roofing grass. Workshops were built in one general form, but in different sizes according to the size of the potential workforce. However, even the largest workshop required less than a quarter of the labour necessary to build a dwelling-house.

Young people learnt carving between the ages of ten and sixteen and an artist's son might also learn in his father's workshop or that of an unrelated neighbour. Most elderly artists claimed that no one ever paid anything to learn carving, the consensus being that a master artist who had learnt the skill and paid nothing for it should not make a profit out of teaching someone else, even the son of an unrelated artist. This explains the unstructured nature of the training and meant that, if space was available, any youth who was keen to learn might attach himself to a master to learn the craft. The benefit to the master artist in taking on an apprentice consisted mainly in the fact that the latter performed such physically demanding tasks as cutting down the tree, dividing it in to sizeable logs, cutting it into the required shape and bringing it to the workshop. The apprentice was also the one who took the finished products to the market.

Thus the process of learning to carve was very informal: a youth was told simply to sit and watch, perhaps after transporting the log to the workshop, for a considerable period of time before he was invited to attempt to carve. Eventually he would be given a small piece of wood to work on and encouraged to make a small item, such as a

statue or a simple stool. The first products of the apprentice were his to keep, sell or give away. A youth who was keen and hardworking might be given a small sum of cowries to spend in the market. Gradually he would progress from making simple statues to masks and then musical instruments and walking-sticks. After the youth has spent a period of some years working daily in the artist's workshop and adequate skills had been acquired, his apprenticeship was considered to have come to an end. No special ritual or ceremony took place and the youth simply continued to work in the artist's workshop. The developing relationship between master and apprentice was characterized by the gradual acquisition of skills by the latter over a long period of time, with the concurrent gradual increase in contribution of his labour to the benefit of his master. This situation then changed so that an individual working in the workshop and indebted to his master for the use of the workshop and his equipment compensated him by working on his behalf on days set aside for this purpose. According to information obtained in the field, this might continue indefinitely until the apprentice decided to move, for whatever reason, and work in another workshop or gathered the necessary resources to meet the cost of establishing his own workshop. This was opened with the help of his master, who was then considered to be its patron. In some cases the master provided some of the raw materials and tools that his former apprentice would then use. An apprentice who had learnt in his father's workshop also had this option, but, in any case, he would eventually succeed to his father's position and premises.

Organization of the Work

In the pre-colonial period, artists worked six days out of the eight-day week, resting only on the country Sabbath days (*nkusee*). On the market days they worked for half a day so they could take the piece they had been working on during the week to the market if had not been specially ordered, or if the order had not been collected. Those who had commissioned the work would come and collect their objects from the workshop, or wait for them in the market. Four of these days were set aside for work on behalf of the master; on some of these days the master would allow the others to continue working while he provided a weekly payment, usually called *njangi*. He provided material, and also food and raffia wine, for the workers, who offered their labour in return for the use of the workshop and its equipment on other occasions. If a client or customer commissioned the master to produce a piece, more time was set aside for this work. In addition to providing food and wine for his workers, the master artist would give them some cowries and also provide meat for them to take home for their wives, but he took all revenues from the sale of the commissioned items. In some cases where the master was very kind to his apprentice and the latter was fast at learning his trade, then the master could obtain a wife for him if he was not already married.

Where and How Working Materials Were Obtained

On the days set aside for working for his master, the young artist provided material input. In the case of a master smith, he provided charcoal, whereas for a sculptor he provided wood. On other days, some artists would all contribute cowries to a central pool, which the master used to buy wood, or else one artist would buy materials for one week and the next week another would buy them. This wood was bought from people who had it in their compounds, while the master provided all the tools and equipment in the workshop. As for the sculptors, they worked either in the workshop or in the bush, where they could get raw materials. In the latter case, they would just do light work on these material and then take them to their compounds for finishing.

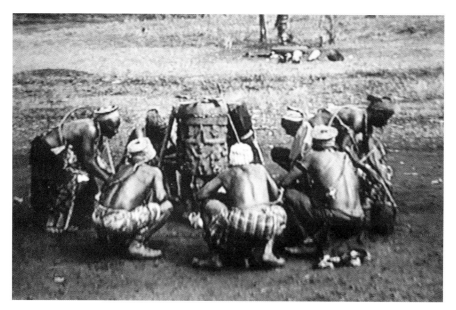

fig. 23. *Nikai* dance, female drum carved by the artist Simbo Melang

Some Deceased Artists with their Specializations

Simbo Melang (cat. 10, 18, 29, 67, 68)
Simbo Melang was the son of Tifuanseh, who left their compound with his brother Kometa Sake. As soon as he had graduated from the regulatory society, he built a house in Finteng during the reign of King Saingi II. Simbo's job was carving and hunting; eventually he was invited by Saingi II to join him in carving long drums and gongs for the *nintai* dance.

Because of his skill, after a long time spent carving with the king, he also carved a long gong for the *juju* (pidgin English name of a customary society which uses masks) of his father, Tifuanseh. The long gong is the most resonant one now used for Tifuanseh's juju (*mekomeh-kwing*). He was also a specialist in carving statues and some of the statues commemorating and retainers; for example, he carved cat. 18 in the Babungo Museum, which is usually displayed during the enthronement of new kings and annual dances. He also worked with King Sake II and trained many other carvers, such as Simbo Kosho and even King Zofoa II.

King Saingi II (cat. 16, 20, 77)
Saingi II, who was the twenty-second king in the Babungo dynasty, is one of the oldest kings to rule for a long period; he had many wives and children and was friendly man. He reformed Babungo in terms of arts and culture: it was during his reign that the first white man visited Babungo in the person of Dr. Zintgraff. He was a carver by profession and a hunter: his works can also be seen in the palace today and in the Babungo Museum, for example perhaps the *munkuncho* mask (cat. 16) used for enthronement and the commemorative statue of a queen (*nah* Yagisi, cat. 20).

He trained many of his children in carving and hunting—for example, Tiwambi, who died in 2002, was a noted carver, while Tinjofuan was a well-known hunter and some of his great-grandchildren are carvers today.

King Sake II (cat. 7, 17, 21, 22, 43, 56, 63, 66, 73)

After Saingi II died, Sake II, who had been educated by the Germans, became king, according to the wishes of his father. Before he became king, he was a lay preacher with the then Basel mission and, when he was made king, he resigned his post because it was not compatible with his royal duties. As king, he practised carving and farming; schools and churches were built in the kingdom during his reign. Altogether he had sixty-five sons and daughters and forty-five wives; he was also a good hunter and was one of the native court presidents at Ndop. Most of his sculptural works can be seen today in museums and in the palaces of many kingdoms in the North-West and even beyond. He carved statues and musical instruments, as may be seen in cat. 7, 22 and 43.

Simbo Kosho (cat. 9, 11)

Simbo Kosho, who died in 1961 at about seventy-six, was a great carver. Informants said that Simbo Kosho was a short fat man and, because of this, he was nicknamed 'short drum' (*kungte nkia*). He had worked with King Sake II and Zofoa II before his death and was a specialist in long drums and gongs. He is remembered today because his drums have some of the best sounds. He learnt carving from Simbo Melang, with whom he worked in the palace, and it was he who taught King Zofoa carving. Some of his carvings are found in the Babungo Museum—for example, cat. 9 and 11.

Nchia Kumeghe (cat. 2, 30, 74)

Nchia Kumeghe is one of the renowned artists, weavers and architects of his day. According to my informants, he died in 1966 at the age of 103, still an active carver. He left his nephew Wembai, who today is a master artist specializing only in musical instruments, especially drums. In the field of carving, his artistic works were regarded as being the best in the community following his specialization in stools, door frames, drums and wooden long gongs. His woven caps were the best and the most durable. During the reign of kings Saingi II and Sake II and during the early years of the reign of King Zofoa II he worked in the palace, where he trained most of the artists and weavers who were also working there. They made most of the venerated statues that were kept in the Babungo Palace, some of which can now be seen in the Babungo Museum.

King Zofoa II (cat. 25, 32, 37, 38, 52, 53, 54, 58, 59, 76)

King Zofoa II, who was the twenty-fourth king in the Babungo dynasty, is one of the greatest and most famous carvers in the kingdom. The son of King Sake II, he became king in 1955 and ruled for forty-four years and, during this time, his main occupation was carving, although sometimes he went hunting. He married more wives than any king who had ruled in Babungo and because of this he fathered many children. His learnt the carver's craft as a result of working with his father Sake II in his workshop, together with other carvers like Nchia Kumeghe and Simbo Melang. According to our informants, he was a king and an outstanding carver, as can be seen from his works and the number of apprentices he had in his workshop. He also represented Cameroon in many cultural festivals, both in the country and abroad: for instance, in 1977 he took part in the cultural festival that was organized in Nigeria. During his visits, he availed himself of the opportunity to copy some of the different styles that can be seen represented in some of his objects. Most of his retainers—for example, Ndifua Ngow, Simbo Njinuh and Amadou Ngow—learnt to carve from him. The reputation of the carver King Zofoa II grew to the extent that many royal collections, both near and far (Mankon, Bafut, most chiefdoms in Ngoketunjia Division and also in the National

Museum in Yaoundé) had at least one of his works of art, or a copy with modifications. He used to work in the palace workshop, but, at times, worked in the bush due to the fact that the species of wood he was using was difficult to transport to the palace. Some of his objects are found in the Babungo Museum (for instance, cat. 25, 32, 37, 38, 52, etc.).

Deceased Smiths and their Specializations
Apart from those artists who used wood in order to produce objects, there were others who also used iron in the production of valuable objects associated with ceremonial and ritual activities. According to the legend of the origins of forging in Babungo, Songuh, one of the most senior smiths, only used stone tools and a pair of bellows at his original settlement site a short distance from the palace. The introduction of iron tools is attributed to a mythical ancestor of Fuambui who fell from the sky with an iron hammer; Songuh and Fuambui then joined forces to form the family of the smiths. After this they taught seven others and so formed a group of nine smiths whose descendants now constitute the *voutueyoe*, the senior council of smiths, to which other smiths are obliged to make considerable payments and gifts if they want to set up their own place of work. They were specialized in making objects mainly for domestic use (cutlasses, hoes, gongs, swords and knives). Most of the objects found all over the kingdoms were made by them. It should be noted here that the first smiths produced their own iron in the traditional way, using it to make the tools mentioned above. This iron was harder than the iron imported at present; samples of this local iron can still be found in Babungo today, but are very scarce.

Living Artists and Smiths in Babungo
Some of the most outstanding living artists in Babungo today include: sculptors, such as Simbo Njinuh, Komboyoh, Ndifua Ngow, Amadou Ngow, Songwe Emmanuel, Tita

Sonjong and Tah Wembai; and smiths, such as Fuambui, Songuh, Tata Fuain and Tih Ndula Mbobo. They learned their art either from their father or from a relative with whom they grew up. The works of carvers like Amadou Ngow, Simbo Njinuh, Songwe Emmanuel and Ndifua Ngow are now found in the Babungo Palace, while some are in the Babungo Museum. As for the smiths, there are gongs to be found in the museum that are made by the smiths, although their identities are uncertain. The specializations of these artists are outlined below.

Carvers and their Specializations
Simbo Njinuh, Ndifua Ngow, Amadou Ngow Komboyoh and Songwe Emmanuel (cat. 5, 6, 14, 26, 27, 31, 36, 42–50, 51, 57, 62, 70, 71, 72)
All the above-named sculptors were born between 1950 and 1965. Between the ages of ten and fifteen they were recruited as young retainers or members into the regulatory societies, with an exception of Songwe Emmanuel, who was a prince. After a period as recruits they were selected as young retainers of King Zofoa II; when they had been initiated as full retainers, they always remained by the king even when he was carving. When the king saw that they were hardworking and interested in artistic work, he had them trained by an elderly and very skilled carver called Dih-Kebeng. With the help of Dih-Kebeng, these artists matured until the king saw that they were ready to be professional carvers. Zofoa II had them work for him and, because they were retainers, everything that they carved belonged to the king. In order to compensate for this, he gave them allowances for their needs. When these artists grew to a certain age and got married, they left the palace to set up their own homes; it was only then that they could find the time to produce objects that they could sell as their own, otherwise all their time was dedicated to working for the king. Most of their works are today

very important in Babungo, especially the masks, dance costumes, thrones and trumpets. Those who fortunate enough to visit the homes of all these artists will see what they are producing today, or what they produced in the past and did not take to the palace or sell. As they were always working with the king they were all specialized in the same fields. Today they produce such objects as masks, stools, statues, standing drums, long gongs, trumpets, and thrones. It should also be noted here that, when some of these artists were about to leave the palace to go to live on their own, the king would provide them with wives.

Tah Wembai

Tah Wembai, formally known as Nchinda Nchia and now about eighty years old, grew up beside his grandfather Nchia Kumeghe. According to oral information, he started learning to carve at the age of eleven before leaving his grandfather to be initiated into the *ngumba* society. After serving in the *ngumba,* he returned to stay with Nchia, with whom he increased his experience in carving. His grandfather was working with another carver called Simbo Melang and it is thanks to these two people that he learned the craft. Tah Wembai says, in fact, that his grandfather forced him to learn the craft. At that time it required about four people to skin a single drum but, thanks to more advanced technology, he can now skin a drum alone in less than an hour. Though he has children who are old enough to learn the craft, none of them is ready to do it and he does not wish to oblige any of them to do so. They all prefer white-collar jobs or jobs where they are paid as soon as they finish without having to wait for customers. He is one of the most renowned artists in Babungo and has a lot of connections with the outside world, although he never needs to find customers for his products; this is because he carves well using good-quality wood. Although absent from the

Babungo Palace, his works are owned by many secret societies in Babungo and are also found in museums all over the world, especially in Britain. He continues to work today and is specialized in drums, making all models, and harps (*ndoe-nti*). Some of his works may be seen his small but well-stocked gallery.

Tita Sonjong

Born in 1970, Tita Sonjong was the son of the quarter head of Finkwi; one of the biggest quarters in Babungo, this was noted for forging and carving. He attended primary school in Babungo until 1982, before leaving to continue his secondary studies outside the kingdom. According to our informants, he never actually learnt the trade from anybody, but, when he was at primary school, he used to sit by one of his late brothers, Ndula Godlove, and Pa Saingui whenever they were carving. Thus, after finishing secondary school, he went to the University of Yaoundé I. He succeeded his father as quarter head 1987, when his father. He completed his education in 1992, during the presidential elections, and, with the experience he gained from the above-mentioned people, he was able to carve a small stool. On this object—although it was not particularly well made—he inscribed the names of all the political parties that were taking part in the elections. When his elder brother died, he continued to use the experience that he had acquired from him; and, whenever he made something, he showed it to a more experienced carver—such as Augustine Saingui, Tumenta Ngowmbena or Behvetoh—who was able to correct the mistakes he had made. When he realized that these people understood that he wanted to learn the trade and so always sent him away, he gave them an order for some objects bought them a jug of raffia wine and, with this, sat by them with the idea of encouraging them to work, but only he knew what it was all about. Thus he only had to pay for the wine and the orders he made, but not to learn

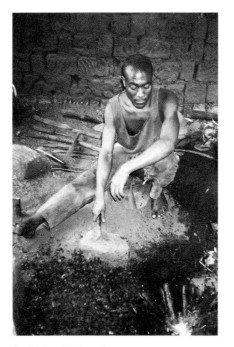

fig. 24. A smith at work

how to carve. The sculptor also says he does not really have a workshop, but mainly works where he sees raw materials; in particular, he does not usually work in the compound because he finds it difficult to concentrate due to the fact that, as he is quarter head, people are always coming to see him about matters concerning the quarter. All the materials that he uses in his work are made at the local blacksmith's forge. He can take a day to sculpt a small stool, but, for a bigger one, he may need two or more days. Most of his objects are sold locally and are mostly made to order. As did not learn the art from anyone specialized in one particular thing, he himself lacks a specialization.

Smiths and their Specializations

Tih Fuambui

According to the oral history of Babungo—and of the smiths, in particular—Fuambui's ancestor fell from the sky with a sledgehammer in his hands. Part of the sledgehammer is still kept in Fuambui's compound and is worshipped by the smiths as they perform rituals on it. Aged about fifty-two, Fuambui Ndula is a smith who, from early childhood, started going to the forge. This is because his late father was always there and he used to ask him to take him inside to see how the work was carried out there. Today he is a retailer of implements and is specialized in making small knives and cutlasses. Fuambui also helps the smiths when they encounter problems and offers yearly sacrifices to their ancestors on their behalf. In fact, he is the most important master smith in the whole village. Visitors to Fuambui's compound can see some of the old materials that were used by the artists of the past. His works are not in the museum, but are found all over Babungo and elsewhere. The works of the smiths, like those by Fuambui, their master, are not found in the palace because apparently the smiths inherited a dispute with the

palace from their forefathers, although they are not ready to explain it.

Songuh

Songuh, who is aged about fifty, succeeded his father in this craft. His ancestor with the same name is believed to have appeared from an unknown place with a pair of bellows and later joined Fuambui's ancestor, and they both started the art of forging in Babungo. The present Songuh, who learnt iron working from his late father, still continues to produce implements such as cutlasses, spears and knives. He is also a trader in some of the implements he makes and in some that he buys. Songuh also offers sacrifices to his ancestors, as it is generally believed that they started the art of iron working. He is also highly respected by the smiths and takes part when one of them is about to become a master smith. He has assistants in his own workshop and, in order to ensure that the art continues, he encourages people, especially his children and family members, to learn the art.

Tata Fuain

Aged about sixty-three, he is the son of the late Fuain who was a master smith noted for the production of special kitchen knives and heavy objects like axes. When Tata Fuain's father died and he succeeded him, he continued smelting and today he produces axes, digging axes, traps and so on. He has one of the biggest workshops that still exist in Babungo and he also encourages his male children to learn the art. Some of his tools—a sledgehammer and bellows—are shown in pictures that are found in the museum.

Tita Tih (Ndula Mboboh)

Tita Tih, formerly called Ndula Mboboh, succeeded his late father whose main profession was iron working. Now aged about seventy-six, he started iron working as an apprentice with his father and began by pumping the bel-lows at the age of about ten. He soon proceeded to making small needles, knives, pins and other small items. He did all this with the help of his father and, when the objects were ready, his father sold them and sometimes gave him part of the proceeds so as to encourage him to work. In addition, his father gave him all the raw materials he needed. As he grew up, he started to produce other more complex implements. Thus, before his father died, he had learnt the art so that he was able to succeed him. Today he is specialized in making traditional cutlasses and special double gongs (fengeng). He has also encouraged his children to learn the art of iron working and some are already master smiths. He is a notable to whom writers such as the anthropologist Ian Fowler have referred.

Comparison between the Former and Present Artists and Craftspeople

Generally speaking, compared with past centuries, there has been an enormous increase in the output of sculptors and iron workers in Babungo. Pottery, on the other hand, which used to be one of the most popular crafts, has declined and there are now no major craftspeople in the kingdom working in this field. This is due to a lack of resources and the unwillingness of young people to learn this art. On the contrary, sculpting and iron working have expanded due to the fact that adequate raw materials are available and there is a larger market for the products, which means higher prices can be charged. In the past people were not interested in these arts from a purely economic point of view because prices were too low and demand was limited.

A critical look at the arts of the Babungo in the past reveals that the people did not produce objects for sale, but because of their love for art. This means that they only produced and stored them in their homes, or else they gave them to visitors as gifts, especially to whites, who kept them as souvenirs.

At first these objects were used as a medium of exchange, in particular for slaves or for concubines. Informants therefore say that centuries ago there were few people who produced objects only to sell, whereas nowadays very few make objects for the love of art in Babungo. Most, if not all, artists in Babungo today produce objects only to sell and earn a living. Many only make objects to order, meaning that, if they do not receive any orders, then they are not ready to produce as, if there is no demand, they will not be able to feed their families. Furthermore, the market for most of the Babungo artists is outside the kingdom. Very few of these artists stay in the kingdom and their products are only bought in Babungo by people who buy to retail or by foreigners who already know the artist.

The quality of the objects produced by the Babungo artists of the past were of higher quality than those made by the artists of today because they used locally made iron, which was more durable the imported metal that is used nowadays. And because they were only working for the love of art—that is, to keep for themselves or to give as gifts to friends— they produced objects in such a way that they lasted for a long time. Today, artists produce to sell and therefore do not have time to produce stronger objects because it takes more time and also due to the fact that, if the object lasts for a long time, their market will shrink. Typical examples are objects that are made of wood. Some centuries ago, only a few species of wood were used and the most renowned of the species that were used by most of the artists was the *ibukwin* (*Cordia platithyrsa*, family *Boraginaceae*), but today artists use all types of wood to produce objects. When they use a type of wood that will not last, they dye it in such a way that it will resemble the more durable species (see the essay by John-Paul Notué). Nevertheless, some artists still produce only with the long-lasting species. As a result of this the durable species are quickly being depleted because the number of artists is rapidly increasing and also because they do not replant the trees as they cut them down. A comparison of the objects made either from wood or iron by the artists of the past with those produced by contemporary artists shows that those produced in the past are harder, smoother and better shaped than those made today. This helps to explain why the old objects more valuable than the new ones; another factor is the species of wood.

The number of the objects is also very important: because the artists of the past took time to produce just a few well-made objects, their production was very limited in quantity, and the fact that they were not producing just for sale also contributed to this. On the contrary, the contemporary artist, who is only out to make money, does not feel the need to spend a lot of time on just a few objects that will only fetch a little money. Thus they produce their objects in large quantities as long as they there is a demand for them. The use of soft types of iron and wood also helps them to produce more.

Thanks to the advance in technology, new machines have been developed that can facilitate an increase in production and a change in people's mentality: thus today's artists are able to produce more than those of the past. One informant, Tah Wembai, a sculptor specialized in making all sorts of drums, said that, when he was young and learning the trade, it used to take about four people at least to skin one drum and, even before this process, it required more than three people to work on the instrument before its completion. Today he can skin a drum alone in less than an hour and can complete a small drum in a single day and a bigger one in two days. According to further information from a smith, Tata Fuain—who got the information from his father—the smith needed to go to the bush to gather materials to be heated to make iron before

he could start work. The iron that was made was stronger, but took a long time to make. Today smiths just have to buy imported iron, which is very easy to work. This improved technology and production methods have also helped to increase the number of objects produced by an individual.

The way motifs are represented on the objects is also one of the important differences between the work of the artists of the past and those of the present. In the past there were representations that could only appear on objects belonging to the palace, for example those of the lion, tiger, elephant, tortoise and lizard (see the essay by Jean-Paul Notué). Thus, if these representations were seen on an object then it was clear that it belonged to the palace, but they could not be used, for instance, on objects that were to remain in **a** compound. This distinction no longer has any importance on objects made today. All contemporary artists have in mind is to produce and market their products, so they represent motifs formerly reserved for the palace on objects that people buy as orna-ments for their homes, which was certainly not the case in the past.

Bibliography

Knöpfli, Hans, 'Craft and Technologies: Some Traditional Craftsmen of the Western Grasslands of Cameroon', British Museum Occasional Paper no. 107, Trustees of the British Museum, London, 1997, pp. 8–15.

Perrois, Louis and Jean-Paul Notué, *Rois et sculpteurs de l'Ouest-Cameroun. La panthère et la mygale,* Karthala, Paris, and ORSTOM, Paris, 1997.

Informants

Ndifuangow Abubaka, retainer and sculptor, aged 49
Njinuh Simbo, retainer and sculptor, aged about 49
Songwe Emmanuel, prince and sculptor, aged about 40
Tah Wembai, carver, aged 80
Tata Fuain, smith, aged 63
Tih Fuambui, smith, aged 52
Tita Bai, retainer since the reign of King Zofoa II until the present, aged 58
Tita Sonjong, quarter head of Finkwi and a sculptor, aged 34
Tita Tih, smith, aged 76

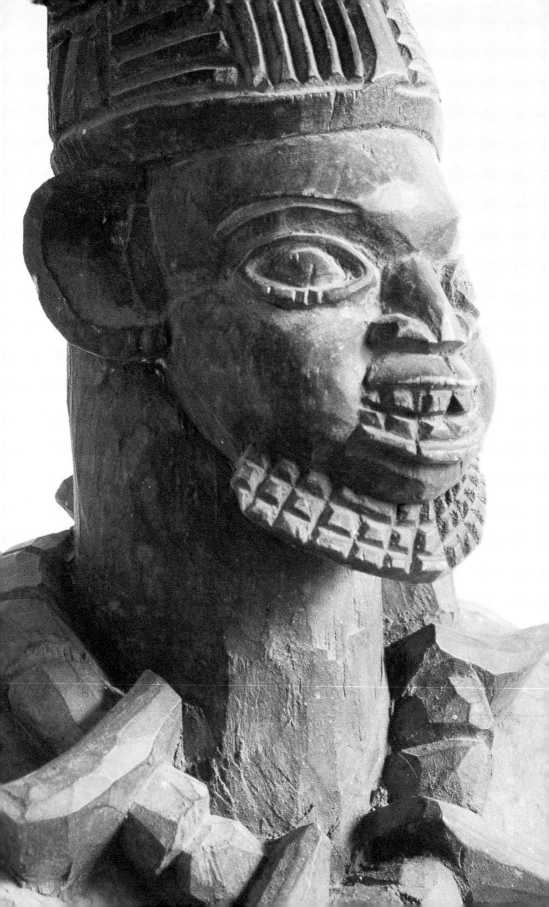

The Traditional and Socio-Political Life of Babungo

Cyvil Nangwa Nsanyui, curator of the Babungo Museum

Introduction

This essay is intended to serve as an outline of the organization of the social and political system of Babungo. It expands on some aspects of the essay in this publication by Emmanuel Nchio Minkee on the political and social structure in Babungo. The public, researchers and anyone else who wishes can refer to this essay as a guide to the socio-political organization of Babungo. My informants, Ndifuan Ngow and Tita Bai, made it clear to me that Babungo is organized into quarters and headed by a king who is the supreme commander of the kingdom. He is the leader of the social, political, economical and ritual life of the people. According to Doris Blank 1986,[1] the social and political system of Babungo is based on a patrilineal and territorial organization in quarters. A native of Babungo is first of all a member of his or her family, lineage or quarter. He or she is also often a member of one or several traditional societies (*njong, fumbweh, gah* and *tifuan*), which are an essential part of the political, social and ritual life in the kingdom.

The socio-political life of this kingdom is organized into quarters and headed by a king who works together with the regulatory societies like the *tifuan or ngumba*. Moreover, the *njong, fembweh, gah* and *nchio* are some of the most important social groups assisting the king, or *tifuan*, in the administration of the kingdom. Prominent social groups, such as the like *nintai* and *shaw* are not omitted, even though they have no political role within this community.

Socio-Political Organization

Compound Head

A compound head, *tii fu,* who has his children, brothers, sisters and wives under his authority, represents every compound. He is usually a male child of the deceased compound head, who, during his lifetime, chose him from among his male children and gave the name to the regulatory society (*tifuan*) or to a close elderly person in his lineage. If the deceased had no male child, his brother or the son of his unmarried daughter will then succeed him, or the son of his brother will sometimes be chosen. Traditionally a *tii fu* had a claim to the services and earnings of his male dependants, but, in return, was expected to assist them with their marriage payments, to buy a gun and build a house. Today, however, each member tries to be financially independent of the *tii fu*, although they still show respect to him and consult him on all important matters.[2] The *tii fu* is responsible for peace and prosperity in his compound. He prays to the gods and ancestors and performs sacrifices for the well–being of all the members of his family.

Generally, each compound head inherits his necklace, stool, cup, cap, gun, staff and traditional costume from his father or else has to buy them. All these objects are quite different from those of the king and quarter heads in terms of styles and motifs. These objects are used by the successor on the day of succession: he wears the traditional loincloth, puts on the cap and holds the staff. Then camwood is mixed on the stool and rubbed on succes-

Wooden camwood container (*yoh-bui*), detail (cat. 23)

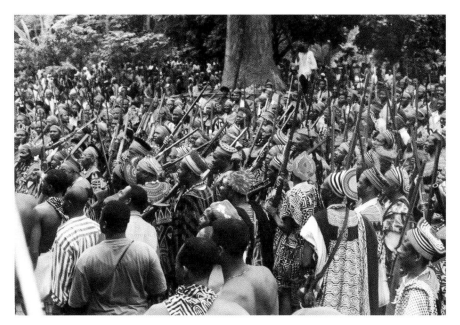

fig. 25. Babungo people

sor's body. The cup, usually a cow or buffalo horn, is used to pour libations to the gods of the compound during times of sickness and misfortunes. After the libations, every member of the compound drinks from this cup, which signifies purification. All these objects are kept in a box in a special place in the successor's room and only used by him on particular days. The compound head's stool is usually decorated with geometric motifs, most frequently with spiders in relief.

Quarter Head

In accordance with the hierarchical organization, above the compound head is the quarter head (*tii ntih*). Each quarter has one *tii ntih*, who represents the king (*fuan*) in his quarter and is assisted in his tasks by his councillors (*vetiih ngii njong*). The quarter head has the right and responsibility within his quarter to allocate land to the citizens of Babungo and to settle land, marital and other civil disputes. He is also responsible for the organization of community work (*ngong*). All quarter members are obliged to participate, for, in the event of absenteeism, the rest of the quarter community will claim some of the absentee's domestic animals, or even one belonging to his neighbour, in which case the absentee must pay for this animal. Apart from this, he formerly collected the poll tax (which no longer exists today), levies (*nswi*) and other taxes, such as contributions for the village development (leases). Traditionally, a quarter head is a descendant of one of the original immigrants from Ndobo who founded the Babungo chiefdom. However, due to the idea of development, other influential men of Babungo, as well as princes from neighbouring chiefdoms like Bamunka (for example, Tita Sonjong, the quarter head of Finkwi), who came and settled in Babungo, were appointed quarter heads and integrated into the political and social structure of the chiefdom and many others.[3]

The position of the quarter head is hereditary: all the male descendants of the quarter head are eligible for succession. If

there is no eligible male child amongst the quarter head's patrilineal descendants, the son of his unmarried sister is sometimes appointed. The new quarter head's installation comprises specific rituals and lavish ceremonies that are intended to inform the public of the successor's new status. All the quarter heads are owners of *juju*, with numerous masks and customs (see cat. 3).

Council of Seven

The council of seven consists of quarter heads and dignitaries in the regulatory society with their head, the Fuanje. Fuanje was the eldest son of Mange, who stopped and built a house at Mbenje and acted as the quarter head of that quarter (see the essay by Emmanuel Nchio Minkee). He is the speaker in the house of the regulatory society, the *tifuan*, and he is the one that wears the *munkuncho* mask (cat. 16) during enthronement. He appears with this mask on the day the new king is being presented to the entire population. All these members meet together with the *fuan* in the *tifuan* house once a week, every Sabbath day (*nkuse*), with each member having his own seat according to his rank. The *fuan* occupies the first seat, followed by the *bah* and the rest of the members. The supreme status of the members of the councils of five and seven are indicated by the title *tiighaw*, which means 'father of the spear'. During the pre-colonial period, they distributed spears to those going to the war front, although they never went there themselves because they were not allowed to see dead bodies.

Council of Five

Formed by some quarter heads and other dignitaries with sufficient financial resources to pay the initiation dues, the council of five comprises the highest rank of notables within the community. Constituting the executive power in the chiefdom, its members are known as the servants of the *tita bah*, the assis-

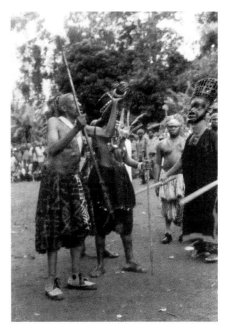

fig. 26. Enthronement ceremony of the King Ndofua Zofoa III, 1998

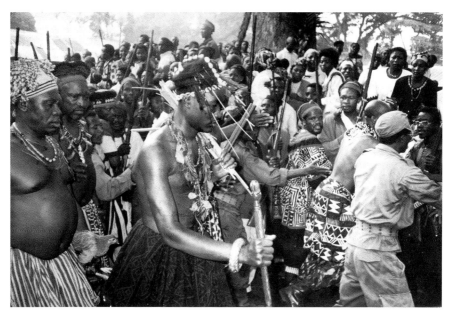

fig. 27. Enthronement ceremony of King Ndofua Zofoa III wearing the royal cap *fatoh-yikwe*

tant of the *fuan* (king), who is the kingmaker. The *tita bah* is the head of the council of five and presides over the regulatory society (*tifuan*). He is a descendant of the only child of Mange, who arrived at Ntoh-Ngineh, the first palace (see the essay by Emmanuel Nchio Minkee). He and his servants help the *fuan* to make major decisions in the kingdom in collaboration with the council of seven, which forms the legislative body of the people (*fuan* is a Babungo language form of *fon*, King).

Regulatory Society (tifuan)

The regulatory society known as the *tifuan* is the most powerful political institution in Babungo and serves to limit the powers of the *fuan* (king). The king is the head of the social, religious and political hierarchy of the Babungo kingdom. As the supreme leader of the kingdom, he has the right to various goods and services from his subjects. In particular, he has an auxiliary role in the state government, being responsible for the implemen-

tation of all the state laws in his kingdom, and he settles disputes that are above the powers of the quarter head. However, he always needs the collaboration of the regulatory society, the *tifuan*, when taking important decisions. That is why the Babungo people consider the *tifuan* to be the father of the king, the *fuan*. The *tifuan* members advise the *fuan* and take messages from the house of *tifuan* to the various quarters of the village. Since they are responsible for the execution and implementation of the political decisions taken, the only way the members of the *ngiih tifuan* can disobey or oppose the king's decisions is by not implementing or transmitting them. The king has his objects like the throne, tiger skin, staffs (cat. 4), cap (cat. 12), necklace (cat. 14 and 15), royal bed (cat. 2), royal stool (cat. 7 and 21), elephant tusks (cat. 5 and 6) and pipes (cat. 55–64), which are all symbols of power, authority and prestige. The king's objects are always decorated with special motifs that belong to him alone (see the essay by John-Paul Notué). In the

Babungo tradition, it is strictly forbidden to either touch or greet king with the hands. To greet the king you have to clap your hands three times: the first clap belongs to the land, the second to the *ngumba/tifuan* and the third to the king himself.

The *tifuan* is divided internally into various houses or societies, each having its own rights and responsibilities, fetish medicine, masks, costumes and musical instruments, which constitute the juju of the society. The most important societies are the *jaw* and the *nshay*, the two complementary groups with the most fearsome juju, which is taboo for non-members; the *guu*, which formerly had powers to judge witchcraft and other criminal cases; the *yifung*, which is a small house meant for the burial rites of the *fuan* and other dignitaries, and for sacrifices to the major gods and ancestors of Babungo.

Apart from the members of the royal family (*vang ntoh*)—that is, the descendants of the *fuan* down to the fourth generation in the case of men and the second generation in the case of women—all males are eligible for membership of the *tifuan* at about the age of eight, even though today there are males above this age who have not yet been initiated into this society. A boy at this age is generally recruited for initiation into the *tifuan* to learn the laws and doctrines of the country. He serves as *nshingi* (servant) of the *tifuan*. There are other royal servants that are *ndifuan* (see cat. 11 and 18), who are divided into two groups: the *ndifuan tambu* and the *ndifuan shubuh*.

The *ndifuan tambu* is a personal guide to the king, who goes into the interior parts of the palace while the *ndifuan shubuh* stops at the front of the palace. A member of the *tifuan* is permitted to join the houses of the *tifuan* when he has sufficient financial resources to pay the initiation dues. The only exceptions are the *vetigah tifuan,* which restricts its membership to the palace retainers (*tantoh*),[4] and the *ngii tifuan*, which opens

its ranks only to the members of the councils of five and seven (see Emmanuel Nchio's essay, p. 28). As its juju, the *tifuan* has the *mekometifuan* with numerous helmet masks (cat. 73). The *tifuan* celebrates the death of its members, the king, the queen mother, princes and princesses, as well as friendly kings from neighbouring fondoms. Traditionally a Babungo man believes that the *tifuan* is a secret *juju* that has supernatural powers.

Other Customary Societies

Njong (Samba)

There are other customary societies that have an important role in Babungo, such as the *njong*, which is organized at quarter level. The quarter community itself builds the *njong* house where they gather once every week. The *njong* is headed by the *tii ngi njong*, nominated by the quarter community. It is obligatory for all the quarter members to join and always be present at the *njong*. If any of them fails to do so, the rest of the quarter members will never help that person if he or she has any difficulties and the quarter community might put an injunction order on his or her door, which means that he or she should not visit or talk to anyone within that quarter. The *njong* helps the *tii ntih* to control and rule the community well; it is in this *njong* house that the *tii ngi njong* transmits information coming from the *tii ntih* to the entire quarter community, and also decides upon how to implement decisions taken by the *tifuan*. Furthermore, it takes action if a quarter member refuses to participate in community work. In such a case, the other quarter members will take any domestic animal of the recalcitrant person, especially a fowl or goat, and if there are none, they will catch one of the neighbour's animals and the offender will be responsible for any charge imposed by the owner. It is understood that it is obligatory for all the quarter members to be present at this *njong* house each week so

as to air their points of view and also to receive information regarding the entire village. Every *njong* house has its musical instruments (double gong, long drum, female drum) that are played on every meeting day; the double gong is used particularly for communication during community work.

Fèmbwêh

Membership of this society is open only to women and the owner of the *fèmbwêh* (*tiih fèmbwêh*). The women themselves are proud of their indispensable role in the economic life of the communityand their importance as food producers and child bearers is recognized by the rest of the population. This becomes clear when we look at this society, the *fèmbwêh*, the only women's society with political and ritual functions. There are several *fèmbwêh* groups in Babungo, each belonging to one family or lineage. Any woman, apart from the *fuans*' wives (queens), can become a member by paying a small fee and performing particular rituals. The *fèmbwêh* has it own instruments (*wee fèmbwêh*), which are generally taboo for men and nonmembers. When the *fèmbwêh* is invited to celebrate the death of a woman, these instruments are played on certain days and during the night. The *fèmbwêh* celebrates the deaths of all women and the owner, who is usually a compound head.

The *fèmbwêh* also takes action when a woman of a quarter refuses to participate in community work. In such a case, the members hasten to the compound of that particular woman the following night, enter the rooms with frightening howling and noises and remove the pots, pans and other things, which are taken to the palace where the case is judged. On their way to a funeral ceremony, or any other destination, the members of the *fèmbwêh* carry their instruments in a special bag (*mba fèmbwêh*), which is identified by a small branch of a particular tree. This branch is the injunction of the *fèmb-

wêh*: men and non-members have to flee from it, and when the injunction is put at the door of a house, it is strictly forbidden to enter it. The fact that someone does not flee from such a society is itself a challenge to its members. If *fèmbwêh* has been offended, their members will put the injunction at the entrance of the compound of the culprit, who will then be punished by the *tifuan*.

Gah

In every quarter of Babungo there is the *gah*, a secret society headed by the quarter head with a group of executives called *vetufong* (a council that is responsible for peace, settling land disputes and other social and economic problems of the quarter). The *gah* has auxiliaries who are mostly youths aged between fifteen and twenty-five. They are message bearers to the *gah* and even the quarter head; when carrying messages, they are either disguised or have their normal appearance. These youths are divided into two categories depending on their ages: the group of youths aged fifteen to twenty-five is called the *ngwa suuto*, while the group of young people aged ten to fifteen is known as the *ngwa wee-gah*. Both groups are subjects to the *gah* and the *njong* of the quarter. Whenever there is communal work in a quarter, these youth groups (both the *ngwa suuto* and the *ngwa wee-gah*) play an important role: they go from door to door to motivate or drive people out of their homes to the community work site, wherever it may be. The *gah* has it own instruments, which are taboo for women and non-members.

Nchio

'Nchio' is a title conferred on the king's mother meaning means 'mother of the people'. According to Babungo tradition, when a king dies and a new king is installed, his mother will be named 'nchio'. The *nchio* has her compound built by her son, the king, or by any of her children in the palace or outside it. When a *nchio* stays in the palace,

fig. 28. Funeral ceremony (mourning the lost of the king Zofoa II)

she is responsible for the well-being of the people, in particular, that of the queens, princes and princesses. She resolves minor disputes amongst the royal family, educates and trains the king's new wives and she receives leases and part of the bride-price of the princesses. None of these rights is conferred on a queen mother, however, while the deceased king's mother is still alive: the new queen mother is not called 'nchio' until the late king's mother dies. The nchio's throne and many other objects are used by her alone. Her position is higher than any other notable in the Babungo kingdom. Her death celebrations are the same as those of the king and take nine days. Normally, after her death, her daughter succeeds her for the first generation and one of her daughter's male children for the second generation. But, if she has no female child, a male child can succeed her. Many nchio exist in Babungo, but not all of them receive the same honours as the nchio whose son is the present king. All the nchio are

buried in tombs and annual sacrifices and rituals are performed on their tombs.

Organigram of the Socio-Political Organization of Babungo

Other Social Activities
Shaw
This is a royal dance group for the queens and elderly princesses. The *shaw* dance celebrates the death of the king, the king's assistant, queens, princes, princesses and other royal family members. Their musical instruments comprise a long drum, a single and double gong, a rattle and maracas; in addition there is the branch of a decorated tree, which was introduced to this dance by King Sake II thus to make it more attractive. The *shaw* dance has its secret executive called 'the mother of the *shaw*'. The king nominates the queen who is the head of this executive on the basis of her honesty and administrative and singing ability. The *shaw* also dances during the annual rituals of the kingdom.

Nintai

The *nintai* is a society of the princes. Its costumes are made from raffia fibres and coloured red. Its musical instruments are a long gong and a small one with two long drums.

The *nintai* celebrates the death of the fon's wives, princes, princesses and some high-ranking notables, such as the *tita bah*, the *tita nswi* and the *tita fuanje*. This group has its mother (*nshu nintai*) and its father (*fuan nintai*). The *nshu nintai* is a secret society of the *nintai* group that only celebrates the death of the king, the queen mother and its members. This society has only three members (the *tita nswi*, the *tah mombo* and the *tahlaw*) and membership is hereditary. In addition to these members, there is a fourth person, a prince who does not enter this house. The *fuan nintai* is a single person who appears during the death celebration of the king and the annual rituals of the fondom (*tifung*). His costumes and helmet mask have a more beautiful design than that of the other *nintai* dancers. He dances wearing shoes and always carries two spears in his hands.

Traditional Marriage of a Princess in Babungo

In Babungo, marriage is a union between a man and a woman (or more than one woman) to form a family. It is a great honour for a Babungo man to marry a princess: a princess is given in marriage by the king without the consent of the princess and the mother. The king can, at a certain point, offer a princess to any man he wishes or to another king, or he can give a princess in marriage when requested by a man.

If a man asks to marry a princess, he can send friends or relatives to the king begging for *corn-fufu*, which means asking for a wife. They will be warmly welcomed by the king, who asks them to go and prepare the palace bag (*mbaa ntoh*), which means the princess's bride-price. The amount of the bride-price is not revealed to the man who

wants to marry the princess: the man needs to come with this bride-price as many times as possible before the king will finally accept him as a husband for his daughter.

When the king is satisfied with the bride-price, he will fix a day when the princess is to be taken to her husband's compound. The king will call the husband, or send retainers to inform the husband of the following items he needs to buy for the preparation of the marriage: the princess's husband has to buy a hundred litres of palm oil of which sixty litres will be sent to the king and twenty to the queens, and twenty litres will be set aside for the preparation of the marriage meal. This palm oil is bought with one large cow that has to be slaughtered, with one leg being sent to the king.

When all these things are ready, the king orders his retainers to take the princess to her husband's house in the night, together with some queens and a group of musicians (*ndow vangfeh*). Since the princess is being taken to the husband's compound in the night, the escort uses a bamboo light as their lamp for which the princess's husband has to pay when they arrive at his house before the bamboo light is put out, and he also has to pay for his wife to enter his room.

The escort has to stay with the princess in her new house for three days, when heavy feasting takes place. During this period the husband is forbidden from seeing his wife until the last day, when he has to pay those taking care of his wife before he is allowed to see her. Every morning for the three days of feasting, the princess is woken up by the group of musicians playing flutes (*toole*) and a long drum.

At the end of the three days of feasting the princess becomes the wife of her husband. She now lives with her husband for life and has authority over all her husband's property. If the husband has another wife, the princess is in charge of the family in all cases and, even when her husband dies, it is her son that will be the successor.

Notes
[1] D. Blank, 1989.
[2] Ibid.
[3] Ibid.
[4] A *tantoh* is a hereditary title from the *tifuan* society. He is the organizing secretary in the house of *tifuan*. This title, which is a borrowed word from Kom, is selected by the king and other *tifuan* elders. Including the *nchinda* (*nshingi*).

Bibliography
Blank, Doris, *The Modern Elite and Traditional Titles in Babungo (Cameroon)*, Baessler-Archiv 37, 1989, pp. 295–313. The Babungo palace has a copy or another version of this text.
Nothern, Tamara, *The Sign of the Leopard: Beaded Art of Cameroon*, University of Connecticut, Storrs, 1975. Notué, Jean-Paul, 'Forms, Functions and Meanings of the Cultural Objects from the Royal Palace of Mankon', in Jean-Paul Notué and Bianca Triaca, *The Treasure of the Mankon Kingdom. Cultural Objects of the Royal Palace*, Les Cahiers de l'IFA, COE/IFA, Mbalmayo and Milan, 2000 (with the contribution of the European Commission), pp 42–80.
Notué, Jean-Paul, 'Initiation à la culture artistique générale et connaissance des arts et cultures du Cameroun et du Grassland', training course for curators of the museums and artistic and cultural heritage, COE/IFA, Mbalmayo, 2001, unpublished.
Notué, Jean-Paul and Bianca Triaca, *The Treasure of the Mankon Kingdom. Cultural Objects of the Royal Palace*, Les Cahiers de l'IFA, COE-IFA, Mbalmayo and Milan, 2000 (with the contribution of the European Commission).
Perrois, Louis and Jean-Paul Notué, *Rois et sculpteurs de l'Ouest-Cameroun. La panthère et la mygale*, Karthala, Paris, and ORSTOM, Paris, 1997.
Simo, John Mope, 'Royal Wives in the Ndop Plain', in *Canadian Journal of African Studies*, 25 (3), pp. 418–31.

Informants
Nah Fumeh, queen, aged 70
Nchio Minke Emmanuel, aged 65
Ndifua Ngow Abubaka, retainer, artist, aged 49
Ndofoa Zofoa Abubaka III, king, aged 29
Sake Daniel, prince, aged 45
Tita Bai, retainer, aged 58

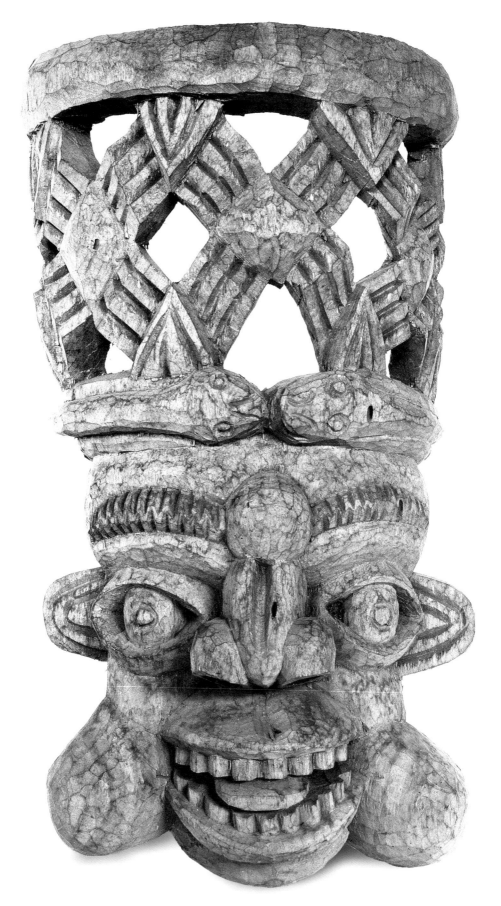

The Traditional Religion of the Babungo Kingdom

Lawrence Mbowoh, curator of the Babungo Museum

Introduction

As many of the visitors to Babungo and those interested in its culture tend increasingly to ask questions about the religion and modes of worship of the Babungo people, we have thought it appropriate to put together some written information to guide them. This chapter dealing with the religious aspects of the kingdom of Babungo describes the different denominations in the kingdom and, in particular, how the people keep their traditions: the religion is embedded in the rituals men or women perform. It also relates how some of the gods were created and how they are linked to the ancestors. Mention is also made of the relationship between the gods of the kingdom and those of the various quarters that go to make it up. A case study is also made on the rituals of Finteng, one of the quarters of the kingdom. From a study of the behaviour of the people of Babungo, one can say that men and women worship in variety of different ways. These include the traditional religion, the most popular belief, Christianity of different denominations (Catholic, Presbyterian, Baptist, Full Gospel Mission) and the Islamic faith. There are many people who practise both traditional religion and Christianity: forming almost three-quarters of the Christian population of Babungo, they believe that the two are quite compatible. This is seen in the behaviour of Petro, the Basel mission catechist.[1] After abandoning his post as teacher and catechist, he became king as Sake II, taking up the traditional rites. The Hausa and Mbororos living in the kingdom, and a number of other citizens

who were attracted to it, practise the Muslim faith. One can say that traditional religion is the most highly practised faith in the kingdom, as will be seen in the following analysis below, although, at present, their percentages cannot be estimated.

Traditional Religion: General

The people of Babungo still believe in and adhere strongly to their customs and traditions. Most of them still consider traditional religion to play an important part in their lives. This is because most of their ceremonies are geared toward rituals, which can be seen especially during the enthronement of the king and other family heads. To begin with, the traditional manner of worshipping is seen in the various rituals and the sacrifices that are offered to the gods and ancestors. The artist and the craftsmen give a deep artistic and spiritual dimension to the objects they create using such materials as wood, metal, beads, clay, bark fibre, nutshells, calabashes, leather and ivory.

Gods and ancestors are believed to live in objects like statues, small clay pots, stones, trees and small rivers. All these places and objects are treated like sacred shrines where the people go to talk to the various gods they represent. From the beginning, however, the Babungo people have always held the firm belief that there is a supreme God (Moh Mbi). They believe that he is so great that an intermediary is needed to transmit their messages to him. After Moh Mbi, they have other gods or spirits (including ancestral spirits) with Ngesekwa, residing at Forghai, being the most respected. In addition, Nyui lai, Nyui

Anthropomorphic helmet mask (*toh mekome tifuan*) (cat. 76)

ndong, Nyui begh and Nyui fisha all dwell in small rivers, pools, stones or at the foot of trees. An informant, Abubaka Ndifuangow, told me that all these gods have their intermediaries in each quarter in the kingdom and it is they who allow the different quarter heads to appease them.

Sacrifices are offered to the ancestors on two levels: the tomb priest performs them at the tombs of kings and queen mothers, while each *tiighau* (quarter head) performs them at the tombs in his compound. According to the Babungo people, the intermediaries between God and the living are their ancestors, who are in spirit form. These ancestors need to be appeased so they will be willing to take messages to God (Moh Mbi). This is done through numerous periodic sacrifices and the materials used at all levels of the society (kingdom, quarter, family and compound level). At the quarter level, the yearly sacrifice is called *josi*.

Sacrifices at the Kingdom Level

The offering of sacrifices at the kingdom level is done for the well-being of the entire population of the kingdom. These kingdom sacrifices are carried out by two secret groups: the *vitii tifung* (tomb priests) and the *mfwei* group. The members of the *vitii tifung* perform them once a year, while the *mfwei* group performs them whenever the need arises. All these groups are charged with bringing peace to the kingdom. The *vitii tifung* members are entrusted with appeasing the gods and asking for a higher yield and an increase in births. The *mfwei* group cleanses the kingdom and protects it from evil. The various groups performing the sacrifices are described below.

The Main Activities of the Vitii Tifung (Tomb Priests)

The tomb priests are members of a secret group in the regulatory society (*ngumba*). They represent the kingdom during rituals performed for the preparation of a fruitful new year. This is usually a special period of inactivity in the kingdom, especially during the celebrations of the dead. The following are some of the names of the gods and sites to which sacrifices are offered: Ngesekwa, the god of Forghai, Nyui nka teng, Weei nyui forghai, Weei nyui lai, Bi ndo and Jo Ngineh. As an informant, Tita Bie told me, some of these gods are associated with places where the people rested during their migration, while some are places where great events or miracles took place in the lives of the people.

Forghai is situated some kilometres away from the Babungo market, in the Mbenje quarter on the road towards Baba I. It is believed to be the first place where the Babungo people settled after they had left Tikari, where Ngesekwa, their founding god, dwelt. For this reason, all the annual activities of the kingdom start from Forghai. The inhabitants of Mbenje (the quarter where Forghai is situated) are responsible for cleaning the road leading to the site. On approaching at the entrance into the cave, everybody is required to be naked. The quarter head of Mbenje, the *tita fuanje*—the man who uses the *munkuncho* mask (cat. 16) during enthronement—opens the activities at Forghai, since it is found in his quarter. The cleaning is followed by the day of the sacrifice, which is usually on *mbaa*,[2] the second day after the local market day. On this day, only men are allowed to go to the site, while women stay at home to prepare food for refreshment after the sacrifice. It should be noted that not everybody can enter the ceremonial site: only the quarter head and a few quarter notables go into the ceremonial ground, while the others stay far away.

On the part of the *vitii tifung*, which conducts the rituals for the benefit of the entire kingdom, an announcement is made at a small local weekly market called *iwing mbing*. This is to make the kingdom aware of the purification period and respect the laws relating to it. The activities of the period start on *fejeng*,

the first day after the Babungo weekly market day. On that day, the *tifuan* (*ngumba*) goes to Ngineh in the evening, carries out its role and returns to the palace the same night. On the next day (*mbaa*), the second day of the local week, the *vitii tifung* members meet the quarter head of Mbenje and he guides them to the cave where the god lives. He does this by using a special language to announce the arrival of the people to the god. It should be noted that before entering the *tita fuanje*'s compound, a special sound is made using a double gong called the *geng*, which also announces the arrival of the tomb priests at the quarter head's compound. This *geng* is played at three different points before reaching the god's dwelling-place and, on each occasion, the quarter head pleads with the god to open the way and welcome the people with their gifts. It is believed that, if this is not done, the people will find it difficult to get into the cave. At the entrance to the cave, the quarter head pleads with the god again to open the door for the children to bring in their gifts. He then makes way for the tomb priests to go in and perform the ritual; he can accompany them right to the site if he wishes. The ritual is performed with a black cockerel called *bi jow*, some camwood and palm oil. As my informants told me, the cock is slaughtered in a special way and thrown into the small pool. There is a special way of finding out whether the sacrifice has been accepted, which is known only to the tomb priests. According to what I myself have experienced—and information obtained from some tomb priests—a newly enthroned king is presented to the god of Forghai with a pure black he-goat.

On their way back, the tomb priests stop at the *tita fuanje*'s compound, where they also perform some rituals. They offer sacrifices to Ngesekwa and Fuan Ndo in the compound; the women bring food, while the men bring palm wine for entertainment. A big clay pot is filled with wine, boiled and served to everybody present in the compound: this is

a sign of unity and peace to the people. It is said by my informants that anybody with evil in his or her mind cannot share in the wine drinking. From there, the tomb priests offer passive sacrifices to ancestors and other gods in different places. When they have finished, other groups like the *guo*, the *nkoh*, the *mubuu*, the *ndau mensau* (a princes' dance group) and the rest play their part by dancing in front of the tombs. On *mbing*, a traditional Babungo day, the *nintai*, (another princes' dance group) and the *shaw*, (the queens' and princesses' dance group), take their turn at Ngineh.

The *ngumba* opens the tomb celebrations in the palace on the evening of a day called *mbuane*. They take place in front of the palace tomb throughout the night. Other branch jujus in the *ngumba* society (*mubuu*, *nkoh*, *guo*, *munkwaan* and others) perform on *ngai*, the day following *mbuane*. Also on *ngai*, the *vitii tifung* performs a special ceremony in the night using the *munkuncho* mask (cat. 16). General kingdom juju dances and feasting occupy the next day, *feke*. This marks the end of the sacrificial period and the resumption of normal daily activities.

Other Important Sites and their Rituals

The Site of Nyui Dong

Dong is a pool in the River Mene, which passes through Shikau, a sub-quarter of the Finkwi quarter. The first person in this quarter collected water for his daily use from this small stream; he then considered this place as a source of inspiration or life and, for this reason, he then made it a habit to offer periodic sacrifices at the small pool, which he considered to be a god. Sacrifices are offered here at three different levels. Nchiafe, the founder of the place does it at the individual level: as I was told by my informants (Taila Bikeh and Tita Gang), Nchiafe has the right to offer sacrifice to Dong whenever the need arises and he may be accompanied by some

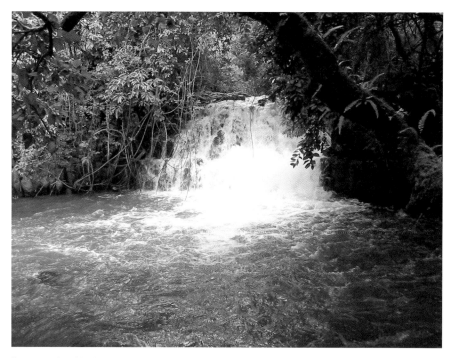

fig. 29. Begh, a fall where masquerades were believed to emerge and fight for the Babungo during wars

of the elderly men from Shikau. The quarter head of Finkwi offers sacrifices there on behalf of the entire quarter; he does so with some of the notables of the quarter. At the kingdom level, the tomb priests are responsible for the rite. It should be noted that sacrifices here are performed with camwood, fowls, oil, and selected mudfish.

The Site of Weei Nyui Begh

Begh is a waterfall situated in the Finkwi quarter: it is another site where sacrifices are offered at three levels. The quarter head of Ibia, the *ti ibia*, performs the ritual, followed by the quarter head of Finkwi and lastly by the tomb priests (*vitii tifung*) on behalf of the kingdom. The god of Begh is very useful to the Babungo people. It is said that during inter-tribal wars, some special magical jujus (*menai*) came out of it to fight for the Babungo people, unseen by the enemies. Again, when something bad is about to happen in the kingdom, such as the death of an important person, the sounds of some *ngumba* jujus are heard being played inside the pool, as well as the constant noise made by the water falling into the pool below.

The Site of Weei Nyui Fesha

Fesha is a small forest, situated about three hundred metres from the palace. It is from this small forest that the palace women collect water for the king's use. Other people, who live near the forest, also collect water from there. A kingdom god called Nyui Fesha lives here. As I was told by Tita Mbombo and other people living in Fesha, this god is so good that at times he appears to some people in the area in dreams and shows them useful herbs that they use to cure illness. He also gives warning signs to people passing through the forest during forbidden hours, especially late at night. It is also said that when the kingdom disturbs the god in the for-

est, he reacts by drying up the water until he is appeased. It is forbidden to pass through Fesha with a light late at night. Only those living close to the forest can use its wood. The tomb priests offer a sacrifice here once a year, although, in certain circumstances, the people offer this sacrifice more than once a year.

The Site of Weei Nyui Lai

This is a small stream on the road to Ibal Oku. It is believed that a god lives in a small pool in the stream, which is full of well-shaped round black stones. It is said by some of my informants that most iron workshops used stones taken from the stream. Tufentoh, a tomb priest, also told me that nobody can take a stone out of the stream and successfully make off with it because it should only be taken if found outside the water. Only the *vitii tifung* offer sacrifices here.

The Mfwei Group

The *mfwei* is a special society that functions outside the palace, but is answerable to the *tifuan* (*ngumba*). It is responsible for the peace, protection and cleansing of the kingdom and its members perform their rituals once a year: but when there is an abomination in the kingdom, they are called on to perform the cleansing sacrifice. During the rainy season, especially in the weeding period, they go out and move from door to door and from one corner of the kingdom to another, performing protection sacrifices. It is said by most of my informants that during this period the crops are protected from evil, insect pests and the wind, especially the maize that is about to ripen. They go round with special calabashes, called *ghene mfwei*, which contain a concoction made from different herbs. The purifiers also use the leaves or stem of a special plant called *inkegh* (peace plant) and another leaf called *membua*. From my own experience and information obtained from the majority of informants, when somebody dies of disease with a protruding stomach or com-

mits suicide, it is this group of people that buries him.

Sacrifice at the Family and Compound Level

General

The family and the compound head perform almost the same sacrifices in their respective dwellings. When somebody builds a new compound in the kingdom, special rituals are performed during which the new sacred site for the protection of the compound, called the *ijeng*, is created. This is always a tree planted ceremonially by the person who has provided the piece of land to be constructed on or by the quarter head. In certain compounds, there is also a small sacred pot called the *buh*, which is a sort of protective utensil for the family or compound. Periodic sacrifices are offered using the small pot.

Before people are buried, a stone is rubbed on their forehead and kept in a private place in the house. Continuous rituals have to be observed so as to ease their journey to the next world, for example juju dancing and other celebrations. After some time a special ceremony is performed during which the small stone that was rubbed on the deceased's forehead is placed in a sacred corner—called *nghi iweh*—in the house. The stone representing the first person who died on this piece of land is called the *ntegh viyuan*. This helps the family or compound head to know the number of people who have been buried in the family compound. This is so because each person who dies is represented by a small stone. When this is done, the late man is then believed to join the ancestral world and can then act as a mediator between God and the living world. Periodic sacrifices can then be offered to him by pouring libations and calling his name to receive their gifts and give them peace. This is done using raffia wine, palm oil and, at times, mudfish.

The Buh

This is a small magical pot that protects the family or the compound. It is said that this kind of object was introduced into the kingdom in the early nineteenth century due to tribal wars and epidemics. As it is believed by the Babungo people that their ancestors could defend them in times of war or epidemics, these pots were associated with the small stones representing the ancestors. They were placed at all the entrances to the kingdom, so that an enemy, on crossing it automatically became weak. Even if the Babungo people were defeated, their enemies could not come to live in the village because they would not know how to perform the periodic rituals to calm the magical powers of the small pots. As it was a tradition that somebody with a well-built compound could be obliged to live in that compound, but under the control of a prince, many people decided to place these small pots there. This is because princes never knew the secret of the pot. It should be noted that not every compound has this pot which contains a mixture of herbs and liquid. These are special herbs known only to a few people who are bale to use them. These herbs are usually prepared by the family head and distributed to the members of the family in whose compounds these small pots are to be found. Since the herbs are not easy to collect and processed, the mixture can be dried and preserved for periodic use. When the contents of the small pot have completely decayed and form a solid block, it is then removed and replaced with the preserved dry mixture. The contents of the pot are always moistened by the addition of palm wine.

Case Study of a Quarter Sacrifice (Josi) Performed in Finteng

Finteng is a quarter that is at the centre of the Babungo kingdom. The main market and the royal palace of Babungo are located here: for this reason, it is the main commercial quarter in the kingdom. Finteng is governed by the *tita nswi*, a descendant of the inhabitants of Babungo coming from Tikari or Ndobo. The quarter head submits reports to the fon, the overall ruler of the kingdom. He also plays an important role in the great sacrifice in Finteng, according to the witnesses who provided the following information.

The sacrifice starts with an announcement and it is performed on *nkusi* (the fourth day of the local week). It is carried out in the evening by the *gah vituh*, a secret sacred group comprising the quarter notables (*vitifong*). The members of *gah vituh* go round the quarter producing a special sound signalling the beginning of the period of sacrifice. Every adult in the quarter will quickly understand since this occurs every year, usually in the same month. The messengers (*tisi nteh*) come for the announcement on *mbuane* (the fifth day of the local week), *ngai* (the sixth day) or *feke* (the seventh day). They are three people chosen by the *vitifong* from amongst their members and represent the three sub-quarters of Finteng (Nka Finteng, Titoh and Nkone). Since there are three messengers and only one *mba nteh* (the bag of the quarter), the messengers go round and only give verbal information without the bag. The people are told to bring the things (mostly palm oil and mudfish) to the quarter head's compound on or before *feke* (I personally saw some people bringing their things early on the morning of the sacrifice). Cleaning is done on *feke*, but some people, who are responsible for cleaning sites nearer their compounds, can decide to do it on the first day of the week (*fijeng*).

The proper day for the sacrifice is the second day of the week (*mbaa*). The day's activities start early in the morning, with some of the wives and children from the quarter head's compound going to the stream to fetch water for the quarter head. This is carried in special calabashes and the process is called *kwe nteh*. Dressed in cloths covering them from their breasts downward, these women

carry the calabashes on their shoulders in a special way. They do not talk to anybody on their way to and from the stream.

While the women are at the stream, the men are at home and begin putting together the things that are to be used for the sacrifice. These comprise palm oil in a calabash called the *gheng,* mudfish, camwood, raffia wine in a calabash called the *dang,* the bag in which the fish and oil will be put, called the *mba josi,* and a small bag in which the camwood is placed.[3] All these things are put in a special sacred place called the *foir-teshui* in the quarter head's compound. The most important figures at this time are the *tita nswi* (quarter head) and *ti-nyanchi* (an important notable of the quarter). The departure from the compound takes place at seven thirty in the morning in this order: the *ti-nyanchi,* the quarter head, a small girl carrying the quarter head's gun, other children from the compound in the middle and three other notables at the end. All the participants walk in a straight line.

The following incantations are made at each point where the sacrifice is to be offered: when the quarter head takes the fish, he calls on the name of the god and says: 'La lu kue wuh (wuh: singular; wing: plural) ne you yai dchue la yai dchue koh gho ndee, gho fi-ne ne ghau ndongne koh yai ne ghau zote' (This is your cockerel that we have come to offer you today; take it with hot hands and give us cool hands.). Here, the sacrificial name for the fish is cockerel. The offering of camwood is followed with the following words: 'La lu buu wing (wing: plural; wuh: singular) you yai dchue la yai dchue koh yiyuh ying (ying: plural; yeh: singular) ndee, la bie buu ngwe fi si yai, teisi wubue fi moh yai' (This is your camwood that we have come to offer today, let it shine in front of us and keep bad people away from us.). Lastly, palm wine is poured on the stone or on the spot accompanied by the following words: 'La lu meluh mbin-ne you yai dshui la yai dshui ko veng ndee. La

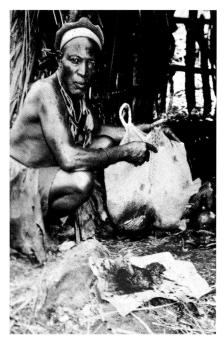

fig. 30. *Mba nteh*

ving fi ne meluh mbe nuh ni gho ndong-ne ko yai ne gho zote, ko yai ne wey-wundong ne wey-wuzoi, ko yai ne fuh-nkie…' (This is your wine that we come to offer you today, take this wine, drink it with hot hands and give us cool hands, give us boy and girl children, give us a good yield…) The group visits about twenty-three sites with different gods and spirits, making various sacrifices.

Back at the quarter head's compound, the last sacrifice of the day takes place on a special spot called the '*foy-tishui*' where three fireside stones are arranged. Here, a clay pot is placed on the stones and all the vitifong touch it. The quarter head pours some raffia wine into the pot until it is full to the brim and begins to flow out onto the ground; a fire is lit under it with the pretext of boiling its contents. He carries some in a small calabash container (*ngui*) and pours it on the ground in a special manner, while calling on the gods of Lai, Forghai, Fuanso, Ngavehey and the others to join them in drinking the wine. The quarter head drinks and gives wine to the *vitifong*. A few family members and people from the quarter gather inside the courtyard of the quarter head, the women bringing food, while the men bring wine. If there is any fish left over from what was donated, the men then cook it. The food is shared by the people, particularly by those who went round to carry out the sacrifice.

On the afternoon of the third day of the week, *mbing*, there is the sacrifice of the tombs, where family members bring fowl and wine. The *vitifong* perform some rites behind closed doors, hidden from women and non-initiated members of the *gah*. The *langshui* rhythm is played using a drum, again behind closed doors. A black cockerel is slaughtered in a traditional way (the head is pulled off with the hands). The blood is poured into the pipe leading into the tombs of the late Tita Nswi Jongwe and Nswi Kiekwi, calling on them to bless and protect the people. Some oil, camwood and wine are also applied to the

two tombs while incanting as mentioned before. This is followed by the anointment of people with camwood placed in a special sacrificial container called the *yuh buu*. This is done by the quarter head while calling on the recipient's name and uttering the following words, for example: 'Ndula, la lu buu wu-ne, bie buu nwe fi kweng gho, buu wey wozio, buu wey wondong, tchesi wobue fi moh gho, koh gho ne fuh nkie…' (Ndula, this is your camwood, let it shine on your arm, camwood of female child, camwood of male child, chase away bad people from you, give you more yield…) The day ends with general feasting and jubilation because it is believed that the quarter has been cleansed for the year. It should be noted that all the gods are male; some of them are subsidiary to those that bear the same name but sacrifices are offered by the *vitifong* at the kingdom level.

Notes

[1] 'Preliminary Material for a History of Babungo. Historical Text by Zintgraff, Vollbehr, Leu and Fon Zofoa II', compiled and presented by Ian Fowler, Oxford, 2001, unpublished.

[2] The Babungo week comprises eight days as follows: 1. *fijeng*; 2. *mbaa*; 3. *mbing*; 4. *nkusi*; 5. *mbuane*; 6. *ngai*; 7. *feke*; 8. *fewing* (market day).

[3] This bag always hangs inside the quarter head's courtyard and before taking it down, it is compulsory to throw a small stone at it.

Bibliography

Chilver, Elizabeth Millicent, *Zintgraff's Explorations in Bamenda: Adamawa and Benue Lands, 1889–1892*, Ministry of Primary Education and Social Welfare and West Cameroon Antiquities Commission, Buéa, 1966.

Chilver, Elizabeth Millicent and Phyllis M. Kaberry, *Traditional Bamenda. The Pre-colonial History and Ethnography of the Bamenda Grassfields*, Ministry of Primary Education and Social Welfare and West Cameroon Antiquities Commission, Buéa, 1968.

Fowler, Ian, 'Babungo: A Study of Iron Production, Trade and Power in a Nineteenth Century Ndop Plain Chiefdom (Cameroon)', PhD diss., University of London, 1990.

Notué, Jean-Paul, 'Prospections relatives aux tré-sors des chefferies de l'Ouest et du Nord- Ouest du Cameroun; rapport scientifique de mission de recherche dans le Nord-Ouest du Cameroun, MESIRES and ORSTOM, Yaoundé 1984, unpublished.

Notué, Jean-Paul, 'Forms, Functions and Meanings of the Cultural Objects from the Royal Palace of Mankon', in Jean-Paul Notué and Bianca Triaca, *The Treasure of the Mankon Kingdom. Cultural Objects of the Royal Palace*, Les Cahiers de l'IFA, COE/IFA, Mbalmayo and Milan, 2000, (with the contribution of the European Commission), pp. 42–80.

Notué, Jean-Paul, 'Initiation à la culture artistique générale et connaissance des arts et cultures du Cameroun et du Grasslands', training course for curators of the museums and artistic and cultural heritage, COE/IFA, Mbalmayo, 2001, unpub-lished.

Notué, Jean-Paul and Bianca Triaca, *The Treasure of the Mankon Kingdom. Cultural Objects of the Royal Palace,* Les Cahiers de l'IFA, COE-IFA, Mbalmayo and Milan, 2000 (with the contribu-tion of the European Commission).

Perrois, Louis and Jean-Paul Notué, *Rois et sculp-teurs de l'Ouest-Cameroun. La panthère et la mygale*, Karthala, Paris, and ORSTOM, Paris, 1997.

Informants

Gohnde Nchinda Michael, notable of Finteng quarter, aged 61

Ndifuangow Abubaka, retainer and an artist, aged 49

Tita Bai, retainer since the reign of King Zofoa II to the present, aged 58

Tita Nswi, quarter head of Finteng, aged 58

Tita Tisah, retainer since the reign of King Sake II, aged about 70

Plates

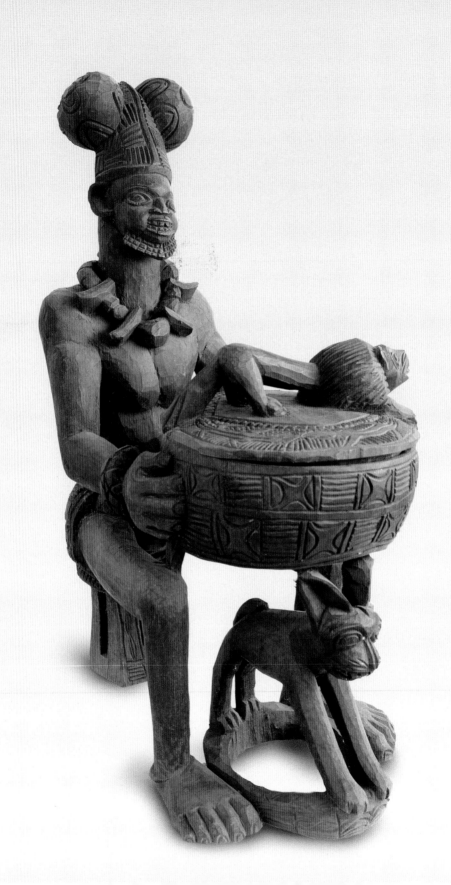

Wooden camwood container
(*yoh-bui*)
[cat. 23]

Commemorative statue of King
Sake II
[cat. 32]

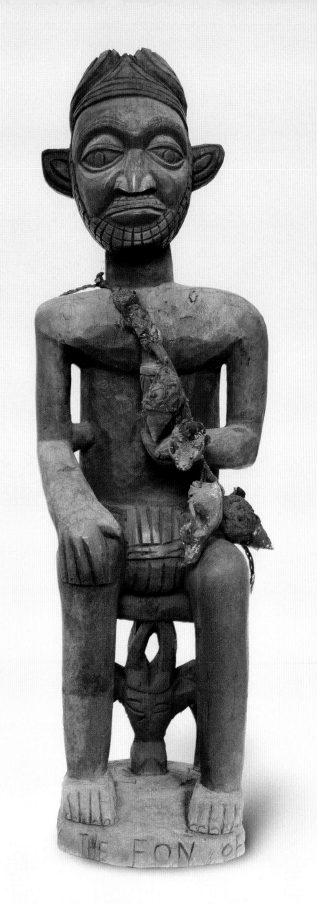

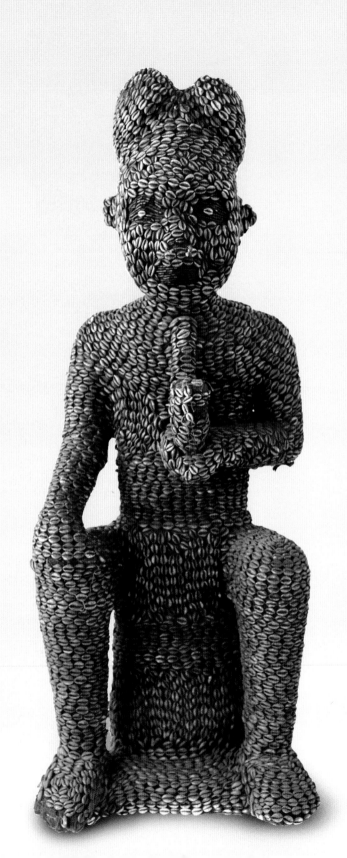

Commemorative statue of King
Saingi II
[cat. 8]

Commemorative statue of a royal
guardian (*ndifua tambu*)
[cat. 29]

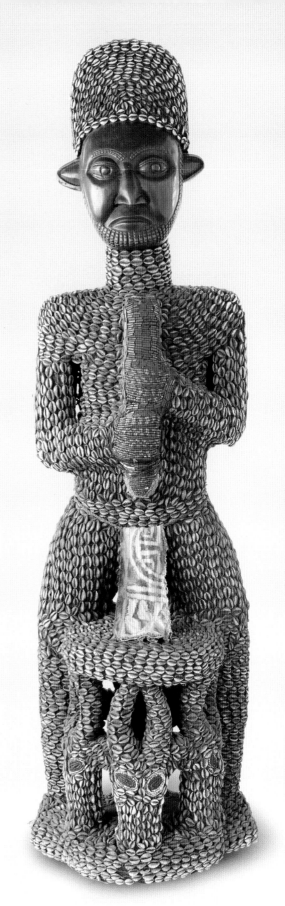

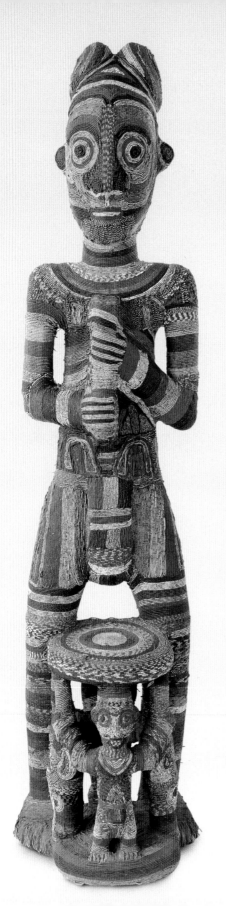

Statue throne of a retainer
(*wenyui ntoh*)
[cat. 11]

Commemorative statue throne
of a royal guardian (*ndifua tambu*)
[cat. 18]

Commemorative statue throne
of a queen mother (*nchio* Minkee)
[cat. 19]

Commemorative statue throne
of a queen (*nah* Yagisi)
[cat. 20]

Commemorative statue throne of a
king and wife (*fuan* Forting and *nah*)
[cat. 35]

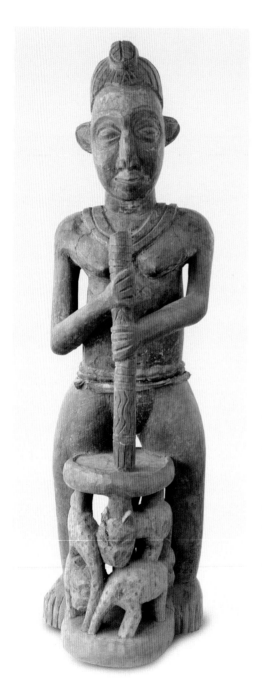

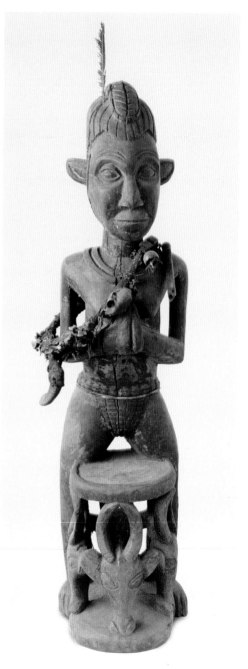

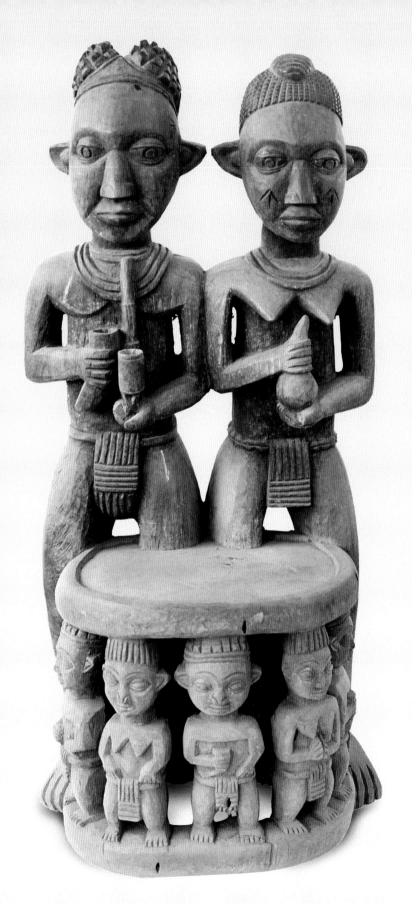

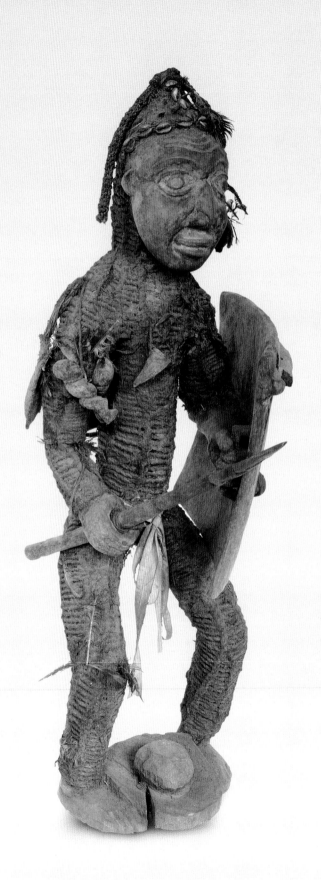

Commemorative statue of warrior
(*gwi yighau*)
[cat. 24]

Commemorative statue throne of
king and wife (*fuan* Forting and *nah*)
[cat. 28]

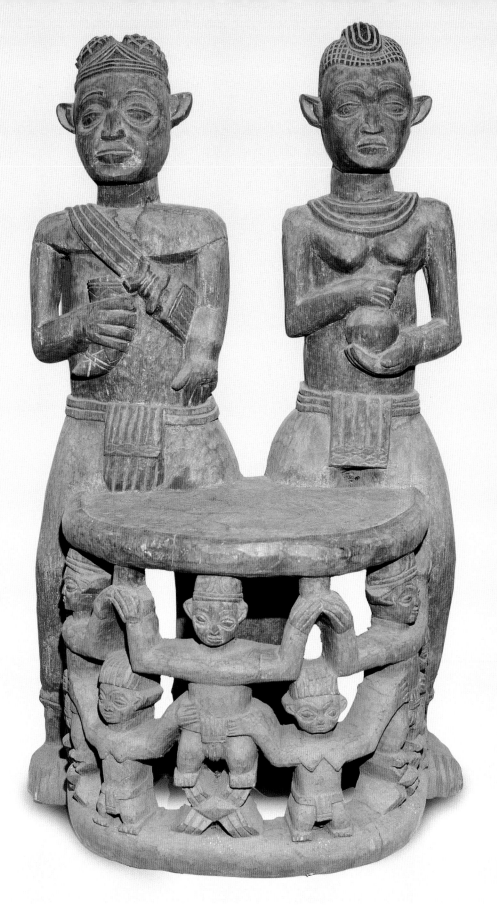

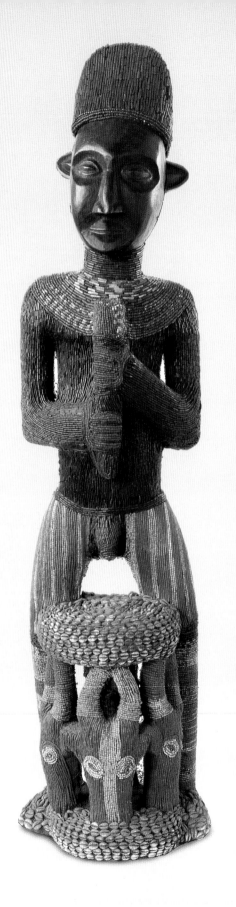

Commemorative statue throne
of a royal guardian (*ndifua tambu*)
[cat. 33]

Statue of King Sake II
[cat. 30]

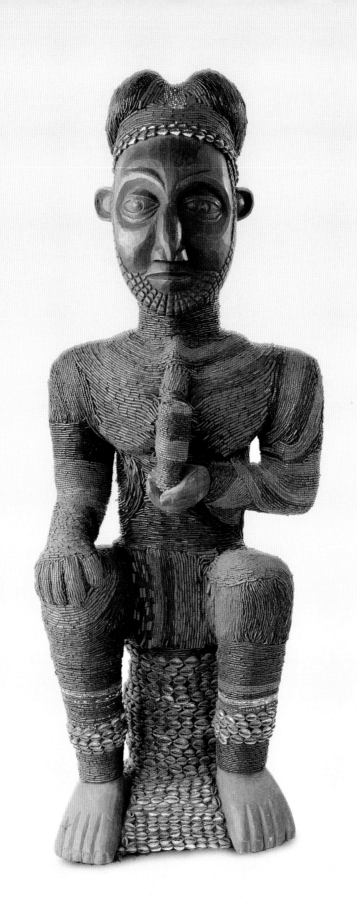

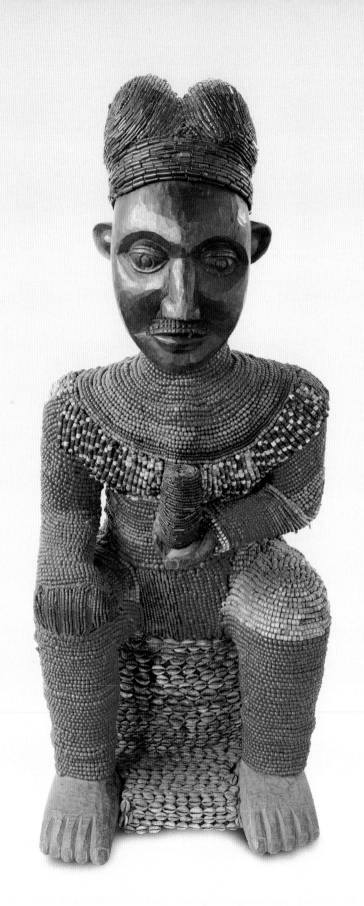

Commemorative statue of King
Sake II
[cat. 74]

Statue throne (*keneh*)
[cat. 37]

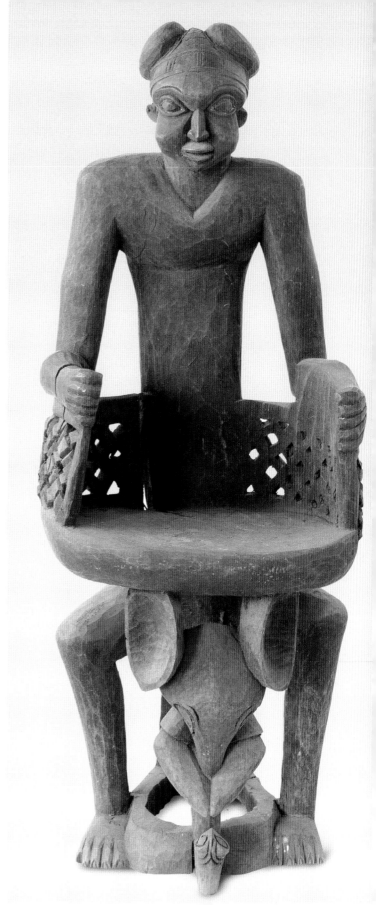

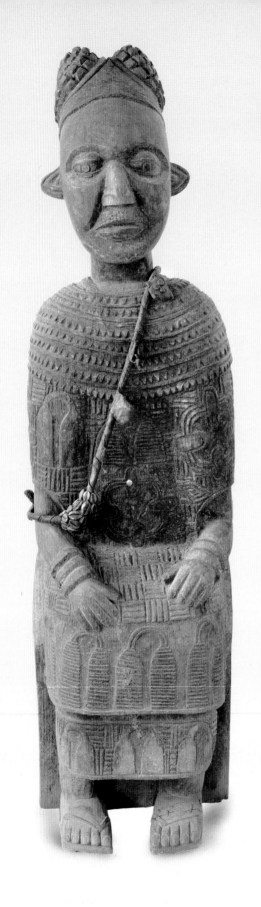

Commemorative statue of King
Sake II
[cat. 31]

Commemorative statue of King
Seevezui
[cat. 10]

Single gong with human figure
(*fengeng*)
[cat. 39]

Royal throne (*keneh*)
[cat. 38]

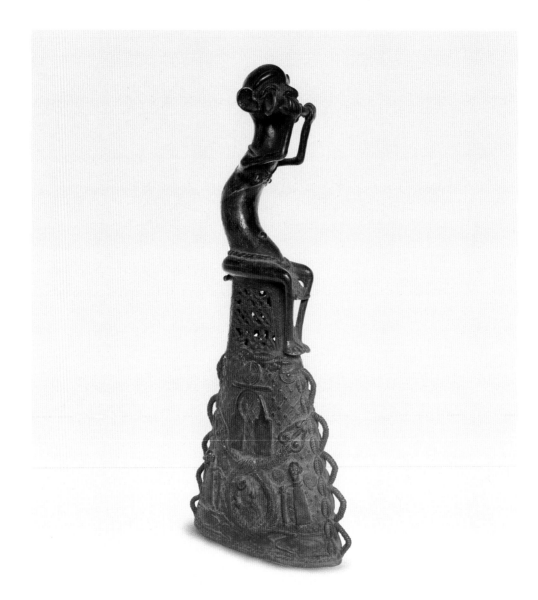

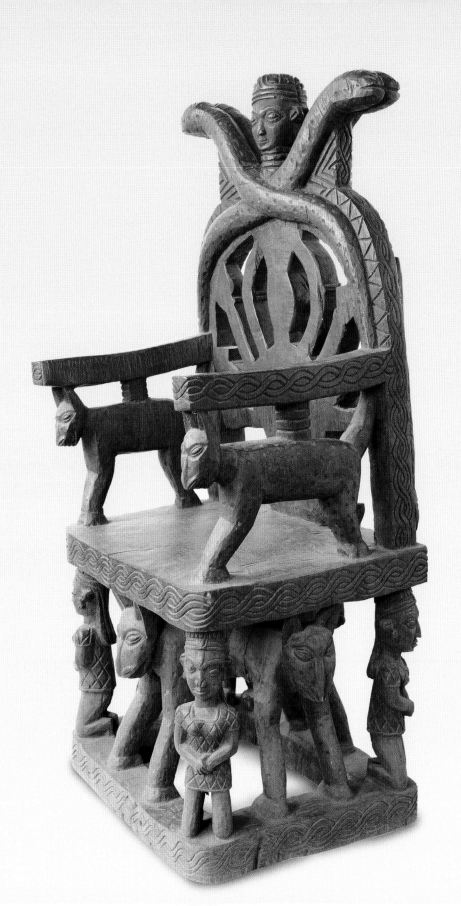

Royal bed (*keng*)
[cat. 2]

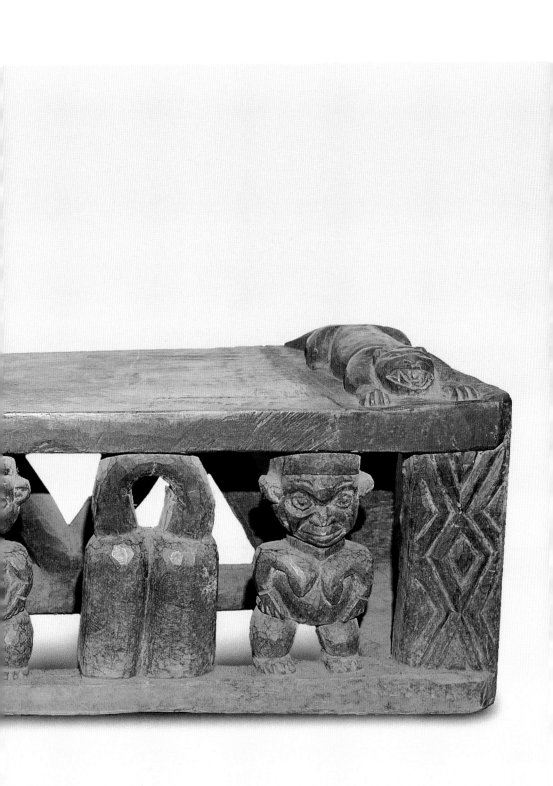

Enthronement camwood container
(*yoh-bui*) or dish (*ngui*)
[cat. 1]

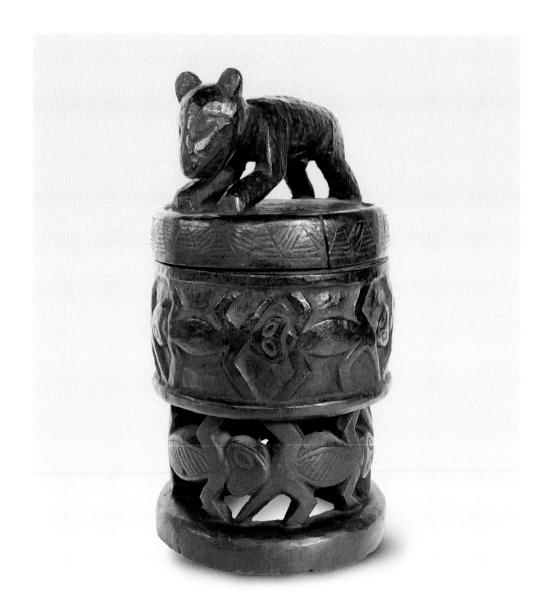

Wooden camwood container
(*yoh-bui*)
[cat. 22]

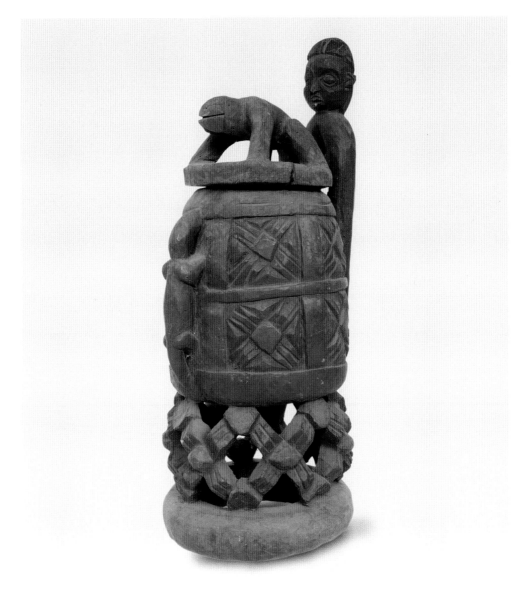

Enthronement stool (*keneh*)
[cat. 13]

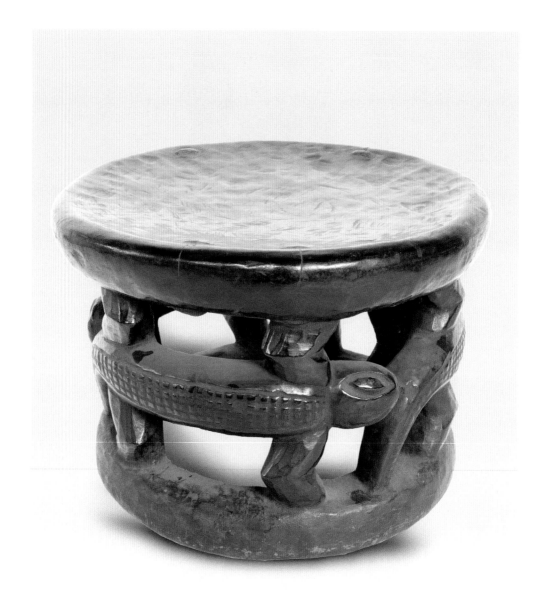

Royal stool with animal motifs (*keneh*)
[cat. 36]

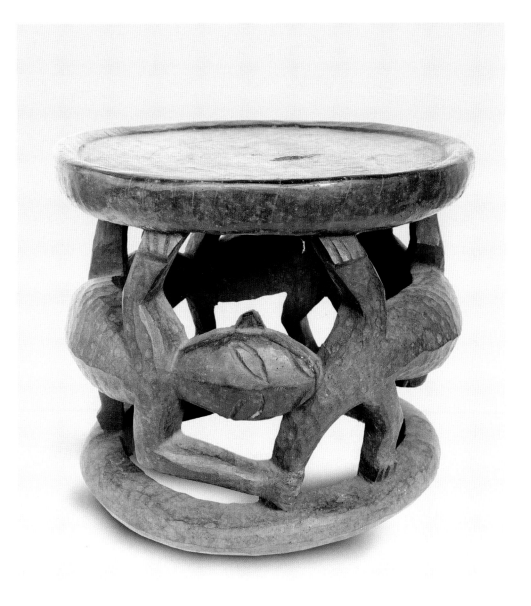

Royal stool (*keneh*)
[cat. 7]

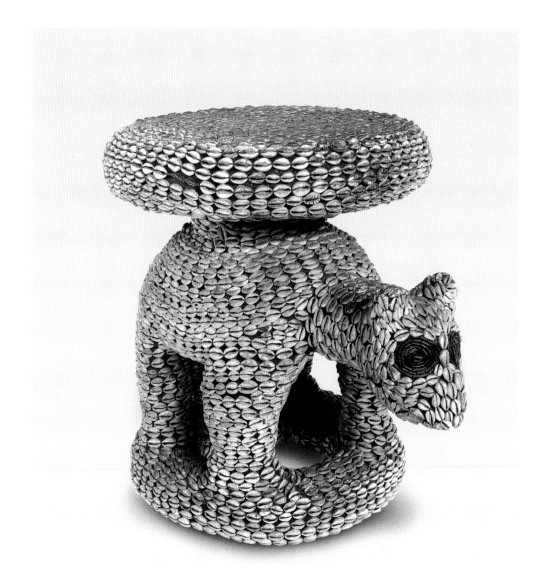

Royal beaded stool with animal motif
(*keneh*)
[cat. 21]

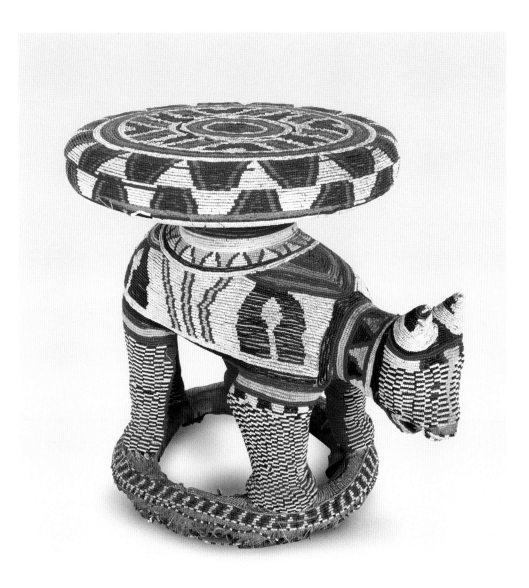

Royal elephant tusk trumpet
(*yisau nsee*)
[cat. 6]

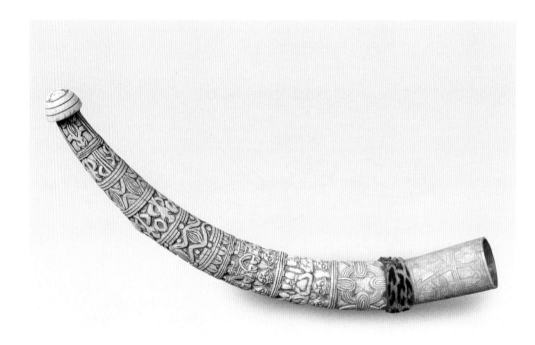

Royal elephant tusk trumpet
(*yisau nsee*)
[cat. 5]

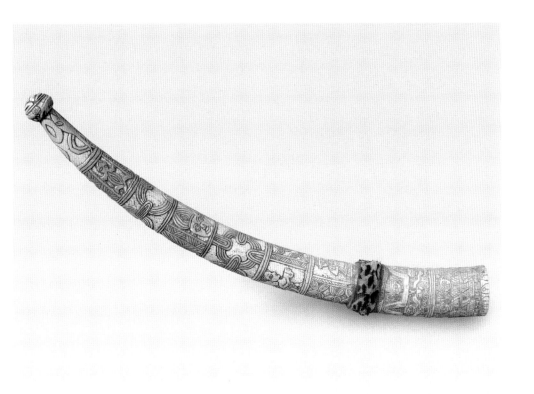

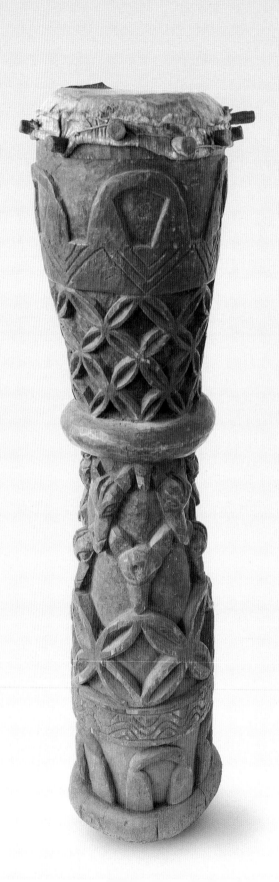

Male drum (*nkia nintai*)
[cat. 40]

Drum (*nkia yisang*)
[cat. 41]

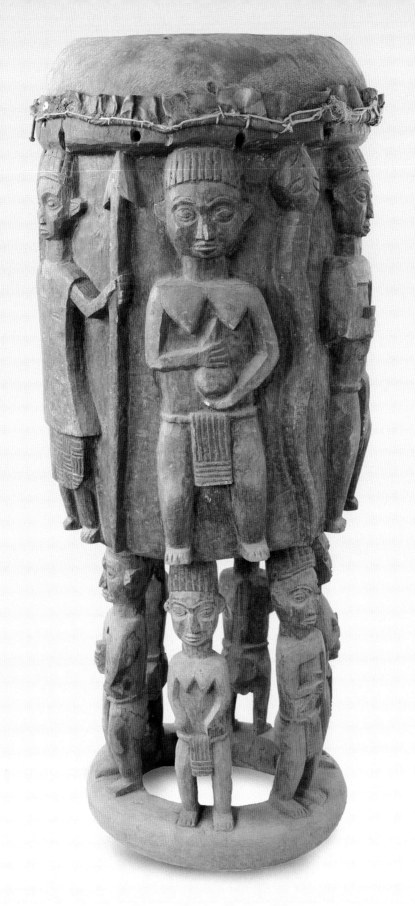

Horizontal drum (*kwing nintai*)
[cat. 43]

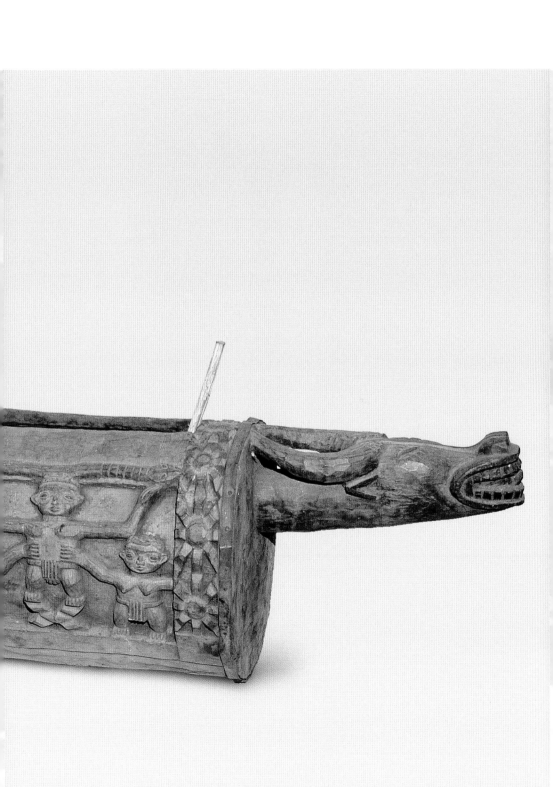

Royal beaded calabash with cat motif
(*fiteng-fintoh*)
[cat. 48]

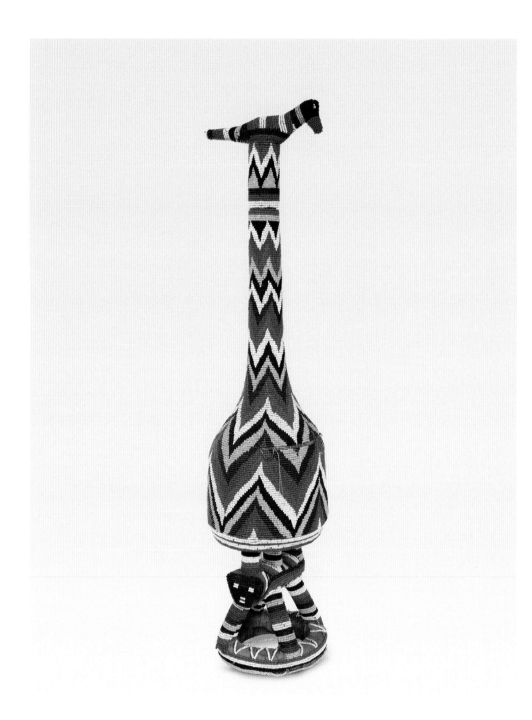

Royal wine container (*fiteng-fintoh*)
[cat. 49]

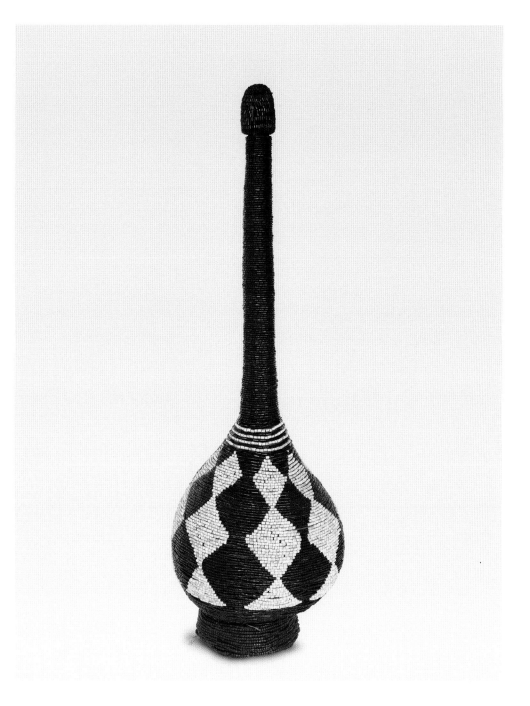

Dish (*kui*)
[cat. 52]

Round container (*yikung*)
[cat. 51]

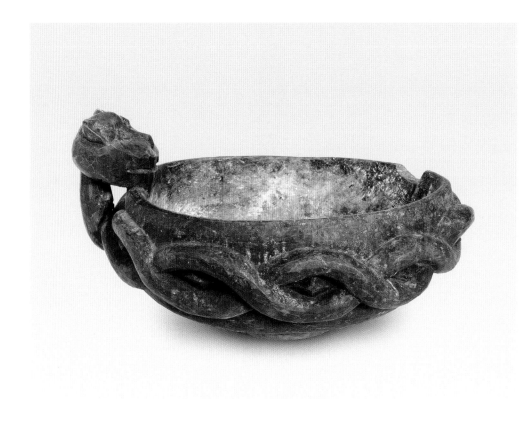

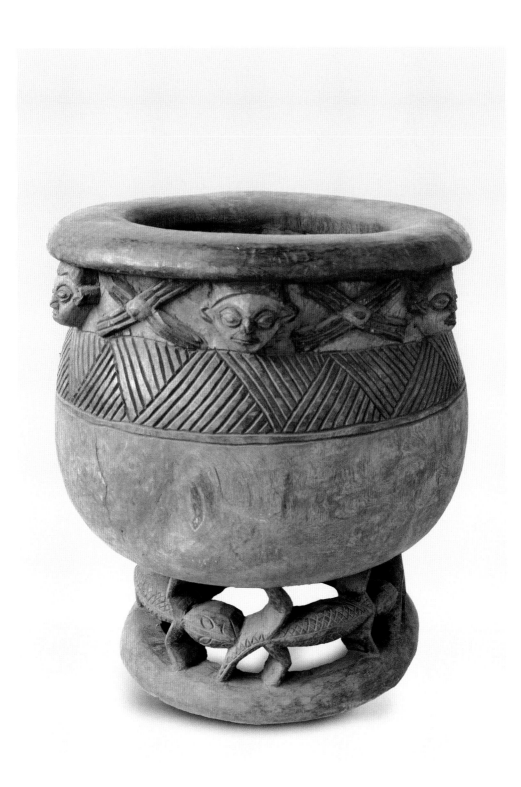

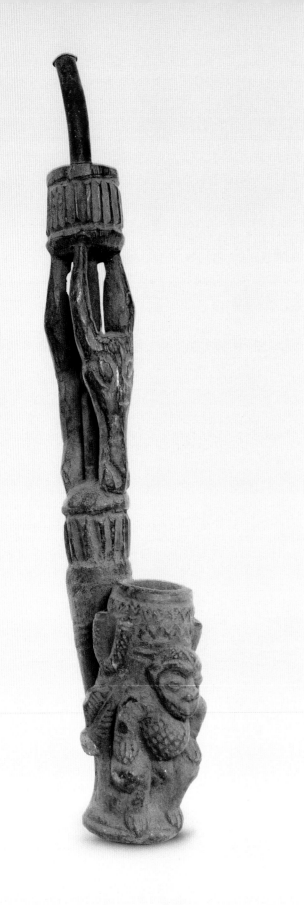

Royal pipe with animal and human
figures (*yikeng*)
[cat. 55]

Royal pipe (*yikeng*)
[cat. 63]

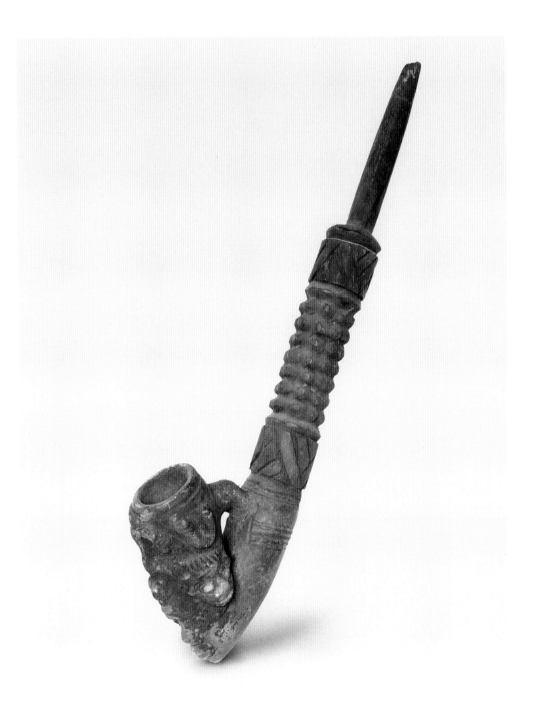

Anthropomorphic head-mask
(*toh ngoyuh*)
[cat. 3]

Anthropomorphic mask (*munkuncho*)
[cat. 16]

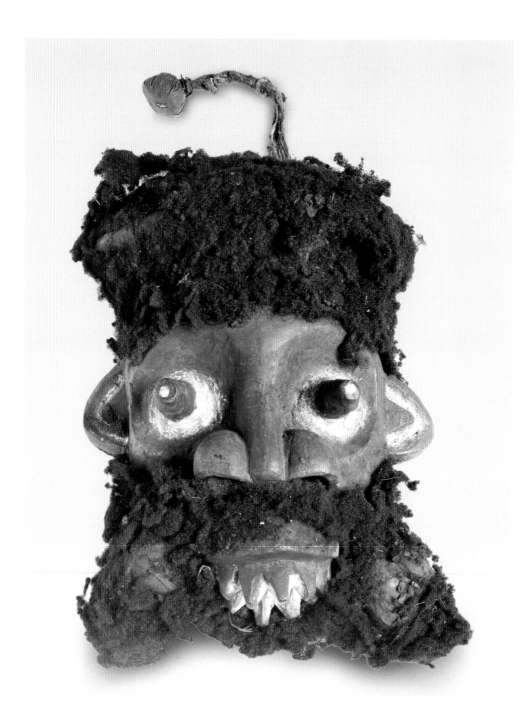

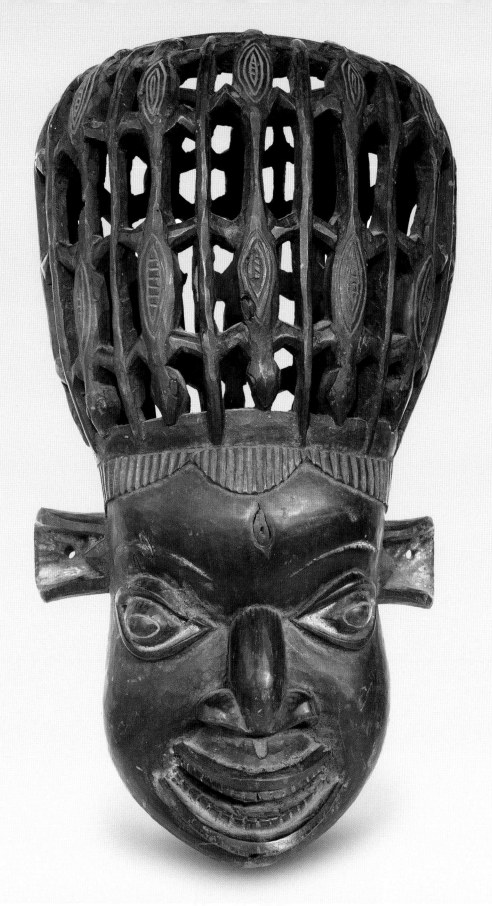

Zoomorphic mask (*ngwang neteng ngonji*)
[cat. 65]

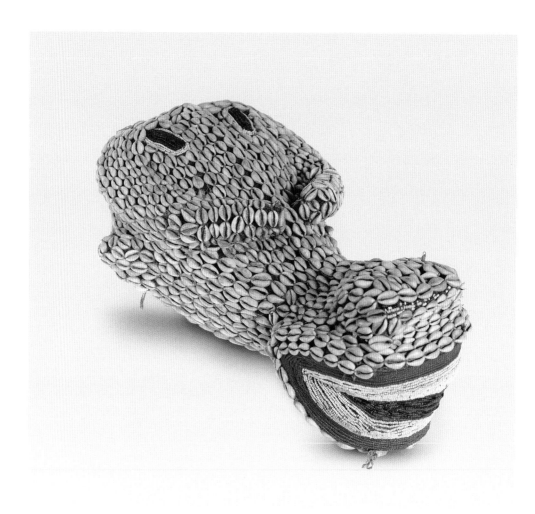

Zoomorphic mask (*kosho*)
[cat. 66]

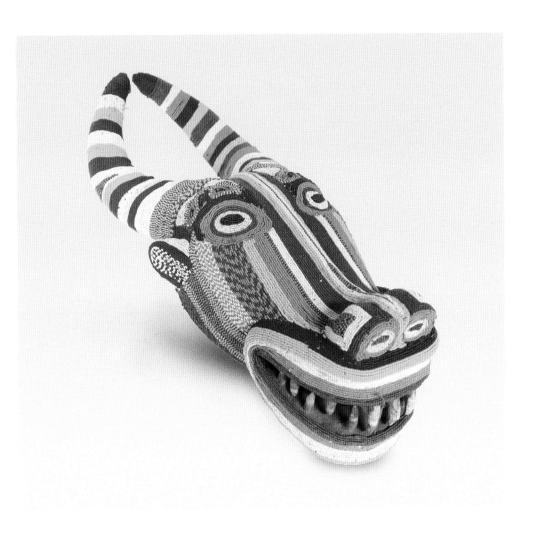

Anthropomorphic mask (*toh mekome tifuan*)
[cat. 67]

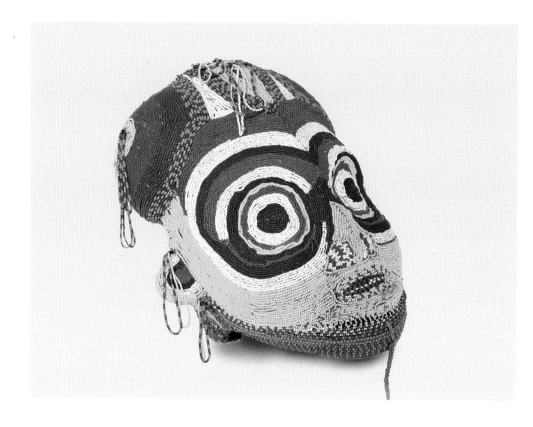

Anthropomorphic mask (*toh mekome ngonji*)
[cat. 69]

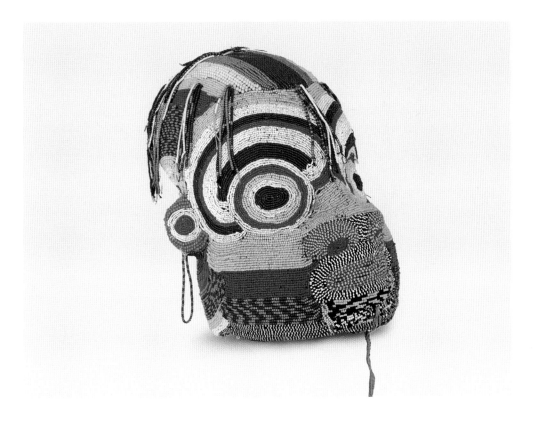

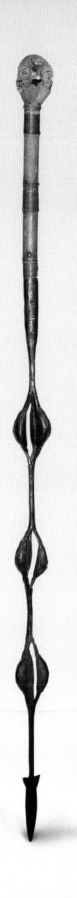

Royal staff (*mbai-ghoole*)
[cat. 4]

Royal spear (*yeghau-ntoh*)
[cat. 78]

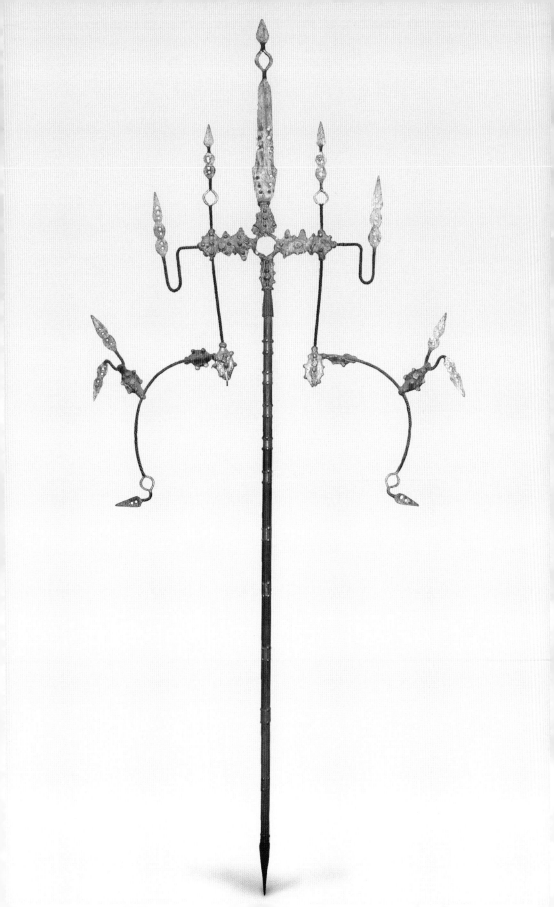

Catalogue of Cultural Objects of the Babungo Museum

Permanent Exhibits
Babungo: Memory, Arts
and Techniques

General editor: Jean-Paul Notué
Coordination: Bianca Triaca

Notes:
Jean-Paul Notué
Bianca Triaca
Protus Bofua (*P.B.*)
Lawrence Mbowoh (*L.M.*)
Cyvil Nangwa Nsanyui (*C.N.N.*)
Julius Ndifor (*J.N.*)

The Kingdom, Myths, Legends and History

1. Enthronement camwood container (*yoh-bui*) or dish *(ngui*

Unknown
Babungo, Ndop, North-West Grasslands, Cameroon
Probably pre-colonial period, nineteenth century
Wood
Height: 49 cm; diameter: 40 cm
Previously in the Babungo Royal Palace collections; gift, 2002, King Ndofoa Zofua III
• Inv. BB.02.2.23c, 23d, Babungo Museum

The body of this wooden cylindrical container is decorated with animal figures (lizard or chameleon); the lid is adorned with a representation of a panther. The whole body of the object is rubbed with camwood, forming a remarkable dark pattern. This container was perhaps purchased by King Nyifuan, the twenty-third king in the dynasty, who transferred the palace from Ntoh Yindo to its present site. It was used during the enthronement of King Saingi II and all the other kings that fol-

lowed. The camwood that is put into this container is used for the rituals that are performed when the new king is anointed. The representation of the panther on the container symbolizes royal power. (C.N.)

2. Royal bed (*keng*)

Nchia Kumeghe
Babungo, Ndop, North-West Grasslands, Cameroon
Colonial period, first half of the twentieth century
Wood
Height: 52 cm; length: 177 cm; width: 18 cm
Previously in the Babungo Royal Palace collections; gift, 2002, King Ndofoa Zofua III
• Inv. BB.02.1.028, Babungo Museum

2

The headrest of the royal bed is adorned with a leopard carved in high relief. The rear end of the animal is curved towards the left. The mouth is large and open, with the teeth exposed. The rectangular bedstead rests on four supports in the form of parallelepipeds at the corners and some openwork figures in between. At the corners on the front of the bed there are three carved human statues (one male and two females). Two corner supports on the other side of the bed are decorated with spider motifs. The artist, Nchia Kumeghe, made the piece of furniture, which was acquired by King Sake II and then inherited by King Zofa II. The animal representation on it symbolizes power. (J.N.)

3. Anthropomorphic head mask (*toh ngoyuh*)

Unknown
Babungo, Ndop, North-West Grasslands, Cameroon
Probably colonial period, second half of the 19th century
Wood and human hair
Height: 21 cm; length: 54 cm; width: 34 cm
Previously in Tita Tiefe Tifuan's collection; gift, 2002, Tita Tiefe Tifuan
• Inv. BB.02.3.7, Babungo Museum

1

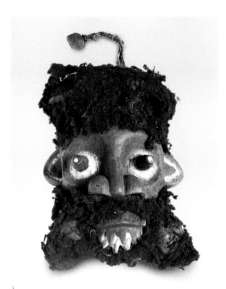

3

This wooden head mask is covered with human hair. The face, which is flat, has two pointed round protruding elements forming the eyes. The mouth is large and open, allowing the long teeth to be seen. Behind the head there is a long *gri-gri* (magic object or a kind of talisman) that has a small piece of tied nylon at the end. The leader of the *keshu* juju dance group wears the mask during death ceremonies in Babungo and elsewhere. Tiefe Tifuan ancestor founded the *keshu* celebration, the first group to dance in the palace during the king's death celebration. (*C.N.*)

4. Royal staff (*mbai-ghoole*)

Finkwi forging workshop
Babungo, Ndop, North-West Grasslands, Cameroon
Colonial period, first half of the twentieth century
Wood and iron
Height: 157 cm
Previously in the Babungo Royal Palace collection; gift, 2002, King Ndofoa Zofua III
• Inv. BB.02.2.34, Babungo Museum

The top of the royal staff is decorated with three human heads and three rows of strings held by twelve pins each round the handle. The wood is joined to the open space of the second part containing three rows of bells in groups of three and in each of the gaps there is a round piece of iron. The part that touches the ground is in the form of a knife. The *mbai-ghoole*, the special ancestral

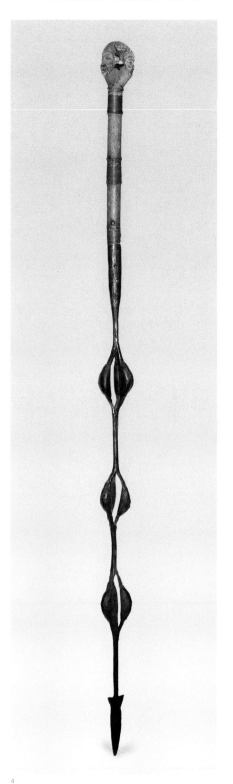

4

spear, is used during enthronement of a new king and when the king's wives go to fetch water for the king. It was made in Finkwi quarter, a popular blacksmith's quarter in Babungo during the reign of Sake II. Bah, a notable and a kingmaker, is the one who holds it in his right hand as a symbol of authority and leadership in the Babungo culture. This spear is thought to be a copy of the original used by the leader of the first migrants to protect the people. (J.N.)

5. Royal elephant tusk trumpet (*yisau nsee*)

Ndifuan Ngow-Bungo, Ndop
North-West Grasslands, Cameroon
Post-colonial period, second half
of the twentieth century
Horn
Length: 106 cm; diameter: 8.5 cm
Previously in the Babungo Royal Palace
collection; gift, 2002, King Ndofoa Zofua III
• Inv. BB.02.2.67, Babungo Museum

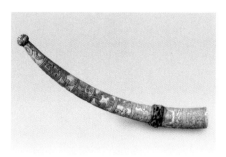

5

This trumpet made from an elephant tusk is decorated with human figures and animals (spiders, elephants, lizards), as well as geometric figures. The horn bears the inscription 'King Ndofoa Zofua III'. The instrument is blown when the king is about to go on a journey or when there is an important announcement to be made in the kingdom, as well as to signal war. The representations of spider on it are signs of the power attributed to the king. Ndifua Ngow made this trumpet in the year 2000 for King Ndofoa Zofua III. (P.B.)

6. Royal elephant tusk trumpet (*yisau nsee*)

Ndifuan Ngow
Babungo, Ndop, North-West Grasslands,
Cameroon
Post-colonial period, second half
of the twentieth century

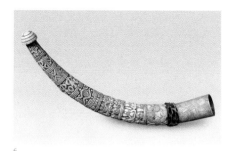

6

Horn
Length: 105.5 cm
Previously in the Babungo Royal Palace
collection; gift, 2002, King Ndofoa Zofua III
• Inv. BB 02.2.2, Babungo Museum

See cat. 5.

7. Royal stool (*keneh*)

King Sake II
Babungo, Ndop, North-West Grasslands,
Cameroon
Colonial period, first half of the twentieth
century
Wood, beads, textile and cowries
Height: 40 cm; height with pedestal: 48 cm
Previously in the Babungo Royal Palace
collection; gift, 2002, King Ndofoa Zofua III
• Inv. BB.02.1.15, Babungo Museum

The royal wooden stool has a cylindrical seat supported by the representation of a leopard standing

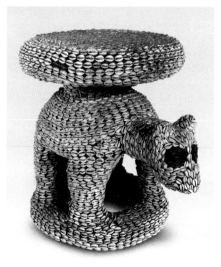

7

on a round pedestal. The whole object is covered with cowries, apart from the eyes of the animal, which are formed by a circle of blue beads. The wood is decorated with cloth onto which the cowries and beads are sewn. King Sake II, the twenty-fourth king in the dynasty, who reigned from 1927 to 1955, carved this royal stool. Before his enthronement, he was a lay preacher of the Basel Mission. The stool is carried behind the king during important ceremonies such as *benefuan* and *nikai*. *Benefuan* is an annual dance celebrated by the whole village, while *nikai* is also an annual dance that is, however, only celebrated by the *ngumba* members. (C.N.)

The seated wooden statue represents King Saingi II holding a pipe and wearing a cap with two loops (*isuh buu*). Two cowries form the eyes of the king and the mouth is covered with tubular beads. The fon has a cylindrical neck placed on slightly slanting shoulders. His left arm is bent at the elbow, holding a pipe against the chest, while his right hand is placed on his bended knee. Saingi II sits on a stool completely covered with cowries. The statue may have been made by King Sake II himself during the first half of the twentieth century, after his enthronement in 1927. The statue is displayed outside the palace during important occasions such as the annual festivals *benefuan* and *nikai*. (L.M.)

8. Commemorative statue of King Saingi II

Perhaps by King Sake II
Babungo Ndop, North-West Grasslands, Cameroon
Colonial period, first half of the twentieth century
Wood, cloth, cowries and beads
Height: 136 cm; depth: 56 cm; width: 59 cm
Previously in the Babungo Royal Palace collection; gift, 2002, King Ndofoa Zofua III
• Inv. BB.02.2.54, Babungo Museum

9. Seated statue of King Sake II

Simbo Kosho
Babungo, Ndop, North-West Grasslands, Cameroon
Colonial period, first half of the twentieth century
Wood, beads and cloth
Height: 148 cm, depth: 57 cm; width: 50 cm
Previously in the Babungo Royal Palace collection; gift, 2002, King Ndofoa Zofua III
• Inv. BB.02.1.29, Babungo Museum

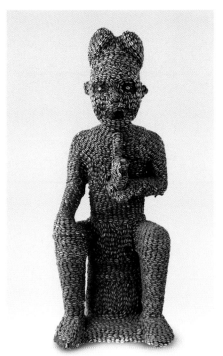

8

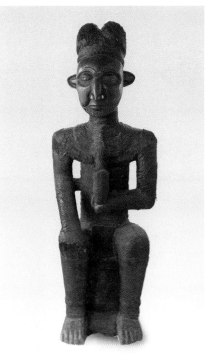

9

Holding a pipe, the king, who is wearing a cap (*isuh buu*), is sitting on a stool. His ears are large and protruding. His face is characterized by two lines on the forehead forming the eyebrows, large eyes, a flat nose flanked by flat cheeks and engraved square marks below his closed mouth representing his beard. His cylindrical neck stands on the rounded shoulders. He is dressed in a loincloth that passes between his legs and held in place by a belt at the waist. On both ankles there are round bands of beads. Apart from the feet and face, the whole statue is covered with blue beads; it was carved by Simbo Kosho, an artist who worked in the palace during the reign of Sake II, and King Sake II sewed on the beads. The statue is exhibited in front of the palace during the nine days of the king's death celebrations, and also during annual festivals. (*C.N.*)

10. Commemorative statue of King Seevezui

Simbo Melang
Babungo, Ndop, North-West Grasslands,
Cameroon
Colonial period, first half of the twentieth
century
Wood
Height: 135 cm; depth: 25 cm;
width: 40 cm
Previously in the Babungo Royal Palace
collection; gift, 2002, King Ndofoa Zofua III
• Inv. BB. 02.1.32, Babungo Museum

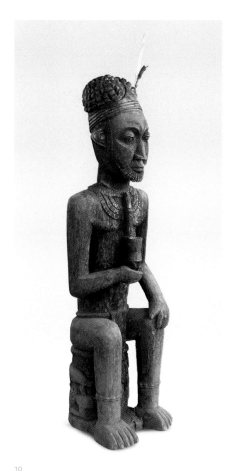

10

This wooden statue represents King Seevezui seated on a throne. The king is wearing a cap with two loops (*isuh–buu*) decorated with four engraved lines and carved square motifs. The ears are large and pointed and two engraved lines form the eyebrows above the oval eyes. The fon has a long nose, a closed mouth and a bearded chin. He holds a pipe in his left hand and his right hand is placed on his knee. He is dressed in a loincloth, which passes in between his legs and is held at the waist by a belt. He is sitting on a stool decorated with five carved leopards in relief. This statue was made by an artist called Simbo Melang and acquired by King Sake II. King Seevezui is said to have transferred the palace from Ntoh Ngeneh to Ntoh Yindoh. This sculpture is used together with other statues during the nine days of the enthronement of a new king. (*J.N.*)

Society and Religion

1. Society

11. Commemorative statue throne of a retainer (*wenyui ntoh*)

Simbo Kosho
Babungo, Ndop, North-West Grasslands,
Cameroon
Colonial period, first half of the twentieth century
Wood, beads and textile
Height: 170 cm; depth: 41 cm;
width: 40 cm
Previously in the Babungo Royal Palace
collection; gift, 2002, King Ndofoa Zofua III
• Inv. BB. 02.1.16, Babungo Museum

In this beaded statue throne, the back represents
the king's servant (*ndifua*) standing and wearing a
cap (*isuh buu*). Small multicoloured glass beads?
mainly blue, orange and yellow? cover the entire
object and form a multiplicity of decorative motifs
including the details of the eyes and mouth in min-
imal relief. The statue has a long nose; its long cylin-
drical neck stands on the straight shoulders. The
slightly open arms are bent and the hands hold a
large traditional whistle (*tulleh*) resting on the flat
chest. A row of small blue beads alternating with
yellow ones forms the fingers. In the middle of the
slim back there is a multicoloured decoration of glass
beads forming three circles (red in the centre, then
white and black on the outside). Between the legs,
at the level of the slightly bent knees, the servant
bears the platform of the throne decorated with con-
centric circles of multicoloured glass beads. Two
cow's heads and two small male statues support the
platform of the throne. Simbo Kosho, an artist who
worked in the palace during the reign of King Sake
II, carved this object, which is exhibited in front of
the palace during the nine days of the king's death
celebrations. Representing the special guide of the
king, *ndifuan tambu*, it has been used since the reign
of King Sake II. (C.N.)

12. Enthronement cap (*fatoh-yikwe*)

Unknown
Babungo, Ndop, North-West Grasslands,
Cameroon
Colonial period, first half of the twentieth
century
Fibres and cowries
Height: 15 cm; diameter: 30 cm
Previously in the Babungo Royal Palace
collection; gift, 2002, King Ndofoa Zofua III
• Inv. BB. 03.2.76, Babungo Museum

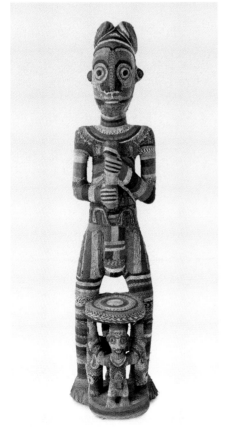

11

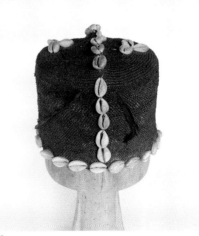

12

This royal cap of enthronement (*fatoh-yikwe*) is made of fibres and cowries. Its front part is adorned with two red feathers. *Fatoh-yikwe* is used during the enthronement of a new king. Made during the reign of Sake II, it is one of the most important artefacts found in the Babungo Palace, where it was kept in a special room. (*J.N.*)

13. Enthronement stool (*keneh*)

Unknown
Babungo, Ndop, North-West Grasslands
Cameroon
Perhaps pre-colonial period, nineteenth century
Wood
Height: 42 cm
Previously in the Babungo Palace collection;
gift, 2002, King Ndofoa Zofua III
• Inv. BB. 02.1.25, Babungo Museum. (only a photograph of this object is displayed)

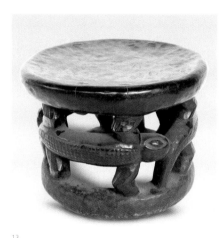

13

This is a royal wooden stool supported by three carved lizards or chameleons attached to a round base. It was used for the enthronement of King Saingi II, Zofua II and more recently, in 1999, during the enthronement of King Ndofoa Zofua III. (*C.N.*)

14. King's necklace (*gih booh*)

Ndifuan Ngow
Babungo, Ndop, North-West Grasslands,
Cameroon
Post-colonial period, second half of the twentieth century
Animal teeth, thread and beads
Length: 56.7 cm; width: 17cm; diameter: 44 cm

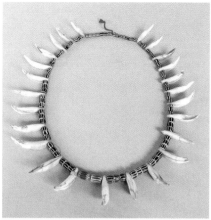

14

Previously in the Babungo Palace collection;
gift, 2003, King Ndofoa Zofua III
• Inv. BB. 03.2.80, Babungo Museum

Made from thread, boar's teeth and three kinds of beads, this necklace is used on important occasions by the king. Ndifua Ngow produced it during the reign of King Zofua II. (*P.B.*)

15. King's necklace (*neeh vetang*)

Ndifuan Ngow
Babungo, Ndop, North-West Grasslands,
Cameroon
Second half of the twentieth century
Ivory, thread and beads
Diameter: 45 cm
Previously in the Babungo royal collection;
gift, 2003, King Ndofoa Zofua III
• Inv. BB. 03.2.81, Babungo Museum

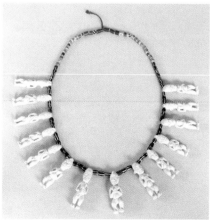

15

This royal necklace is made from thread, small statues and beads. There are seven male statues divided into two categories: three of them place both hands on their chest, while four others hold a staff on both hands. There are also seven female statues: they represent the king's wives, while the males are his servants. All the beads and statues are strung on a red thread. This necklace, which was made by Ndifuan Ngow, is used by the king and his wives during important traditional festivals such as *benefuan* and *nikai* (C.N.).

16. Anthropomorphic mask (*munkuncho*)

Perhaps by a Babungo Palace workshop
Babungo, Ndop, North-West Grasslands,
Cameroon
Probably nineteenth century
Wood

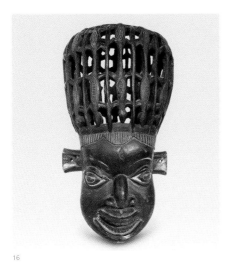

16

Height: 53 cm; depth: 26 cm; width: 23 cm
Previously in the Babungo Royal collection;
gift, 2002, King Ndofoa Zofua III
• Inv. BB.02.1.35, Babungo Museum

This anthropomorphic helmet mask represents a face surmounted by an ovoid structure consisting of twelve pairs of lizards arranged vertically. The heads of the first row face towards the base, while those of the second row are oriented towards the round border of the large upper opening. This mask was perhaps carved in a Babungo Palace workshop during the first half of the nineteenth century. It was kept in a special room in the palace called the *munkunda*. The spokesman for the *ngumba* society wears it during the enthronement of a fon. (L.M.)

17. Commemorative statue of the king's assistant (Bah Ngow)

King Sake II
Babungo, Ndop, North-West Grasslands,
Cameroon
Colonial period, first half of the twentieth century
Wood
Height: 126 cm; depth: 31 cm; width: 21 cm
Previously in the Babungo Royal Palace collection; gift, 2002, King Ndofoa Zofua III
• Inv. BB. 02.1.20, Babungo Museum.

This wooden male statue is seated on a high stool decorated with square motifs. The man portrayed is wearing a cap (*isuh buu*). Below his rounded forehead are large eyes, while a thin line marks the profile of his nose; he has protruding lips with a pipe

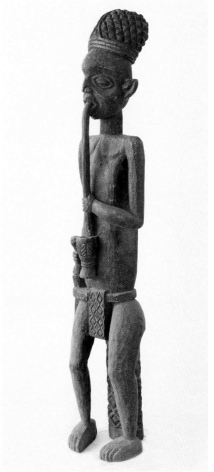

17

149

in his mouth held by his left hand at chest level. The bowl of the pipe is decorated with geometric motifs. Holding the handle of a large knife, his right hand is placed at waist level. King Sake II, who was a lay preacher of the Basel Mission, carved the statue before his enthronement: it represents his assistant Bah Ngow, the architect who designed the third palace (the present one). The statue was displayed during the enthronement of King Zofoa II in 1955 and that of Ndofoa Zofua III in 1999. (C.N.)

18. Commemorative statue throne of a royal guardian (*ndifuan tambu*)

Simbo Melang and Nchia Kumeghe
Babungo, Ndop, North-West Grasslands, Cameroon
Colonial period, first half of the twentieth century
Wood, beads, cowries and textile
Height: 166 cm; depth: 46 cm; width: 39 cm
Previously in Babungo Royal Palace collection; gift, 2002, King Ndofoa Zofua III
• Inv. BB. 02.1.34, Babungo Museum

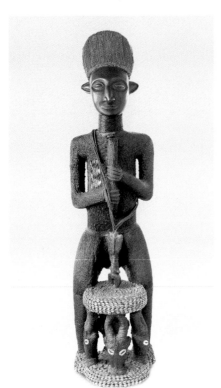

18

The backrest of the statue is a standing human (*ndifuan tambu*) figure completely covered with multicoloured cylindrical beads, except the head. He is wearing a cap (*isuh kom*) typical of the Kom area, decorated with multicoloured beads. This is one of the most admired pieces in the Babungo Palace collection. It was displayed outside the palace during *nikai* and *benefuan*, and also during the enthronement of a new king. It was kept in a special room inside the palace called *tambu*. The beads and cowries on the sculpture are a sign of the wealth of the Babungo Palace during that period. The figure is carrying the flute (*fuele*) used to announce the return of the Babungo people from the war front. (*L.M.*)

19. Commemorative statue throne of a queen mother (*nchio* Minkee)

Simbo Melang
Babungo, Ndop, North-West Grasslands, Cameroon
Colonial period, second half of twentieth century
Wood
Height: 135cm; depth: 25 cm; width: 40 cm
Previously in Babungo Royal Palace collection; gift, 2002, King Ndofoa Zofua III
• Inv. BB.02.2.53, Babungo Museum

The statue throne represents *nchio* (queen mother) Minkee, the mother of King Sake II. The woman has abundant well-plaited hair and two protruding pointed ears.
Two engraved lines form the eyebrows underneath which there are two large eyes, giving her a pensive look. Between her two round cheeks there is a long nose with a curved profile surmounting a closed mouth with thin lips. Two bands in relief represent her necklace, which she wears on her robust neck resting on her curved shoulders. Both arms, which are bent, are held away from the trunk; her hands are placed on a round pestle decorated with engraved geometric lines that stands on the seat of the throne. Her breasts are small and pointed and she is wearing a string of carved cowries and a piece of cloth round her waist. She is standing naked, which allows her pronounced genitals to be seen. Four leopards and a buffalo support the circular base of the throne. The leopards have black spots on their backs and are disposed facing in opposite directions in two rows, forming the front of the throne. When Simbo Melang carved the statue, it was bought by King Sake II and kept in the palace

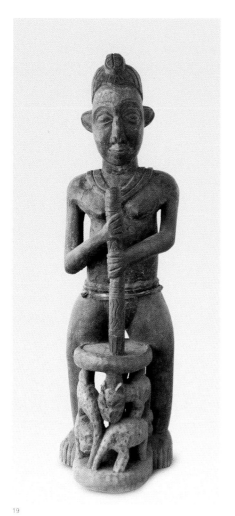

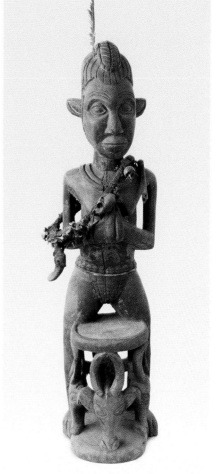

19

20

for commemoration. The statue is displayed out-
side the palace arena during the nine days of the
enthronement ceremonies of a new king. The rep-
resentations of leopards and buffaloes on the throne
are symbols of royal power. (*J.N.*)

20. Commemorative statue throne
of a queen (*nah* Yagisi)

King Saingi II
Babungo, Ndop, North-West Grasslands,
Cameroon
Colonial period, first half of the twentieth century
Wood
Height: 146 cm; depth 43 cm; width: 38 cm
Previously in Babungo Royal Palace collection;
gift, 2002, King Ndofoa Zofua III
• Inv. BB.02.1.4, Babungo Museum

Yagisi was a very loyal wife (*nah*) to King Saingi
II and so he decided to carve her statue as a sign
of his love for her.

The queen has plaited hair, marked eyebrows, oval
eyes, triangular pointed ears, a large nose and a
protruding mouth. She is wearing a necklace and
a talisman, which hangs across the body from her
shoulders.

Her two hands are joined at breast level in a
respectful manner and she has pointed breasts.
She is dressed in a loincloth that goes around her
hips and is secured at the level of her waist.
Between her large hips there is a throne supported
by four cows' or buffaloes' heads. The statue was
displayed in the palace arena during the enthrone-
ment of a new king.

The joining of the hands at breast level is a sign
of her loyalty. (*P.B.*)

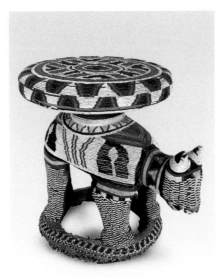

21

21. Royal beaded stool with animal motif (*keneh*)

King Sake II
Babungo, Ndop, North-West Grasslands
Cameroon
Colonial period, first half of the twentieth
century
Wood, beads and fibres
Height 42 cm; diameter: 39 cm
Previously in Babungo Royal Palace, gift, 2002,
King Ndofoa Zofua III
• Inv. BB.03.2.77, Babungo Museum.

This wooden royal stool is decorated with mul-
ticoloured glass beads. It has a cylindrical seat
suspended by the carved figure of an animal
standing on a round pedestal.
The wood is covered with fibres on which the
queens sewed the beads. Carved by King Sake
II during his reign, this stool was usually carried
by a queen or retainer, who demurely followed
the king when he was dancing the *nikai* or *bene-
fuan*. *Nikai* is an annual dance celebrated by the
ngumba members, while *benefuan* is also cele-
brated annually by the entire kingdom as a
whole. (*C.N.*)

22. Wooden camwood container (*yoh-bui*)

Probably King Sake II
Babungo, Ndop, North-West Grasslands,
Cameroon

Post-colonial period, second half of twentieth
century
Wood
Height: 44 cm; height with pedestal: 50 cm;
width 25 cm; diameter (container): 38 cm
Previously in the Babungo Royal Palace
collection; gift, 2002, King Ndofoa Zofua III
• Inv. BB. 02.2.1, Babungo Museum

The handle of this wooden container consists of
the representation of a human face, while the lid
is formed by a carved chameleon and the back con-
sists of two rows of spider decorations in relief. The
lower part of the container that is supported by the
pedestal is composed of spider decorations carved
in the round. Carved by King Sake II during his
reign, this container was used to mix camwood dur-
ing palace rituals. It was kept in a special room in
the king's palace. (*L.M.*)

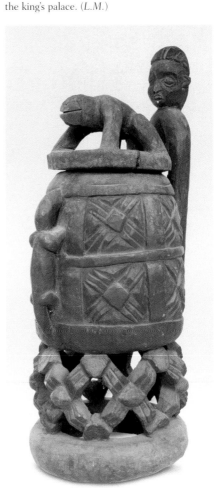

22

23. Wooden camwood container (*yoh-bui*)

Probably King Zofoa II
Babungo, Ndop, North-West Grasslands,
Cameroon
Post-colonial period, second half of twentieth
century
Wood
Height: 95 cm; depth (statue and container): 68 cm;
width: 43 cm; diameter (container): 51.5 cm;
depth: 10.9 cm
Previously in the Babungo Royal Palace
collection; gift 2002, King Ndofoa Zofua III
• Inv. BB.02.2.64, Babungo Museum

A seated retainer supports the wooden camwood con-
tainer. This human figure sits on a stool decorated
with geometric lines. Two engraved lines form the eye-
brows of his almond-shaped eyes. The vertical line
of his nose contrasts with the horizontal one of his
open mouth, showing his teeth, while geometric
motifs under his chin form his beard. There is a neck-
lace on his long cylindrical neck. Tilted forward, his
arms are bent to support the container on the lap,
and he wears a bangle decorated with geometric lines
on both of them. The man is dressed in a loincloth
that passes between the legs. Made by King Zofoa
II during the second half of the twentieth century,
this container was used to mix the camwood that was
applied to the bodies of princesses when they went
to their marriage homes (*L.M.*)

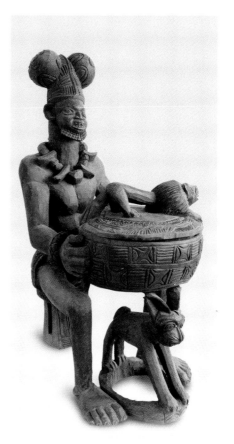

23

Society and Religion

2. Religion

24. Commemorative statue of a warrior
(*gwi yighau*)

Perhaps King Nyifuan
Babungo, Ndop, North-West Grasslands,
Cameroon
Probably pre-colonial period, first half
of the nineteenth century
Wood, feathers and fibres
Height: 100 cm; height with pedestal: 101 cm;
depth: 37 cm: width 48 cm
Previously in the Babungo Royal Palace
collection; gift, 2002, King Ndofoa Zofua III
• Inv. BB. 02.1.1, Babungo Museum

Standing on a round pedestal, this statue of a war-
rior is covered with fibre cords, except for his feet,
hands and face. He is wearing a hat covered with
feathers and cowries. On his forehead there are two
geometric lines carved in an irregular manner; two
engraved lines form the eyebrows underneath
which there are two broad almond-shaped eyes. His
mouth is protruding and his nose is small. His short
neck is placed on his slightly curved shoulders, the

right one having a small bag and a small human
figure attached to it by a fibre cord. His right arm,
which is slightly bent at the wrist, is adorned with
snail-shells, feathers and goat horns and the hand
is holding a spear. His left arm holds a shield, the
back of which is decorated with a carved
chameleon in relief. His trunk is thin and long,
while genitals are exposed and his legs slightly
curved. Between his feet, on a pedestal, there is
a magic stone for protection during war. King
Nyifuan, who moved the Babungo Palace from
Ntoh Yindo to its present site, carved the statue,
which is displayed at the palace arena when there
is a gun-firing procession. The chameleon behind
the shield is a symbol of protection against any mis-
fortune that may occur during war because it is
regarded as a very clever animal and can change
its appearance whenever it likes, just as people may
do during war. (P.B.)

25. Commemorative statue of a warrior
(*gwi yighau*)

King Zofoa II
Babungo, Ndop, North-West Grasslands,
Cameroon
Post-colonial period, second half of twentieth
century

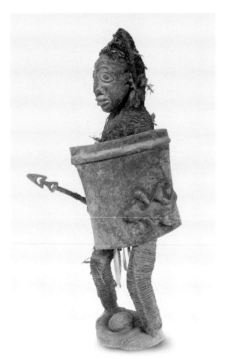

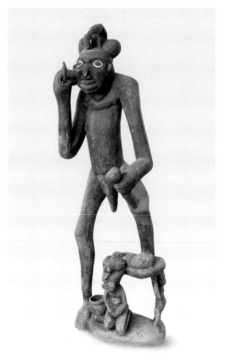

24

25

Wood
Height: 143 cm; depth: 14 cm; width 20 cm
Previously in the Babungo Royal Palace
collection; gift, 2002, King Ndofoa Zofua III
• Inv. BB. 02.2.61, Babungo Museum

Wearing a magic cap with a chameleon on it, this
warrior has one leg placed on a stool supported by
two human figures. One of the figures is standing
and supporting the stool with two hands and the
other kneeling with its hands covering its genitals.
There is a bird on the head of the kneeling figure
and a magic pot beside it. The man is holding a
spear in his right hand in a shooting posture and
a carved sledgehammer in his left hand placed on
his knee.
A chameleon one's cap and a magic pot were
believed by the Babungo to make them almost
invisible to the enemy. The statue of the warrior
is displayed on important occasions. (*L.M.*)

26. Buffalo mask (*toh mekeme tifuan*)

Probably Simbo Njinuh
Babungo, Ndop, North-West Grasslands,
Cameroon
Post-colonial period, second half of twentieth
century
Wood
Height: 25 cm; length: 70 cm; width 33 cm
Previously in the Babungo Royal Palace
collection; gift, 2002, King Ndofoa Zofua III
• Inv. BB. 02.2.40, Babungo Museum

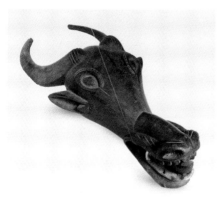

26

The helmet mask represents the head of a buffalo,
characterized by two horns that curve inwards and
are engraved at their base with four lines each,
pricked pointed ears and two ovoid vertical eyes.
It is used by the members of the *tifuan* for danc-

ing during the death celebrations of the king or an
important notable, and during annual festivals. It
was carved by Simbo Njinuh, a retainer working
in the palace during the reign of king Zofoa II.
(*J.N.*)

27. Costume of the *felingwi* dance (*mba kang vessi*)

Probably Simbo Njinuh
Babungo, Ndop, North-West Grasslands,
Cameroon
Post-colonial period, second half of the
twentieth century
Fibres and snail-shells
Height: 147 cm; width: 110 cm
Previously in the Babungo Palace collection;
gift, 2002, King Ndofoa Zofua III
• Inv. BB. 02.2.58, Babungo Museum

The costume is decorated with snail-shells and this
makes it very frightening for the Babungo people.
It was used by the leader of a princes' dance group
(*felingwi*). Snail-shells are attributed with magical
powers in Babungo. In 1985 King Zofoa II
decided for political reasons to make a statue rep-
resenting President Amadou Ahidjo (the first pres-
ident of Cameroon) wearing this costume. (*L.M.*)

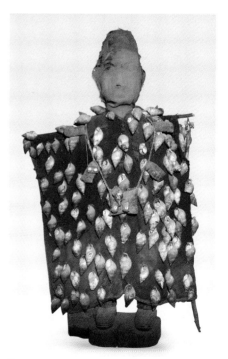

27

Arts and Techniques

1. Statues and Furniture

28. Commemorative statue throne of king and wife (*fuan* Forting and *nah)*

Perhaps by King Zofoa II
Babungo, Ndop, North-West Grasslands,
Cameroon
Colonial period, second half of the twentieth
century
Wood
Height 135 cm; depth: 74 cm; width: 63 cm
Previously in the Babungo Royal Palace
collection; gift, 2003, King Ndofoa Zofua III
• Inv. BB. 03.2.65, Babungo Museum

The commemorative statue throne represents King
Forting and his wife. The monarch is wearing a cap
with two loops (*isuh buu*). He has pointed triangu-
lar ears, eyes and a slightly curved nose; his mouth
is small and closed. He is wearing a cutlass in its
sheath across his body and is holding a cup decorated
with geometric lines against his stomach. His left
hand is stretched down by his side. He is dressed in
a loincloth that passes between his legs and he has
a string of cowries on each leg. The statue of the wife
is similar to that of the king, except for the specially
plaited hair (*fencho*). The woman has a carved neck-
lace consisting of four bands, pointed breasts and a
calabash held in her hands against her stomach.
Seven alternating human figures, three male and four
female, support the seat of the throne. Made by King
Zofoa II during his reign, the sculpture is a copy of
the original. The king is holding a cup and a pipe,
which represent his nobility and authority. The statue
throne is displayed outside the palace during *bene-
fuan* and *nikai*. King Forting, who drowned in the river,
was on the throne for eleven years, probably in the
eighteenth century (see Emmanuel Nchio's essay).
(*L.M.*)

29. Commemorative statue of a royal guardian (*ndifuan tambu*)

Perhaps by Simbo Melang and Nchia Kumeghe
Babungo, Ndop, North-West Grasslands,
Cameroon
Colonial period, first half of the twentieth
century
Wood, beads, cowries and cloth
Height: 166 cm; depth: 46 cm; width: 39 cm
Previously in the Babungo Royal Palace
collection; gift, 2002, King Ndofoa Zofua III
• Inv. BB. 02.1.44, Babungo Museum

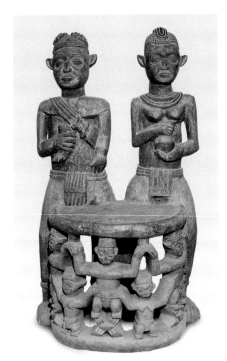

28

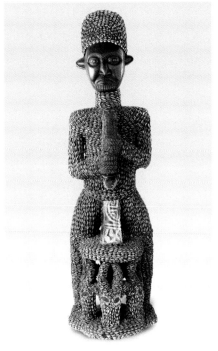

29

The royal guardian (*ndifuan tambu*) is wearing a cap (*isuh buu*) decorated with multicoloured beads. He has pointed triangular ears, almond-shaped eyes, a slightly curved nose and a small mouth. He has a cylindrical neck and a flute (*fuele*) is hanging from his shoulder down his long body. He is holding another flute (*toole*) against his chest. Four buffalo heads support a cylindrical seat. This object is one of a series of statues made during the first half of the twentieth century by Simbo Melang and Nchia Kumeghe to portray the king's special guardians. The cowries and beads represent the wealth of the palace. The flute held in the guardian's hand is used for the retainers' dance (*ndau vang fee*). The statue throne was kept in a special room inside the palace called *tambu*; it was used by King Sake II during his reign and inherited by King Zofoa II after his enthronement, and then by King Ndofoa Zofua III. (*L.M.*)

30. Statue of King Sake II

Nchia Kumeghe
Babungo, Ndop, North-West Grasslands,
Cameroon
Colonial period, first half of twentieth century
Wood, beads, textile and cowries

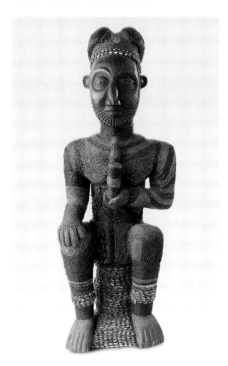

30

Height: 123 cm; depth: 47.5 cm; width: 36.5 cm
Previously in the Babungo Royal Palace
collection; gift 2002, King Ndofoa Zofua III
• Inv. BB 02.1.22, Babungo Museum

This is a commemorative statue of a king sitting on a stool covered with cowries, a symbol of wealth. The fon has a large head and is wearing a cap (*isuh buu*) decorated with two rows of cowries. He has protruding ears and a long nose with a flat profile surmounts his small closed mouth. Around his jaw, three bands of carved motifs, joined at the chin by six others, form the beard. His neck is cylindrical and his shoulders are broad. His left arm is slightly bent at the elbow and in his hand he is holding the bowl of a pipe placed against his chest; his right hand is resting on his right knee. The surface of his back is adorned with five almost circular motifs. The vertical bands of beads in between the legs form his the loincloth. Apart from the head, left hand and feet, the whole statue is covered with beads and cowries. This statue was carved by Nchia Kumeghe, an artist who worked with King Sake II, and beaded by the king himself. A symbol of power and wealth, it was kept in a special room in the palace and only displayed in front of the building during the nine days of the enthronement of kings. The pipe is a symbol of authority and dignity. (*C.N.*)

31. Commemorative statue of King Sake II

Amadou Ngow
Babungo, Ndop, North-West Grasslands,
Cameroon
Post-colonial period, second half of the
twentieth century
Wood
Height: 150 cm; depth: 38 cm; width: 33 cm
Previously in the Babungo Royal Palace
collection; gift, 2002, King Ndofoa Zofua III
• Inv. 02.1.33, Babungo Museum

The human figure, who has a large elongated head, is wearing a cap (*isuh buu*). His ears are pointed and he has almond-shaped eyes. His nose is triangular and he has round cheeks; his mouth is closed with an almost round chin. The dress is decorated with seven curved lines around the neck and six double gongs. Sake II is wearing a talisman hanging from his right shoulder across his body that contains a sheep's horn, a number of cowries and four small stitched bags of med-

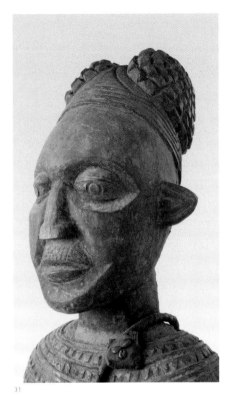

31

icine. His arms, slightly bent at the elbows, are resting on his knees. The king is dressed in a loin-cloth held by a belt at the waist; the loincloth is decorated with carved double gongs with some geometric motifs.

The upper part of the statue throne is decorated in relief with three double gongs and a double-headed snake forming a circle in the middle of which is a spider.

The lower part of the statue throne is decorated in relief with two heads of buffaloes alternating with a human figure. Made by Amadou Ngow, a sculptor working for Zofoa II, the statue throne is used together with other statues during the nine days of the enthronement of a new king. The representations on the throne (double-headed snakes, spiders and buffalo heads) are all royal animals symbolizing power. The statue was last used in 1999, during the enthronement of King Ndofoa Zofoa III. (*J.N.*)

32. Commemorative statue of a king

King Zofoa II
Babungo, Ndop, North-West Grasslands, Cameroon

Post-colonial period, second half of the twentieth century
Wood
Height: 147 cm; depth: 41 cm; width: 36 cm
Previously in the Babungo Royal Palace collection; gift, 2003, King Ndofoa Zofua III
• Inv. BB 03.2.83, Babungo Museum

The wooden statue represents a king sitting on a stool. Four cows' heads support the stool. On his voluminous head, the fon is wearing a cap (*isuh buu*) adorned with geometric decorations. Rectangular marks form the eyebrows below which are two large almond-shaped eyes. The fon has large pointed ears, a large curved nose underneath which there is a closed mouth. The upper lips bear some marks forming the beard. A short neck stands on his flat shoulders. He is wearing a talisman across his body. His straight legs rest on a pedestal with the inscription: 'Carved by the king of Babungo'. The statue was kept in the arena inside the king's compound. The fon is holding a pipe, symbolizing power, in his left hand. (*P.B.*)

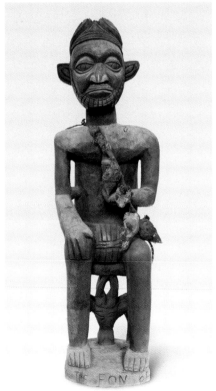

32

158

33. Commemorative statue of a royal guardian (*ndifuan tambu*)

Perhaps by Simbo Melang and Nchia Kumeghe
Babungo, Ndop, North-West Grasslands,
Cameroon
Colonial period, first half of the twentieth
century
Wood, beads, cowries and cloth
Height: 143 cm; depth: 46 cm; width: 39 cm
Previously in the Babungo Royal Palace
collection; gift, 2002, King Ndofoa Zofua III
• Inv. BB.02.1.43, Babungo Museum

34. Commemorative statue throne of a king and wife (*fuan* Forting and *nah*)

Perhaps by King Zofoa II
Babungo, Ndop, North-West Grasslands,
Cameroon
Colonial period, second half of the twentieth
century
Wood
Height: 119 cm; depth: 57 cm; width: 30 cm
Previously in the Babungo Royal Palace
collection; gift, 2003, King Ndofoa Zofua III
• Inv. BB. 03.2.71, Babungo Museum

33

34

This is one of a series of statues made during the first half of the twentieth century by Simbo Melang and Nchia Kumeghe to portray the king's special guardians. Decorated with beads, the figure holds a ceremonial flute (*toole*) placed on his chest. The cowries and beads represent the wealth of the palace during that period, while the flute is used for the retainers' dance (*ndau vang fee*). It is kept in a special room inside the palace called *tambu*. The fon is wearing a high cap (*isuh kom*), typical of the Kom area. (J.N.)

This statue throne represents King Forting and his wife. Wearing a cap with two loops (*isuh buu*), Forting has pointed triangular ears, open eyes and a slightly curved nose. His mouth is small and closed. He is dressed in a loincloth passing between his legs. The statue of his wife is similar to that of the king, except for the specially plaited hair (*fencho*), two scars on her cheeks, her pointed breasts and a calabash held in her hands and placed on her stomach. The seat of the throne is supported by three human figures, two male and

159

one female. Made by King Zofoa II, this statue throne is a copy of the original made by King Sake II in the first half of the twentieth century. King Forting is holding a cup and a pipe, representing his nobility and authority.

The statue throne was kept inside the palace and displayed outside it during the *benefuan* and *nikai* festivals. It has been used by both Zofoa II and Ndofoa Zofua III. (*L.M.*)

35. Commemorative statue throne of a king and wife (*fuan* Forting and *nah*)

Perhaps by King Sake II
Babungo, Ndop, North-West Grasslands, Cameroon
Perhaps colonial period, first half of the twentieth century
Wood
Height: 120 cm; depth: 50 cm; width: 59 cm
Previously in the Babungo Royal Palace collection; gift, 2002, King Ndofoa Zofua III
• Inv. BB.02.1.37, Babungo Museum

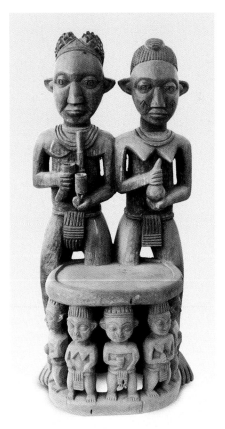

The seat of the throne is supported from below by anthropomorphic figures. The male is holding ceremonial caps in his right hand and is wearing a loincloth passing between his legs. The female figures have specially plaited hair and their hands are placed on their chests. The backrest represents a couple, King Forting and his wife. The king is holding a cup and a pipe, representing his nobility and authority. The statue throne was displayed outside the palace during *benefuan* and *nikai* (two annual festival). King Forting drowned in the river (see cat. no. 28). (*C.N.*)

36. Royal stool with animal motifs (*keneh*)

Ndifuan Ngow
Babungo, Ndop, North-West Grasslands, Cameroon
Post-colonial period, second half of the twentieth century
Wood
Height: 51 cm; diameter: 58 cm
Previously in the Babungo Royal Palace collection; gift, 2002, King Ndofoa Zofua III
• Inv. BB.02.1.46, Babungo Museum

This wooden royal stool is supported by three carved lizards or chameleons attached to a round base. The animals form a circle with the mouth of each attached to the tail of the preceding one and also holding the tail placed on the pedestal with one foot. Each of them has one fore and hind leg supporting the base of the stool. Ndifuangow, an artist and retainer who worked with King Zofoa II, made this stool, which was used only by the king as a piece of household furniture. (*J.N.*)

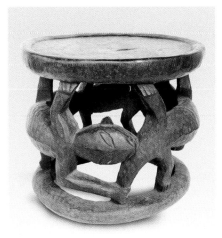

35

36

37. Statue throne (*keneh*)

King Zofoa II
Babungo, Ndop, North-West Grasslands,
Cameroon
Post-colonial period, second half of the
twentieth century
Wood
Height: 117 cm; width: 46 cm; diameter: 67 cm
Previously in the Babungo Royal Palace
collection; gift, 2002, King Ndofoa Zofua III
• Inv. BB.02.2.47, Babungo Museum

ship. The elephant head represented on the object
symbolizes the king's power. (*J.N.*)

38. Royal throne (*keneh*)

King Zofoa II and Ndifuan Ngow
Babungo, Ndop, North-West Grasslands,
Cameroon
Post-colonial period, second half
of the twentieth century
Wood
Height: 126 cm; width: 48 cm; depth: 66 cm

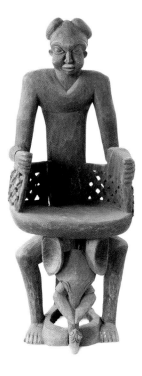

37

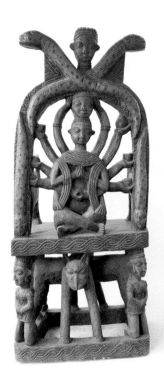

38

This is a wooden throne with the backrest consisting of a male statue seated on a stool decorated with geometric motifs standing on a base. The fon is wearing a cap with two loops (*isuh buu*). His face is characterized by two engraved curved lines forming the eyebrows, deep oval eyes, swollen cheeks separated by a small nose with a straight profile and a small closed mouth. The cylindrical neck stands on muscular shoulders and the arms are bent. The throne is decorated with spider motifs. The human figure is dressed in a loincloth that passes between the legs. The side of the base is attached to the feet of the statue. King Zofoa II carved the throne to demonstrate his craftsman-

Previously in the Babungo Royal Palace
collection; gift, 2003, King Ndofoa III
• Inv. BB.03.2.79, Babungo Museum

This throne is supported by four small-carved kneeling female figures and four leopards all standing on a pedestal. The backrest of the throne, which is only used by the king, is decorated behind with four snakes that cross on the right and left sides. The kneeling female figures show how the queens have to bend before talking to the king? as does any Babungo woman, while the representations of leopards are a sign of power. (*C.N.*)

Arts and Techniques

2. Musical Instruments

39. Single gong with human figure (*fengeng*)

Bamoum workshop
West Grasslands, Cameroon
Probably post-colonial period, second half
of the twentieth century
Bronze
Height: 45 cm; depth: 20.5cm; width: 6.5 cm
Previously in the Babungo Royal Palace
collection; gift, 2002, King Ndofoa Zofua III
• Inv. BB.02.2.21, Babungo Museum

40. Male drum (*nkia nintai*)

Ndula Wangfung
Babungo, Ndop, North-West Grasslands,
Cameroon
Post-colonial period, second half of the
twentieth century
Wood and hide
Height: 107 cm; diameter: 42 cm
Previously in the Babungo Royal Palace
collection; gift, 2002, King Ndofoa Zofua III
• Inv. BB.02.1.26, Babungo Museum

The top of the drum is covered with an antelope hide
held in place by twelve pins and a nylon cord. It is

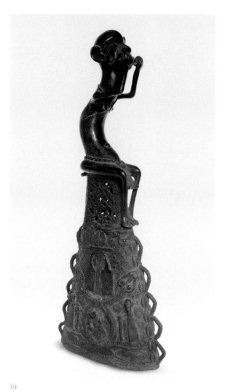

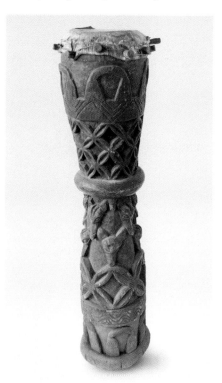

39

40

The handle of the gong consists of a human fig-
ure sitting with a bent back and blowing a trum-
pet (*isau*) held in both hands. One side of the gong
is decorated with a double gong, two sword
sheaths, a spider and other decorations, while the
other side is adorned with a double gong, two
human figures and a two-headed snake. A gift from
the Bamoum king to King Zofoa II, the gong was
kept in a special room in the palace and used by
the *shaw* dancers during death celebrations and
palace rituals. (*J.N.*)

decorated with double gongs, carved cowries, spi-
ders and geometric motives. This drum is used dur-
ing *nikai* (the annual dance for the *ngumba*
members), *benefuan* (the annual dance for the whole
kingdom), *nintai* (the princes' juju group) and the
yifung (the tomb priests' dance group). (*J.N.*)

41. Drum (*nkia yisan*)

Simbo Melang
Babungo, Ndop, North-West Grasslands,

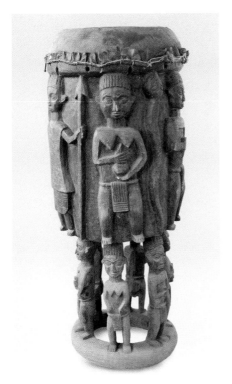

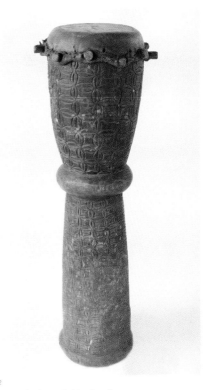

41

Cameroon
Colonial period, first half of the twentieth
century
Wood and hide
Height: 155 cm; diameter: 60cm
Previously in the Babungo Royal Palace
collection; gift, 2002, King Ndofoa Zofua III
• Inv. BB.02.1.24, Babungo Museum

The large wooden drum is supported by six human
figures standing on a base. The top is covered with
an antelope skin. The body of the drum is decorated
with six human figures (five males and one female)
separated by three snakes and two spears in relief.
The female figure represents a standing queen with
plaited hair and pointed breasts; she is holding a cal-
abash, with both hands resting on her stomach. A
piece of cloth with geometric decorations covers her
genitals. The five male figures comprise two nota-
bles and three retainers. The drum is also supported
by six human figures (three males and three females)
standing on the base. The sculptor Simbo Melang,
who carved it during the reign of King Sake II,
worked with both Sake II and Zofua II until his death
in 1966. Used during the *benefuan* and *nikai* dances,
this drum was kept in the palace and was only taken
out on these two occasions. (*J.N.*)

42

42. Male drum (*nkia nintai*)

Amadou Ngow
Babungo, Ndop, North-West Grasslands,
Cameroon
Colonial period, second half of the twentieth
century
Wood and hide
Height: 104 cm; diameter: 45 cm
Previously in the Babungo Royal Palace
collection; gift, 2003, King Ndofoa Zofua III
• Inv. BB.03.2.75, Babungo Museum

The top of this small male drum is covered with
antelope hide.
It is decorated with carved cowries and is used for
the *benefuan* and *nikai* dances; it is played as a prel-
ude to the large drum. (*J.N.*)

43. Horizontal drum (*kwing nintai*)

King Sake II
Babungo, Ndop, North-West Grasslands
Cameroon
Colonial period, first half of the twentieth
century
Wood

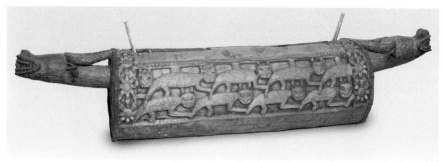

43

Height: 62 cm; length: 220 cm; width: 41cm
Previously in the Babungo Royal Palace
collection, gift, 2003, King Ndofoa Zofua III
• Inv. BB. 03.2.81 Babungo Museum

This horizontal wooden drum of the *nintai* dance
is decorated with buffaloes, snakes spiders, gongs
and so on. The dance is performed during the
death celebrations of the king, a prince, a
princess, or any other member of the royal fam-
ily. The representations on the gong are all signs
of the power to which the princes and princesses
are entitled. (*P.B.*)

44. Double gong (*fengeng*)

Finkwi workshop
Babungo, Ndop, Northwest Grasslands,
Cameroon
Post-colonial period, second half twentieth
century
Iron
Height: 34 cm; length: 25 cm; width: 10 cm

Previously in the Babungo Royal Palace
collection; gift, 2002, King Ndofoa Zofua III
• Inv. BB.02.2.72, Babungo Museum

This double gong is made from iron and a U-shaped
cane. The princes used it during their *ngonji* dance
whenever there were the death celebrations of a
king, a king's wife, a prince or princess, or any other
member of the royal family. This musical instru-
ment was made in an iron workshop in Finkwi, but
the maker's name is unknown. (*P.B.*)

45. Double gong with human figure (*fengeng*)

Ndula Gwaih
Ndop, North-West Grasslands, Cameroon
Post-colonial period, second half of the
twentieth century
Wood and iron
Height: 33 cm; length: 8 cm; width: 7.5 cm
Previously in the Babungo Royal Palace
collection; gift, 2002, King Ndofoa Zofua III
• Inv. BB.02.2.19, Babungo Museum

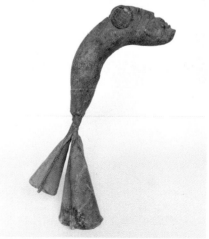

44

45

One side of the double gong is bigger and longer than the other. It was used by the *shaw* dance group for producing music during rituals and the death celebrations of the king, princes and princesses and kingdom notables. Ndula Gwaih is a blacksmith who lived in Finkwi, the blacksmithing quarter in Babungo. (*P.B.*)

46. Single bell or gong with human figure (*fengeng*)

Ndula Gwaih
Babungo, Ndop, North-West Grasslands, Cameroon
Second half of the twentieth century
Wood and iron
Height: 71.5 cm; length: 20 cm; width: 14 cm
Previously in the Babungo Royal Palace collection; gift, 2002, King Ndofoa Zofua III
• Inv. BB.02.2.20, Babungo Museum

The blacksmith Ndula Gwaih produced this single gong, which was used by the *shaw* (the queens' and princesses' dance group) during the death celebrations of the king, or other members of the royal family, and during palace and kingdom rituals. (*C.N.*)

47. Ndenge (*ndeu nteu*)

Nchinda Saingue
Babungo, Ndop, North-West Grasslands Cameroon
Colonial period, second half of the twentieth century
Wood

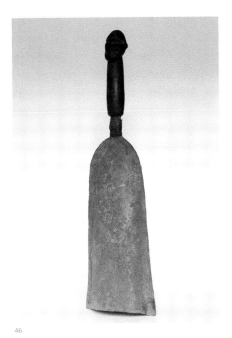

46

Previously in the Babungo Royal Palace collection, gift, 2002, King Ndofoa Zofua III
• Inv. BB.02.2.45, Babungo Museum

This wooden *ndenge* (the instrument is also known as the sanza or thumb piano) is made from hide, strings and cane. The first part contains six sticks that are joined to the second part through small holes. On the second part is a surface covered with hide. There is also a projection with six engraved lines that have six strings tied to the top of the sticks. It was acquired by King Zofua II, who used it during his leisure time. (*J.N.*)

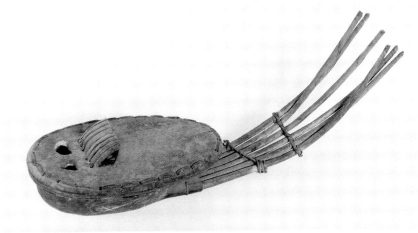

47

Art and Techniques

3. Containers

48. Royal beaded calabash with cat motif (*finteng-fintoh*)

King Zofoa II
Babungo, Ndop, North-West Grasslands,
Cameroon
Colonial period, first half of the twentieth century
Calabash, cloth and beads
Height: 76 cm; depth: 9.2 cm
Previously in the Babungo Royal Palace
collection; gift, 2002, King Ndofoa Zofua III
• Inv. BB.02.2.24, Babungo Museum

A wooden calabash covered with multicoloured glass beaded supported by a cat standing on a pedestal. It was kept beside the king during the *nikai* and *benefuan* dances. (C.N.)

49. Royal wine container (*finteng-fintoh*)

Perhaps by a Babungo Palace workshop
Babungo, Ndop, North-West Grasslands,
Cameroon
Colonial period, first half of the twentieth century
Calabash, cloth and beads
Height: 76 cm; height with pedestal: 79 cm
Previously in the Babungo Royal Palace
collection; gift, 2002, King Ndofoa Zofua III
• Inv. BB. 02.2.55, Babungo Museum

Decorated with white and blue cylindrical beads, this container stands on a cylindrical base and has a long tube-like mouth. It may have been made in a Babungo palace workshop during the first half of the twentieth century. It was carried round the palace dancing arena behind the fon during the *benefuan* and *nikai* dances. It was also placed beside the fon on important occasions in the palace. (L.M.)

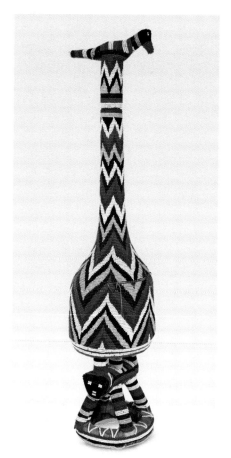

48

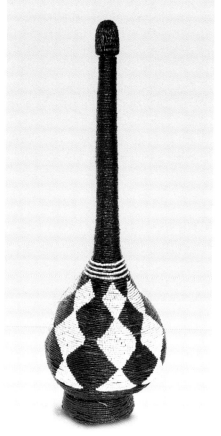

49

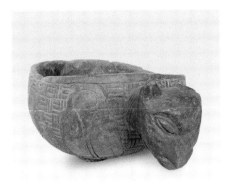

50

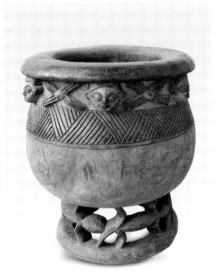

51

50. Dish in the form of an animal (kui)

Simbo Njinuh
Babungo, Ndop, North-West Grasslands,
Cameroon
Post-colonial period, second half of the
twentieth century
Wood
Height: 31 cm; length: 111cm; width: 50 cm
Previously in the Babungo Royal Palace
collection; gift, 2002, King Ndofoa Zofua III
• Inv. BB.02.1.31, Babungo Museum

This wooden container in the form of a leopard is
decorated on both sides with two double gongs and
geometric patterns. The leopard's head is small,
with one of the ears erect and the other broken.
It has open eyes and a large mouth with the teeth
exposed.
The head and the tail of the animal form the han-
dles of the dish and it is supported by a ring. The
dish was used to serve food to the members of the
ngumba, especially when there were death cele-
brations in the palace. It was made by Simbo
Njinuh, an artist and retainer working in the palace
during the reign of King Zofoa II. (J.N.)

51. Round container (yikung)

Simbo Njinuh
Babungo, Ndop, North-West Grasslands,
Cameroon
Post-colonial period, second half of the
twentieth century
Wood
Height: 72 cm; diameter: 61 cm; depth: 49 cm
Previously in the Babungo Royal Palace
collection; gift, 2003, King Ndofoa Zofua III
• Inv. BB.03.2.74, Babungo Museum

The upper part of this wooden container is deco-
rated with six human heads alternating with six spi-
ders in relief; it is also adorned with geometric
motifs. It is supported by four chameleons and a
ring that touches the ground. It was used to hold
wine for the *ngumba* society. (C.N.)

52. Dish (kui)

King Zofoa II
Babungo, Ndop, North-West Grasslands,
Cameroon
Post-colonial period, second half of the
twentieth century
Wood
Height: 23 cm; height with pedestal: 26 cm;
length: 46 cm; width: 33 cm
Previously in the Babungo Royal Palace

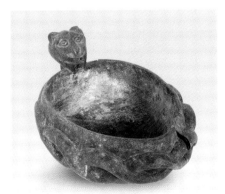

52

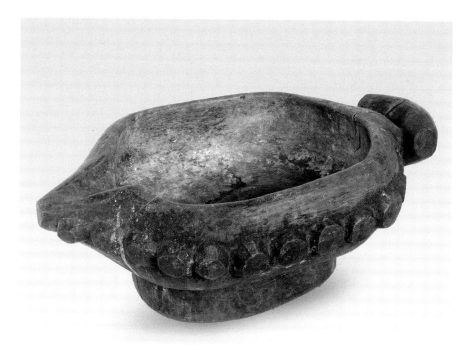

53

collection; gift, 2002, King Ndofoa Zofua III
• Inv. BB.02.1.1.14 Babungo Museum

Decorated with geometric motifs, this food container has the carved head of an animal at the side forming the handle. The king put food in this container to entertain the *ngumba* groups (*tifuan* and *gah tifuan*, two important secret societies) in the palace. (C.N.)

53. Dish *(kui)*

King Zofoa II
Babungo, Ndop, North-West Grasslands, Cameroon
Post-colonial period, twentieth century

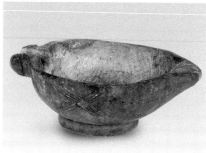

54

Wood
Height: 15 cm; height with pedestal: 20 cm; length: 47 cm; width: 32 cm
Previously in the Babungo Royal Palace collection; gift, 2002, King Ndofoa Zofua III
• Inv. BB.02.1.21, Babungo Museum

Decorated with cylindrical motifs, this container standing on a pedestal was used to contain food shared by members of the *ngumba* society, especially when there were death celebrations in the palace. (C.N.)

54. Dish *(kui)*

King Zofoa II
Babungo, Ndop, North-West Grasslands, Cameroon
Post-colonial period, twentieth century
Wood
Height: 11 cm; height with pedestal: 14 cm; length: 35 cm; width: 23 cm
Previously in the Babungo Royal Palace collection; gift, 2002, King Ndofoa Zofua III
• Inv. BB.02.2.63, Babungo Museum

Carved in wood and attached to a base, this container is decorated with spider figures in relief

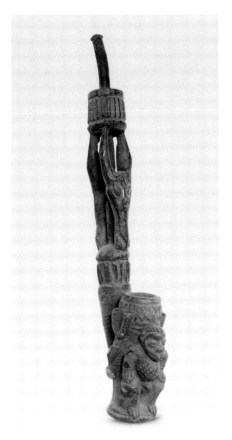

55

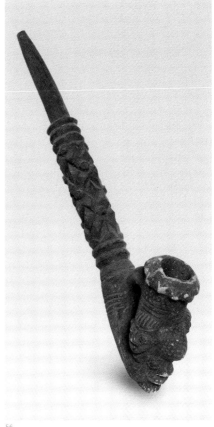

56

and has a round handle on one side. It was carved by Zofoa II, who learnt this skill from Simbo Kosho, a sculptor working with King Sake II. Used for entertaining in the palace on special occasions, the container serves to distribute food to groups from throughout the kingdom during ceremonies in the palace and also to members of the *ngumba* societies. (C.N.)

55. Royal pipe with animal and human figures (*yikeng*)

Komboyoh
Babungo, Ndop, North-West Grasslands,
Cameroon
Colonial period, second half of the twentieth century
Wood and clay
Height: 42 cm; diameter: 8 cm; depth: 9.5 cm
Previously in the Babungo Royal Palace collection; gift, 2002, King Ndofoa Zofua III
• Inv. BB.02.2.36, Babungo Museum

Made of wood and clay, this royal pipe (*yikeng*) is decorated with geometric motifs and two buffalo heads in relief. The bowl is adorned with a double gong and bird and human motifs. The seated human figure has a pointed forehead, two large oval eyes and a short broad nose underneath which is a long closed mouth. His hands are placed on his knees; he has a protruding stomach and pronounced genitals. The pipe was made by Komboyoh from Finkwi and donated to King Zofoa II in the second half of the twentieth century. Komboyoh, who died in 2000, was one of the most renowned potters in Babungo and made most of the clay pipes in the palace. The king used the pipe in his leisure time. The buffalo head and the double gong are all representations of power. (J.N.)

56. Royal smoking pipe (*yikeng*)

King Sake II
Babungo, Ndop North-West Grasslands,
Cameroon

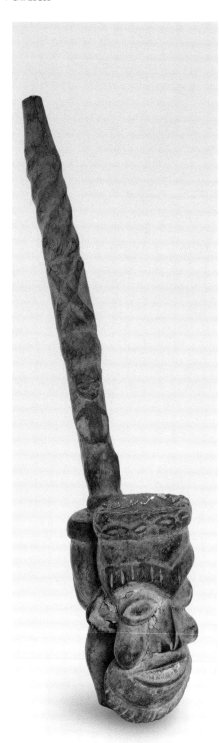

Colonial period, first half of the twentieth century
Clay and wood
Height: 42 cm; diameter: 8 cm; depth: 9.5 cm
Previously in the Babungo Royal Palace collection; gift, 2002, King Ndofoa Zofua III
• Inv: BB.02.1.13 Babungo Museum

This royal smoking pipe is decorated with spider motifs a drum and a figure. The bowl of the pipe is formed by a human face. Only King Sake II and King Zofoa II used the pipe during their reigns. (P.B.)

57. Royal pipe with human head (*yikeng*)

Amadou Ngow
Babungo, Ndop, North-West Grasslands, Cameroon
Post-colonial period, second half of the twentieth century
Wood
Height: 8 cm; length: 42 cm; width: 7.5 cm
Previously in Babungo Royal Palace collection; gift, 2002, King Ndofoa Zofua III
• Inv: 02.2.5, Babungo Museum

This pipe has a tube adorned with a row of spider decorations. On the bowl is the representation of a human face with a protruding forehead, two engraved lines forming the eyebrows, two large oval eyes, small ears, a short nose, swollen cheeks and a closed mouth.
The chin is covered with carved geometric motifs forming the beard. This pipe was produced during the reign of Zofoa II, who used it during his leisure time. (P.B.)

58. Royal pipe with human figure (*yikeng*)

King Zofoa II
Babungo, Ndop, North-West Grasslands, Cameroon
Post-independence, second half of the twentieth century
Wood
Height: 11 cm; length: 53 cm; width: 7.5 cm
Previously in Babungo Royal Palace collection; gift, 2002, King Ndofoa Zofua III
• Inv. BB. 02.2.3, Babungo Museum

The tube of the pipe consists of two lizards carved in relief and facing each other. The bowl is adorned with a human head that has two oval eyes painted

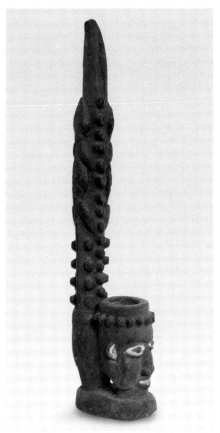

58

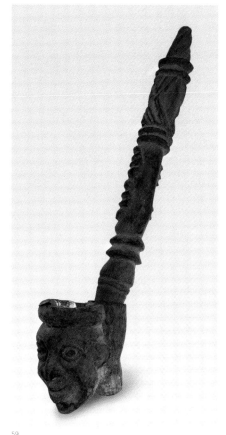

59

white. The pipe is believed to have been made by King Zofoa II.

It was used by the king for smoking whenever he wished, especially when he was angry and wanted to calm down. (P.B.)

59. Royal pipe with human head (yikeng)

King Zofoa II
Babungo, Ndop, North-West Grasslands, Cameroon
Post-colonial period, second half of the twentieth century
Zinc and wood
Height: 14 cm; length: 59 cm; width: 11 cm
Previously in the Babungo Royal Palace collection; gift, 2002, King Ndofoa Zofua III
• Inv. BB.02.2.4, Babungo Museum

The bowl of the pipe is in the form of a carved human head. The face has a pointed forehead, small eyes and ears, a short nose and a V-shaped

mouth with a pointed chin. The inner part of the bowl is made of zinc. King Zofoa II, who made this pipe, used it for smoking whenever he wished, especially when he was angry and wanted to calm down. The spider on the pipe symbolizes the magical powers of the king. The pipe was kept in a special room in the palace and was royal property. (P.B.)

60. Royal pipe with animal figure (yikeng)

Komboyoh
Babungo, Ndop, North-West Grasslands, Cameroon
Post-colonial period, second half of the twentieth century
Clay, brass and wood
Height: 24 cm; length: 59 cm; width: 11 cm
Previously in the Babungo Royal Palace collection; gift, 2002, King Ndofoa Zofua III
• Inv. BB.02.2.69, Babungo Museum

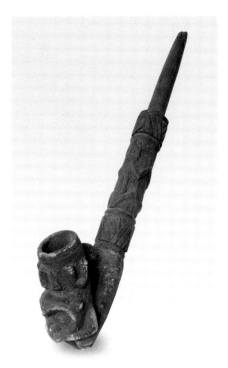

60

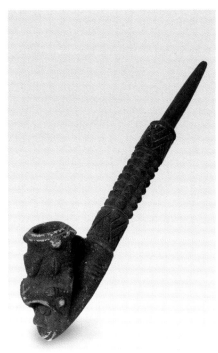

61

The stem of this clay pipe is made of wood and decorated with engraved lines. The bowl is decorated with three double gongs and a seated animal figure in relief supporting its chin with both forelimbs.

The pipe was made by Komboyoh from Finkwi and donated to King Zofoa II. Komboyoh was a renowned potter who produced most of the pipes in the Babungo Palace. (P.B.)

61. Royal pipe (bu ntoh)

Komboyoh
Babungo, Ndop, North-West Grasslands, Cameroon
Colonial period, second half of the twentieth century
Clay and wood
Height: 40.5 cm; diameter: 7 cm; depth: 9.6 cm
Previously in the Babungo Royal Palace collection; gift, 2002, King Ndofoa Zofua III
• Inv. BB.02.2.56, Babungo Museum

This smoking pipe has a wooden stem and a clay bowl. The bowl is decorated with four small protuberances from the rim, two cowrie motifs and a double gong between them. There are also two representations of human heads placed on the head of a chimpanzee in relief. (P.B.)

62. Royal pipe with a human head (buh ntoh)

Komboyoh
Babungo, Ndop, North-West Grasslands, Cameroon
Post-colonial period, second half of the twentieth century
Clay, brass and wood
Height: 50.2 cm; diameter: 9.5 cm; depth: 10 cm
Previously in the Babungo Royal Palace collection; gift, 2002, King Ndofoa Zofua III
• Inv. BB.02.2.66 Babungo Museum

The upper part of the bowl of the pipe is decorated with a human head in relief. Some geometric lines form the eyebrows, with large protruding eyes and small cheeks.

The short vertical line of the nose counterbalances the horizontal line of the mouth. The stem is made of brass and wood, with two engraved lines on it.

This smoking clay pipe is another work by the potter Komboyoh. (P.B.)

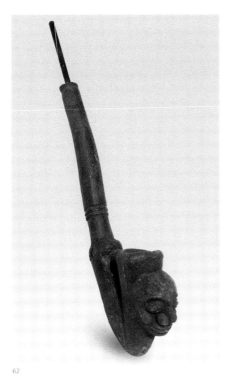

62

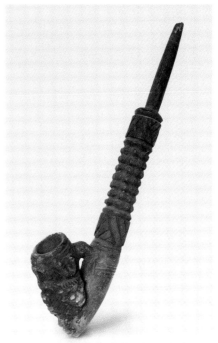

63

63. Royal smoking pipe (*yikeng*)

King Sake II
Babungo, Ndop, North-West Grasslands,
Cameroon
Colonial period, first half of the twentieth
century
Clay and wood
Height: 42 cm; diameter: 5 cm; depth: 8 cm
Previously in the Babungo Royal Palace
collection; gift, 2002, King Ndofoa Zofua III
• Inv. BB.02.2.33, Babungo Museum

Made from wood and clay, this royal pipe (*yikeng*)
is decorated with engraved spider figures, with geo-
metric motifs on the bowl. King Sake II, who was
a preacher for the Basel Mission before his
enthronement, produced this pipe. The pipe was
kept in a special room in the palace and only
removed when it was needed; it has only been used
by King Sake II and King Zofoa II. (C.N.)

64. Royal smoking pipe (*yikeng*)

Bamoum workshop
Grasslands, Cameroon
[Date] unknown
Brass

Height: 20 cm; depth: 5.5 cm
Previously in the Babungo Royal Palace
collection; gift, 2003, King Ndofoa Zofua III
• Inv. BB.03.2.84, Babungo Museum

Made of brass, this small royal pipe is decorated with
geometric motifs, as well as with a man's face wear-
ing a police cap, which form's the bowl. This royal
pipe was a gift to King Saingi II from the king of
Foumban. (C.N.)

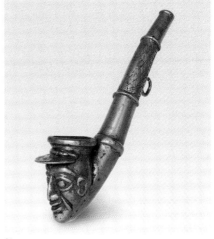

64

Arts and Techniques

4. Masks, Costumes, Personal Adornments

65. Zoomorphic mask (*ngwang nenteng Ngonji*)

Babungo palace workshop
Babungo, Ndop, North-West Grasslands,
Cameroon
Twentieth century
Wood, cloth, cowries and beads
Height: 20 cm; length 54 cm; width: 37 cm
Previously in the Babungo Royal Place
collection; gift, 2003, King Ndofoa Zofua III
• Inv. BB.02.1.9 Babungo Museum

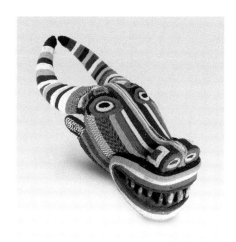

66

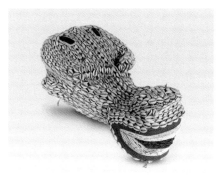

65

This zoomorphic helmet mask representing the head
of a cow or buffalo is completely covered with cowries
and beads. The horns are curved, almost meeting on
the vertical axis of the nose. Its eyes are decorated
with blue and white beads and it has pointed ears;
There is a horizontal line of small beads on the nos-
trils. The mouth is covered with red, white and black
beads and there is a strip of beads on the rim of the
hollow underneath. This mask was carved in a
Babungo Palace workshop during Sake II's reign, but
King Zofua II beaded it. It is used only during spe-
cial ceremonies (such as the death celebrations for
the queen and queen mother) in the palace. Kept
in the king's parlour, it was used by Sake II, Zofua
II and Ndofoa Zofua III. (*L.M.*)

66. Zoomorphic mask (*kosho*)

*Carved by King Sake II and beaded
by King Zofua II*
Babungo, Ndop, North-West Grasslands,
Cameroon
Colonial period, first half of the twentieth
century

Wood, cloth, and beads
Height: 22 cm; length: 80 cm; width: 35 cm
Previously in the Babungo Royal Place
collection; gift, 2002, King Ndofoa Zofua III
• Inv. BB.02.1.40, Babungo Museum

This wooden helmet mask in the form of a buffalo's
head is entirely covered with strips of multicoloured
beads. The curved long horns almost meet at the
crown and occupy half of the total length of the
mask; their surfaces are decorated with bands of
beads of different colours: yellow, white, orange and
brown. Dividing it symmetrically into two, some par-
allel strips of colour in relief descend from the top
of the long face right to the edge of the prominent
nose above the open lips, which allow the teeth to
be seen. The mask is only used when a queen or a
queen mother dies and, when the king wants to par-
ticipate in a masquerade dance ceremony in the
palace, special retainers put on this mask. King
Ndofoa Zofua III and King Sake II used it and, at
present, Zofua II uses it. Usually a buffalo symbol-
izes power in the Babungo culture and titleholders
use its horns as drinking cups. (*L.M.*)

67. Anthropomorphic mask (*toh mekome tifuan*)

Simbo Melang
Babungo, Ndop, North-West Grasslands,
Cameroon
Colonial period, first half of the twentieth
century
Wood, cloth, and beads
Height: 28 cm; length 18 cm; width: 12 cm
Previously in the Babungo Royal Palace

174

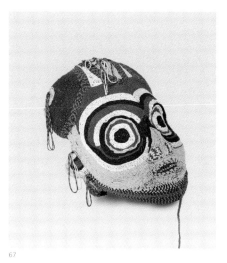

67

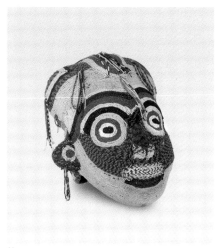

68

collection; gift, 2002, King Ndofoa Zofua III
• Inv. BB.02.2.43, Babungo Museum

This wooden helmet mask representing a human face
is completely covered with multicoloured beads. The
head is large in size and the ears are curved. The eyes
are open and covered with blue, white, red and yel-
low beads. The face has a long nose with a closed
mouth above the round chin; other strings of beads
hang from the head. The mask was carved by Simbo
Melang, one of the retainers who worked in the
palace during the reign of King Sake II. The princes'
dance group (*ngonji*) used it during the death cele-
brations of the king, queen, prince, princess or any
other member of the royal family. (*J.N.*)

68. Anthropomorphic mask
(***toh mekome ngonji***)

Simbo Melang
Babungo, Ndop, North-West Grasslands,
Cameroon
Colonial period, first half of the twentieth
century
Wood, cloth and beads
Height: 35 cm; length: 32 cm; width: 30 cm
Previously in the Babungo Royal Palace
collection; gift, 2002, King Ndofoa Zofua III
• Inv. BB.02.2.44, Babungo Museum

This anthropomorphic wooden mask representing
a human face is completely covered with multi-
coloured beads. The head is large in size and has
ten strings of beads in groups of four. The ears, con-
sisting of red, white and yellow beads, are large,
while the forehead is pointed. The large nose is flat

and the jaw is round, with the mouth closed. This
helmet mask was carved by Simbo Melang, one of
the retainers who worked in the palace during the
reign of King Sake II. It was used by the princes'
dance group (*ngonji*) during the death celebrations
of the king, queen, prince, princess or any other
member of the royal family. (*J.N.*)

69. Anthropomorphic mask
(***toh mekome ngonji***)

Simbo Melang
Babungo, Ndop, North-West Grasslands,
Cameroon
Colonial period, second half of the twentieth
century
Wood, cloth and beads
Height: 34 cm; length: 30 cm; width: 28 cm

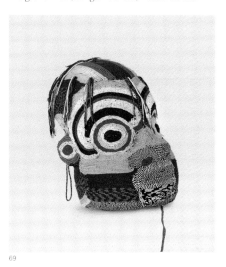

69

175

Previously in the Babungo Royal Palace collection; gift, 2002, King Ndofoa Zofua III
• Inv. BB.02.2.37, Babungo Museum

See cat. 70.

70. Zoomorphic helmet mask
(*toh mekome ngonji*)

Amadou Ngow
Babungo, Ndop, North-West Grasslands, Cameroon
Colonial period, second half of the twentieth century
Wood, fibres and beads
Height: 20 cm; length: 50 cm; width: 43 cm
Previously in the Babungo palace collection; gift, 2002, King Ndofoa Zofua III
• Inv. BB.02.1.17, Babungo Museum

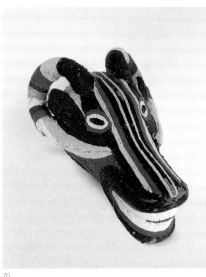

70

Covered with multicoloured beads, this wooden zoomorphic helmet mask has two curved horns passing behind the protruding ears. The eyes and the long open mouth are decorated with red and white beads, while the surface of the face is covered with bands of beads extending from the base of the horns to the upper lip. This mask was carved by Amadou Ngow, a carver who worked with King Zofua II, and acquired by the king, who assigned the task of sewing the beads on it to his wives. The leader of the *ngonji* juju dance wore this mask? which was kept in a special room in the palace? during death celebrations: the *ngonji* juju is a group that only comprises the king's sons (*C.N.*)

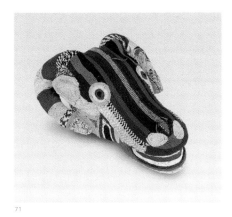

71

71. Zoomorphic helmet mask
(*toh mekome ngonji*)

Amadou Ngow
Babungo, Ndop, North-West Grasslands, Cameroon
Post-colonial period, second half of the twentieth century
Wood, cloth and beads
Height: 20 cm; length: 53.5 cm; width: 33 cm
Previously in the Babungo Royal Palace collection; gift, 2002, King Ndofoa Zofua III
• Inv.BB.03.2.82, Babungo Museum

See cat. 70.

72. Zoomorphic mask of the *ngonji* dance
(*toh ngwang ngonji*)

Amadou Ngow
Babungo, Ndop, North-West Grasslands, Cameroon
Colonial period, second half of the twentieth century
Wood, fibre and beads
Height: 19 cm; length: 53 cm; width: 36 cm
Previously in the Babungo Royal Palace collection; gift, 2002, King Ndofoa Zofua III
• Inv. BB.02.1.6, Babungo Museum

Representing a cow's head, this wooden zoomorphic helmet mask is, except for the teeth, entirely covered with multicoloured beads. It has four horns curving inwards from behind, two large protruding ears, two swollen eyes and two flat vertical nostrils. The mouth is large and open, allowing the teeth to be seen. It was used during the *ngonji* dance, which is usually performed by a princess. (*C.N.*)

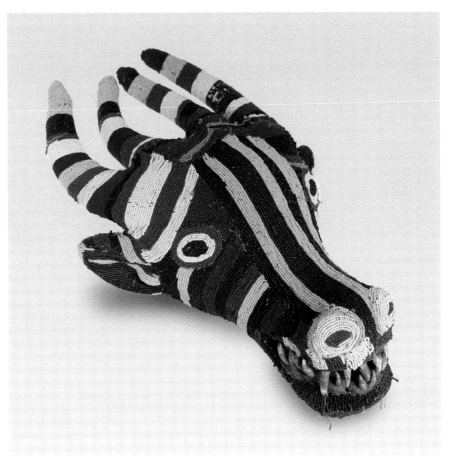

72

73. Helmet mask with animal figure (*toh mekome tifuan*)

King Sake II
Babungo, Ndop, North-West Grasslands,

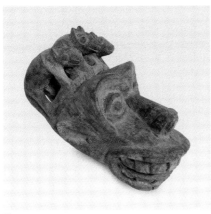

73

Cameroon
Colonial period, first half of the twentieth century
Wood
Height: 25 cm; length: 49 cm; width: 33 cm
Previously in the Babungo Royal Palace collection; gift, 2002, King Ndofoa Zofua III
• Inv. BB.02.2.9, Babungo Museum

The wooden helmet mask represents a chimpanzee's head: above the eyes there are three small carved animals, standing in a line. The *mekome tifuan* dancers that usually used it were members of the *ngumba*. This dance is usually performed when a king or an important notable? including all quarter heads? dies, as well as during rituals. This mask was kept in a special room in the palace and was brought out only when need arose. (*P.B.*).

Artists and Craftsmen

74. Commemorative statue of a king (*fuan* Sake II)

Nchia Kumeghe
Babungo, Ndop, North-West Grasslands,
Cameroon
Colonial period, first half of the twentieth
century
Wood, beads, cowries and textile
Height: 97 cm; depth: 37 cm;
width: 38.5 cm
Previously in the Babungo Royal Palace
collections; gift, 2002, King Ndofoa Zofua III
• Inv. BB.02.1.23, Babungo Museum

This is a commemorative statue of a king sitting on a stool covered with cowries. Wearing a cap (*isuh buu*), the fon has a large head with protruding curved ears. His large face is characterized by two curved lines above the oval eyes. The surface of the back is adorned with five almost circular motifs. Two vertical bands of blue and red beads between the legs and three bands of dark blue, sky blue and yellow beads form the fon's costume. His large legs end in flat feet, which are attached to the pedestal. The statue, which is entirely covered with beads, was carved by Nchia Kumeghe and beaded by King Sake II. It was kept in a special room in the palace and displayed in front of the palace during the nine days of the king's death celebrations. It was used during the enthronement of King Zofoa II in 1955 and that of King Ndofoa Zofua III in 1999. (*C.N.*)

75. Machete (*baah vengo*) – The king's blacksmith's workshop

Babungo, Ndop, Northwest Grasslands,
Cameroon
Colonial period, first half of the twentieth
century
Iron

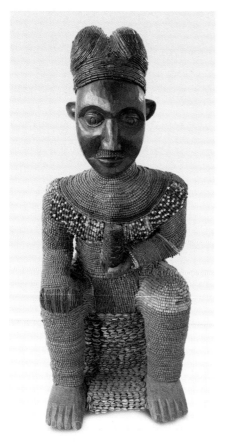

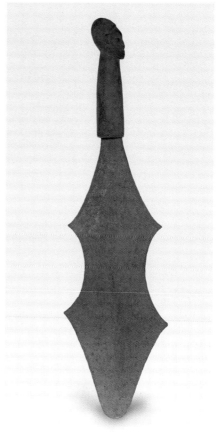

74

75

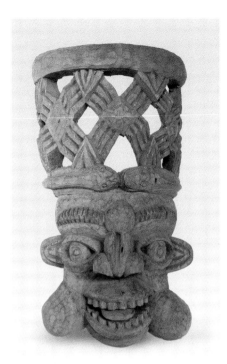

76

Length: 84 cm; width: 24 cm
Previously in the Babungo Royal Palace
collection; gift, 2003, King Ndofoa Zofua III
• Inv. BB.03.2.083, Babungo Museum

This traditional iron machete (*baah vengo*) was
forged in the king's blacksmith's workshop. It has
a wooden hilt adorned with a human head wear-
ing a cap (*isuh buu*).
The figure has a flat nose and open eyes, protruding
ears and a closed mouth.
This machete was used during the death celebra-
tions of a king or a queen, or for traditional ritu-
als. (C.N.)

76. Anthropomorphic helmet mask
(*toh mekome tifuan*)

King Zofoa II
Babungo, Ndop, North-West Grasslands,
Cameroon
Post-colonial period, second half of the
twentieth century
Wood
Height: 23 cm; length: 73 cm; width: 43 cm
Previously in the Babungo Royal Palace
collection; gift, 2003, King Ndofoa Zofua III
• Inv. BB.03.2.78, Babungo Museum

This wooden anthropomorphic helmet mask
(*tohmukong*) is adorned with a round shield,
itself decorated with a row of curved spiders and
two engraved snakes in relief with their heads
joined together.
It was the last object carved by King Zofoa II
before his death in 1999. A juju dance group
(*mekometifuan*) uses it during death celebrations.
The *mekometifuan* dance is performed by mem-
bers of the *ngumba*. (C.N.)

77. Commemorative statue of a queen
(*nah nkekoh*)

King Saingi II
Babungo, Ndop, North-West Grasslands,
Cameroon
Colonial period, first half of the twentieth
century
Wood
Height: 111 cm; height with pedestal: 118 cm;
length: 41 cm; width: 339 cm
Previously in the Babungo Royal Palace
collection; gift, 2003, King Ndofoa Zofua III
• Inv. BB.03.1.045, Babungo Museum

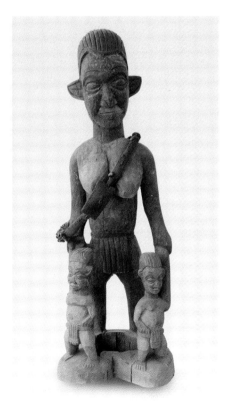

77

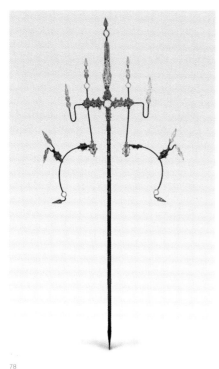

78

This is a commemorative statue of a queen, *nah* Nkekoh, standing on a pedestal. The queen has a large head with pointed triangular ears and well-plaited hair. Two engraved lines form the eyebrows over her large almond-shaped eyes. The profile of her nose is slightly curved and she has a large closed mouth. She is wearing a talisman that hangs across her body. Extending downwards, her hands are placed on two children (male and female) standing in front of her. She is wearing a loincloth that covers only her genitals and is held by a belt at waist level. The male child is wearing a cap, while the female child has well-plaited hair. Both of them are dressed in loincloths covering their genitals. This sculpture was made by King Saingi II during the first half of the twentieth century. It was kept inside the palace and displayed during *benefuan*, an annual dance for the whole kingdom. (*L.M.*)

78. Royal spear (*yeghau-ntoh*)

Finkwi blacksmith's workshop
Babungo, Ndop, North-West Grasslands, Cameroon
[Date] unknown
Wood and iron
Height: 230 cm; width: 100 cm
Previously in the Babungo Royal Palace

collection; gift, 2003, King Ndofoa Zofua III
• Inv. BB.03.3.077, Babungo Museum

Made by a Finkwi blacksmith, this weapon was used in various rituals and ceremonies. This kind of spear, which may be made with different forms, is an important object of power in many Grasslands kingdoms when it is consecrated. It is perhaps a copy of the original and is meant for protection. (*C.N.*)

79. Commemorative head of a queen (*nah* Wasembi)

Unknown
Origin unknown
Colonial period, first half of the twentieth century
Brass
Height: 30 cm; depth: 16 cm; width: 13 cm
Previously in the Babungo Royal Palace collection; gift, 2003, king Ndofoa Zofua III
• Inv. BB.03.3.82, Babungo Museum

This is a commemorative brass head of a queen, *nah* Wasembi. Small in size, the head is decorated with a row of cowries. There is also a row of cowries going round the face and a circle of two rows of cowries above on top of the lips. During the Babungo annual dance, *benefuan*, a queen carries this object dancing demurely behind the king. This piece is probably a copy of a Yoruba sculpture. *Nah* Wasembi was a wife of King Saingi II. (*C.N.*)

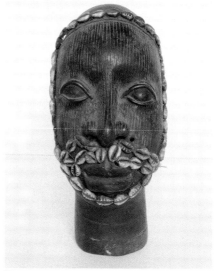

79

List of Objects

The Kingdom, Myth, Legend and History

1. Enthronement camwood container (*yoh-bui*) or dish (*ngui*)
2. Royal bed (*keng*)
3. Anthropomorphic head-mask (*toh ngoyuh*)
4. Royal staff (*mbai-ghoole*)
5. Royal elephant tusk trumpet (*yisau nsee*)
6. Royal elephant tusk trumpet (*yisau nsee*)
7. Royal stool (*keneh*)
8. Commemorative statue of King Saingi II
9. Commemorative statue of King Sake II
10. Commemorative statue of King Seevezui

Societies and Religion

1. Society

11. Statue throne of a retainer (*wenyui ntoh*)
12. Enthronement cap (*fantoh-yikwe*)
13. Enthronement stool (*keneh*)
14. King's necklace (*gih booh*)
15. King's necklace (*gih booh*)
16. Anthropomorphic mask (*munkuncho*)
17. Commemorative statue of king's assistant (*Bah Ngow*)
18. Commemorative statue throne of a royal guardian (*ndifua tambu*)
19. Commemorative statue throne of a queen mother (*nchio Minkee*)
20. Commemorative statue throne of a queen (*nah Yagisi*)
21. Royal beaded stool with animal motif (*keneh*)
22. Wooden camwood container (*yoh-bui*)
23. Wooden camwood container (*yoh-bui*)

Societies and Religion

2. Religion

24. Commemorative statue of warrior (*gwi yighau*)
25. Commemorative Statue of a warrior (*gwi yighau*)
26. Buffalo mask (*toh mekeme tifuan*)
27. Costume of the *felingwi* dance (*mba kang vessi*)

Arts and Techniques

1. Statues and Furniture

28. Commemorative statue throne of king and wife (*fuan* Forting and *nah*)
29. Commemorative statue of a royal guardian (*ndifua tambu*)
30. Statue of King Sake II
31. Commemorative statue of King Sake II
32. Commemorative statue of King Sake II
33. Commemorative statue throne of a royal guardian (*ndifua tambu*)
34. Commemorative statue throne of a king and wife (*fuan* Forting and *nah*)
35. Commemorative statue throne of a king and wife (*fuan* Forting and *nah*)
36. Royal stool with animal motifs (*keneh*)
37. Statue throne (*keneh*)
38. Royal throne (*keneh*)

Arts and Techniques

2. Musical Instruments

39. Single gong with human figure (*fengeng*)
40. Male drum (*nkia nintai*)
41. Drum (*nkia yisang*)
42. Male drum (*nkia nintai*)
43. Horizontal drum (*kwing nintai*)
44. Double gong (*fengeng*)
45. Double gong with human figure (*fengeng*)
46. Single bell or gong with human figure (*fengeng*)
47. *Ndenge* (*ndeu nteu*)

Arts and Techniques

3. Containers

48. Royal beaded calabash with cat motif (*fiteng-fintoh*)
49. Royal wine container (*fiteng-fintoh*)
50. Dish in the form of an animal (*kui*)
51. Round container (*yikung*)
52. Dish (*kui*)
53. Dish (*kui*)
54. Dish (*kui*)
55. Royal pipe with animal and human figures (*yikeng*)

56. Royal smoking pipe (*yikeng*)
57. Royal pipe with human head (*yikeng*)
58. Royal pipe with human figure (*yikeng*)
59. Royal pipe with human head (*yikeng*)
60. Royal pipe with animal figure
61. Royal smoking pipe (*yikeng*)
62. Royal pipe with a human head (*yikeng*)
63. Royal pipe (*yikeng*)
64. Royal smoking pipe (*yikeng*)

Arts and Techniques

4. Masks, Costumes and Personal Adornments

65. Zoomorphic mask (*ngwang neteng ngonji*)
66. Zoomorphic mask (*kosho*)
67. Anthropomorphic mask (*toh mekome tifuan*)
68. Anthropomorphic mask (*toh mekome ngonji*)
69. Anthropomorphic mask (*toh mekome ngonji*)
70. Zoomorphic helmet mask (*toh mekome ngonji*)
71. Zoomorphic helmet mask (*toh mekome ngonji*)
72. Zoomorphic helmet mask (*toh nguan Ngonji-nguansi*)
73. Helmet mask with animal figure (*toh mekome tifuan*)

Artists and Craftsmen

74. Commemorative statue of King Sake II
75. Machete (*baah vengo*)
76. Anthropomorphic helmet mask (*toh mekome tifuan*)
77. Commemorative statue of a queen (*nah nkekoh*)
78. Royal spear (*yeghau-ntoh*)
79. Commemorative head of a queen (*nah* Wasembi)